ANTON OTTO FISCHER—

MARINE ARTIST

HIS LIFE AND WORK

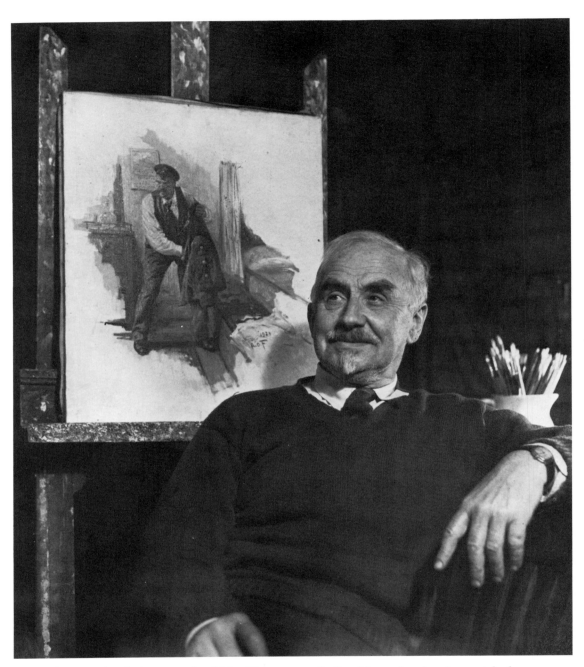

Anton Otto Fischer before a study of Mr. Glencannon, finding his pocket has been picked.

ANTON OTTO FISCHER

MARINE ARTIST

HIS LIFE AND WORK

by

KATRINA SIGSBEE FISCHER

in collaboration with

ALEX. A. HURST

WITH 236 ILLUSTRATIONS

MILL HILL PRESS

NANTUCKET

MASSACHUSETTS

U.S.A.

MCMLXXXIV

Other books by Alex. A. Hurst:

Ghosts on the Sea-Line
The Call of High Canvas
The Music of Five Oceans
The Sailing School-Ships
Square-Riggers – The Final Epoch, 1921-1958.
Arthur Briscoe – Marine Artist
The Medley of Mast and Sail 2

First Printed in Great Britain in 1977.

Published and Distributed in the United States of America by
Mill Hill Press: 134, Lower Orange Street, Nantucket,
Massachusetts 02554

Library of Congress Catalog Card No. 83-63289.
ISBN 0-9612984-0-5.

Printed in Great Britain

Having lived by the sea and collected and admired good marine art for a lifetime, I cannot help but have great respect for Anton Otto Fischer's paintings. His ability to capture the mood of the sea and the people who lived by its laws is unsurpassed. As you review the paintings in this book I am sure you will agree that he was one of America's finest Marine artists.

ALBERT F. EGAN JR.

FOREWORD

It is a great pleasure and a singular privilege for me to write a foreword to this book devoted to the Life and Work of that great American marine artist, Anton Otto Fischer. He was not only one of the most gifted artists of his generation, but also one of the most popular and versatile illustrators of books and magazines during the veritable golden age of that genre in the United States.

As a twelve year old school-boy in Australia, it was my good fortune to become acquainted with the work of Fischer—or of A.O.F. as he was known to his friends—in the early '30s, from his illustrations in the *Saturday Evening Post,* and the colourful paintings made a powerful impression on my youthful imagination. What sea-struck youth could resist the magic of their over-whelming appeal: those lively, rolling seas; hard-bitten sailors toiling alow and aloft, displaying their every emotion in their faces, and all those rust-streaked, storm-beaten ships of both sail and steam? Being familiar with much of Sydney's waterfront and shipping, it became immediately apparent that the vigorous maritime subjects of this artist bore the unmistakable hall-marks of truth, and that he himself must have been to sea and served before the mast.

My favourite pastime during those early years was to watch and sketch the outward and inward bound shipping which linked Sydney with the uttermost ports of the world. The traffic at the harbour approaches was attended by the bustling old clipper-bowed pilot steamer *Captain Cook*—a relic of the 1890's. My vantage point was a dip (known as "The Gap") in the towering sandstone bluffs of South Head at the entrance to Sydney's blue and beautiful harbour. In bad weather, when the coast was lashed by south-east gales from the Tasman Sea, I would take a copy of the *Post* to

compare the Fischer seas with the actual ocean itself. I could only marvel how the artist had so perfectly interpreted the mighty form and flow of those mountainous, green combers as they broke in spray and swept over the dark rocks far below, while the cliffs underfoot seemed to tremble from the shock of those thunderous Pacific rollers. Bystanders on the cliff were often old sailors (Sydney was then full of them) many of whom had sailed in the later clippers of the 1870's. They would invariably nod with enthusiastic approval when I showed them an evocative, full-page colour painting in the *Post* of ships and sailors by Fischer, and this would invariably lead to fascinating reminiscences of past days at sea under sail in the old windships.

In calmer weather, to obtain a closer look at the ocean from the perspective of the Fischer paintings, I would sometimes hire a small canoe from a harbour boat-shed and venture to sea outside the Heads. With the usually heavy ground swell, this was probably a foolhardy and hazardous activity, tempting fate—and the sharks! (Indeed, one day a seaman friend in the pilot steamer tossed a lump of coal in my direction and shouted:– "We'll have a rescue job yet!")

Being influenced by the sea pictures of Anton Otto Fischer, the books of Joseph Conrad and others, and by the sea poems of John Masefield, I told my parents of my intention of going to sea and eventually becoming a marine artist. By going to sea, I hoped not only to obtain practical experience, but also to be able to visit the United States and so to meet Fischer, and in England to meet such personalities as John Masefield and the artist Charles Pears, but my parents were wholly opposed to my expressed ideas, either of going to sea or of becoming an artist. Nevertheless, at the age of fourteen, I spent much of my spare time after school visiting the studio of the noted Australian marine artist, John Allcot, trying his infinite patience and good-nature by watching him paint. It was a golden day when he invited me to accompany him aboard a small full-rigger which was anchored in Double Bay and when I could listen with rapt attention to the conversation between Cape Horn sailors, but as I watched the little ship beat down the harbour in a fresh nor'easter with her old-fashioned single topsails several days later, to disappear into the purple summer haze, the inspiration of the sight was tinged with regret that I could not have sailed in her to New York, and to have met Fischer.*

The following year, my parents despairingly agreed to my enrolment as an art student in the East Sydney Technical College, after which I would be

* This was the *Joseph Conrad,* a tiny vessel which was being sailed round the world by her owner-master, Alan Villiers, and which had been a training vessel previously. She was a far cry from the larger cargo vessels on which I had set my heart, but was probably the only square-rigger likely to visit Sydney during that period.

free to go to sea. It was while I was a student there that a piece written by Fischer, called *Innocence Abroad,* appeared in the 1937 Christmas issue of the *Saturday Evening Post.* This gave me my first glimpse of the artist's personality, and some details of his early life in the Cape Horn trade. The accompanying illustrations to a story in that issue were absolutely marvellous, and the smaller of the two is perhaps his *pièce de resistance.* It has been a favourite of mine for forty years.

A year or so later, I realised my long-cherished ambition of going to sea. During the ensuing years, there were only occasional opportunities to see Fischer's illustrations but, one day in Halifax, N.S., during the bitter war in the Atlantic, I came across a superb portfolio of his paintings in *Life* magazine, showing the U.S.C.G. *Campbell* on convoy duty and in action with a U-boat. The accompanying photographs of the artist, afloat and ashore, indicated a warm and friendly personality with a great enthusiasm for his subject. I had already met John Masefield at Oxford and Charles Pears at his studio at St. Mawes, opposite Falmouth, and I hoped one day to make the pilgrimage to meet Fischer amidst the pines of Woodstock, but did not realise that it would be some years and many thousands of miles before I would have that pleasure.

At that time it had not occurred to me that I would marry in the United States and, with my wife and family, settle ashore in suburban Long Island. One day in 1947 I noticed an oblong book entitled *Foc's'le Days* in a bookstore window near Grand Central Station. It was by Anton Otto Fischer, and the jacket featured one of his superb paintings of a Cape Horn sea. It need hardly be said that I bought a copy without further thought, and that I was fascinated by the text, concerning his early life, and by the unique collection of the reproductions of his paintings. Indeed, it prompted me to write to the artist, who replied and cordially invited me to visit him.

My own commitments precluded such a visit until 1949. In retrospect, perhaps, it would have been better to have made an appointment for, on arrival, I found him confined in bed after a minor heart attack. Mrs. Fischer was adamant that he should have no visitors but, when I explained that I had travelled a long time and a long way since the age of twelve, and had come in response to an open invitation, she consulted her husband, and I was allowed a bare fifteen minutes in which to meet him.

I found the artist in a small room at the head of the stairs, sitting up in bed and wearing a khaki officers shirt, and looking the picture of health, with the afternoon sun streaming through the window. I was struck by his

irrepressible enthusiasm and apparently boundless energy while he spoke enthusiastically of his time in a "tramp sailing ship", which was "my college education". Modest, direct and by no means lacking a sense of humour, he gave the impression of great competence and a feeling, at the same time, that he would not suffer fools gladly. Regretting that he was laid up in his "bunk", he delightedly, and most graciously, autographed my copy of *Foc's'le Days* and a number of old *Post* illustrations I had treasured for many years, commenting "my old crimes coming back to haunt me!"

During the next decade I came to know A.O.F. well and visited his studio on a number of most enjoyable and instructive occasions. I was always treated to a dazzling display of magnificent paintings, and I remember in particular a dramatic painting of Cape Horn greybeards, with the Horn itself just visible in the mist, which had been inspired by a photo given to him by Jack London.*

Any work of mine which I showed to him on these visits he would always gladly and patiently criticise, making numerous suggestions which he deemed helpful. He also encouraged me to send him photographs of my work, and in his reply would invariably illustrate his remarks with a detailed pencil sketch indicating how the composition, particularly the sea, might be improved. This bespoke a generous and patient nature, and was characteristic of A.O.F's consideration and thoughtfulness towards a younger and aspiring artist.

His concern with his own work was with the painting as a balanced design of ship, sea and sky, with technical detail always subordinate to the painting as a unified work of art. In a letter which he wrote to me in June 1957, he made the following strictures on the work of some contemporary artists:–

> "These pictures almost look as if they came from an architect's drafting board. I know the tendency today amongst illustrators is an over-emphasis of detail. That always detracts from the pictorial quality. But then again, that is my personal opinion, besides, I have always been impatient with detail, too much detail, especially in modern steamships. On the old time sailing ships, detail was more or less interesting, but on steamships, and especially naval vessels, detail is overwhelming. I am personally more interested in the struggle between a man-made contraption like a vessel, and an elemental force like the sea."

Three years later, he made another interesting observation on the

* See p.98 (Ed)

manner in which he conceived a story illustration:–

"When I illustrated stories for the *Saturday Evening Post* I always, before planning the illustration, took the atlas and placed the ship, figuring in the story, at the spot where the author had it placed. Then I took the course of the ship, figuring on the type of sea in that locality, prevailing wind, the position of the sun, and tried to make it as realistic as possible. It may not have made any impression on the casual reader, but sailors, young and old, and retired captains subconsciously felt that the picture was right."

On another occasion I visited Woodstock with two friends, of whom one was Capt. Archie Horka, a well-known shipmaster who spent his early years at sea in sail. Knowing A.O.F's taste for fine cigars, I had brought some along and we enjoyed them in the studio, while he and Capt. Horka exchanged anecdotes of life at sea. A.O.F. was delighted to learn that Capt. Horka had been aboard the *Gwydyr Castle,* his old ship, in her old age when he had visited Mauritius as a young seaman in an American barquentine. Two other passions of his manifested themselves on this visit. One was gardening, and the other baseball. He related how he was a dedicated New York Yankee fan, and saw his first game with this team in 1903 directly after he paid off the *Gwydyr Castle* in New York.

When I enquired what medium he used with oils, he said that it was always turps, as this dries quickly and publishers are usually in a hurry to receive work. He used a direct approach with his pigment, painting it fairly thickly and directly on to the canvas while, in places, such as the highlights on clouds, leaving the canvas bare. In a magnificent painting I once bought from him, of a ship shortened down in bad weather, with the sails sodden and dark from rain and spray, the painting is handled in this manner and is not varnished. I admire it every day as I see it in my living room, and it continually gains in interest and vitality, expressing the artist's dictum that a painting of a ship "must be *in* the sea and must *move,* conveying the dramatic element present when man is in conflict with the elements."

I had wondered for some forty years whether a book such as this would ever be published, and now it is an additional source of gratification to me that I was able to suggest the project to my old friend, Alex. Hurst, and to put him in touch with Katrina Fischer, whom I had met in Woodstock. As a result, she visited the Hursts in Sussex, in England, and the book began to take shape. It was, I gather, a memorable visit for the

treasure trove of her father's material which she brought with her. For the Hursts it was equally memorable for the horror with which they saw their guest consuming fungi and other wild growths, which they themselves would not have dared to touch, in the English countryside! (She is an expert on such matters!) Yet another story lies in the bewilderment with which they saw vast quantities of Sussex flint, which fascinated her (and which are not to be found in the Catskills), being borne back to their house, and their astonishment when, finally, she filled two large suitcases, emptied of Fischer memorabilia, with flints and took them back to Woodstock with her *by air*. Fortunately, it seems, they were never weighed at the airports, but to Alex. Hurst the mystery of the purpose of that operation remains unsolved!

These are side issues and merely by-products of the making of this book. To write a foreword to it presents almost as many problems as the actual compilation of the work itself for, being such a prolific artist, no single study can hope to encompass the complete range of A.O.Fs accomplishments during the half century of his active career as an artist. There are so many facets to his work which must draw forth admiration, but in one particular feature he must surely be held to stand head and shoulders above all his peers, namely: in the delineation of men's emotions in a way which no other marine artist has ever attempted—let alone succeeded. Oddly, for one born so far from the sea, he seems to have achieved some uncanny *rapport* with it: to have had a natural understanding of its very "run"; of matching his ships and the elements with unerring accuracy, and of capturing the way every type of crafts "sits" in the water. This definitive work will serve as an enduring memorial to the genius of this inspired artist. I wish it fair winds and a prosperous voyage!

Oswald Brett
New York

ACKNOWLEDGEMENTS

The volume of help and goodwill which I have received from so many people in the making of this book has been quite overwhelming, and has left me with debts of gratitude in so many directions that I scarcely know where to begin. My thanks are due to very many people who have taken untold and much appreciated trouble on my behalf, whether as private individuals or whether acting for a firm, for an institution or for some other body, and I can only hope that they will all find that the finished result has justified all their kindness.

It is not my intention to credit every single picture used in this book, since so many of them are derived from my own collection and from the vast store of material which my father left in his studio, and to itemise each of these individually would be unduly repetitious. For the same reason, I acknowledge my thanks to the Curtis Publishing Company for their permission to reproduce some of the pictures which appeared in *The Saturday Evening Post.*

My thanks are also due to the Bibb Company for their permission to reproduce Pl. 213, and to Oswald Brett, to whom I have already referred on page XXVI, for supplying Pls. 73 – 99 – 122 and 228, and to the Budd Manufacturing Co. for Pl. 229. From Seattle, Mr. Sidney D. Campbell, with both Mr. Henry and Mr. Drew Foss, have kindly produced Pls. 30 – 127/9 – 131 – 173 and 176/80, together with much encouragement and kindness. Mr. R. M. Cookson has supplied Pl. 6 and my thanks are due also to Admiral E. M. Eller, USN, for his help in securing a transparency of Pl. 158 owned by Admiral Arleigh A. Burke, and to Admiral A. A. Heckman, USCG, for his unfailing co-operation, and to Admiral E. B. Hooper, USN, for his patience and for all the information he provided so freely.

Capt. Archie Horka has kindly provided Pls. 93 and 167 and Alex. A. Hurst the transparency for Pl. 172. Dr. Herbert Levine took the splendid photograph which is Pl. 74, and Capt. T. McDonald, USCGR helped tremendously in the matter of the plates acknowledged to the U.S. Coast Guard (*infra*).

Plate 19 is from a painting owned by Lt. Cdr. Merrin, and my thanks are due to Dr. Jürgen Meyer of the Altonaer Museum for Pl. 8 and for the help and information which he gave about the *Renskea.* Regrettably, not all those who provided pictures or material are still alive, but I nevertheless record my thanks for the use of Pl. 105 which was owned by the late W. M. Mills, whilst the picture on page 89 was taken by the late Mr. Bates, of High Woods. The copies of the log of the *Gwydyr Castle,* with attachments, provided by the Memorial University of Newfoundland have proved to be invaluable. The Imperial War Museum, of London, provided Pls. 66/7.

The Norsk Sjøfartsmuseum of Oslo kindly allowed the reproduction of the *Agustina* (Pl. 7). Mr. Kenneth Stuart, art editor of the *Reader's Digest* and previously art editor of *The Saturday Evening Post,* has given me much information and a great deal of patient advice, for which I am eternally grateful. Pls. 57/9 are reproduced by permission of the Time/Life Picture library, and Pl. 214 by courtesy of the Travelers Insurance Co. In particular, I must express my gratitude to the U.S. Coast Guard, and to all its other personnel, apart from those already mentioned, who gave so much help, and for providing the wherewithal to reproduce Pls. 61 – 71 – 134 – 138/40 – 141/2 – 146/7 – 149/50 – 151/4 – 155/7 – 159/60 – 211/2 – 216 and 230. The U.S. Naval Institute kindly sent me Pl. 134, and I acknowledge my indebtedness to Admiral R. R. Waesche for Pl. 144 and for his initial help in my extensive dealings with his service, and to Mr. William Webb for permission to reproduce his painting which is the original of Pl. 15: to Mr. Robert Weinstein for providing the splendid picture of the *Gwydyr Castle* at the time my father was serving in her, together with contemporary information, and to Mr. H. F. Willeche for Pl. 92.

In seeking to avoid striking any distinctions, I have endeavoured to list all these kind people in alphabetical order, and it is thus unfortunate that, since there is no-one whose name begins with Z, that of Mr. John Youell, of Portland, Ore. should come last, because his efforts and assistance have been enormous—witness alone his tremendous contributions in the form of Pls. 183/6 – 190/1 – 196/8 and 202/3, besides his much appreciated permission to quote from his father's classic book *Lower Class*. (Of his pictures, the original of Pl. 190 is on loan to the public library at Lowestoft, in Suffolk). Regrettably, Mr. Youell died during the production of this book.

Last, I would like to thank all the various photographers whose skill has contributed to the reproduction of the pictures in this book, and in particular to J. Peter Happel and Howie Greenberg for their sterling efforts when taking pictures in my own home.

Most of the people mentioned above have dealt solely with me: some have dealt with the publishers direct, and others have dealt with both myself and the publishers, who nevertheless wish to associate themselves with my appreciation for all the enthusiasm and assistance which has been given, including the individuals and museums who were unable, in the event, to make positive contributions.

As to quality, it has been difficult to trace some pictures, and others are reproduced rather for their interest value. My father was primarily a Marine Artist, and that is the theme of this volume. Nevertheless, other pictures *have* been included, whilst some subjects have been consciously excluded. The possibilities were so enormous that some decisions had to be somewhat arbitrary. I hope, at least, that they will find favour with all the people listed above, to whom I reiterate my heartfelt thanks.

Katrina Sigsbee Fischer
Woodstock, N.Y. 1977.

CONTENTS

Foreword VII

Acknowledgements XIII

List of Illustrations XVII

Author's Note XXV

Biographical Sketch 1

The Pictures 124

LIST OF ILLUSTRATIONS

A plate number in bold type indicates that the picture is in colour.

		Page
Anton Otto Fischer before a study of Mr. Glencannon		Frontispiece
1. The author posing for her father at Key West in 1937		XXIV
2. Otto, Julie and their Mother, 1886		5
3. Kloster Indersdorf – the orphan asylum		6
4. General view of the Kloster Scheyern seminary		8
5. Martin Kandlbinder and his wife		11
6. A craft similar to the *Renskea*		17
7. The *Agustina*		19
8. The s.s. *Chios*		21
9. Anton Otto Fischer at St. Pauli, 1900		22
10. The *Gwydyr Castle* outward bound off Cape Flattery		23
11. The *Gwydyr Castle* lying off Tacoma		25
12. A.O.F. in Paris as a student		31
13. Everett Dominick and A.O.F.		31
14. Julian's Academie, with Fischer and Jean Paul Laurens		33
15. Yachts *Virginia* and *Yankee* off Long Island		37
16. The Anvil Chorus		39
17. Illustration from Jack London's *The Heathen*		40
18. Schooner *Henriette* hove to on George's South Shoal		40
19. The Irish of it		41
20. The Bushnellsville house under snow		44
21 Illustration from a Jack London Yukon story		44

22. Locke's Road, near the Bushnellsville home 45
23. The Bushnellsville home and studio. 45
24. A.O.F. (circa 1909/10). 46
25. Mary Sigsbee Ker at the same time 46
26. David, 1920 48
27. Katrina (the author), 1923 48
28. The Rock-bound coast of Maine, near Ogunquit. 49
29. A.O.F. with David and the author, 1915 50
30. Cheering the Trooper 52
31. Sailing out of the Morning Mist 53

32. A.O.F. at Bushnellsville, 1919 55
33. Summer Flowers, 1923 56
34. Autumn Pond, Wilmington, 1921 57
35. Fisherman's Luck 60
36. Every Dog has his Day 61
37. A.O.F. posing as Mr. Glencannon 63
38. A.O.F. posing in a falling position 63
39. A.O.F. posing as Tug-Boat Annie 63
40. A.O.F. posing as Ben Gunn 63
41. A.O.F. posing with the author 63

42. Trout Fisherman working a Pool, 1944 64
43. Sawkill Creek, 1952 65
44/45. A.O.F. posing for Fishing photographs 67
46. Christmas Mouse 68
47. The Courtyard of Kloster Indersdorf. 69
48. At Kloster Scheyern 70
49. The Fidelgasse 71
50. The Kandlbinder Homestead at Asang 72
51. Julie and Oskar Lindner 75
52. A.O.F. with a brown beard, 1928 77

53. The Fischer's Woodstock Home 81
54. At the launch of U.S.S. *Sigsbee* 83
55. Eugen Haile 84
56. Eduard Hermann 85
57. Lt. Cdr. Anton Otto Fischer, U.S.C.G. 89

58. A.O.F. and his wife, 1943 97
59. A.O.F. at the piano with the author 98
60. The Fischer family at Woodstock, 1943 99
61. In Extremis 101
62. A.O.F's studio in the garden at Woodstock 103
63. Mullein Pastures in the Catskills, 1943 104
64. Winter Brook, Shandaken, 1923 105
65. A.O.F. at his easel 107
66. A Needless Sinking 108
67. A Needless Loss 108

68. Autumn with a pointer in the Catskills, 1943 109
69. Ogunquit Seascape 111
70. Autumn Colours near the Fischer Home 112
71. The End of the Boat Journey 113
72. Shandaken Country, 1940 116
73. Has She seen Us? 117
74. A.O.F. before one of his paintings of *The Rescue* 119
75. Men and the Sea 120
76. Speaking a dismasted Schooner 121
77. The *Pequod* 123

78. The Death Watch 124
79. The Whaler – from *Moby Dick* 124
80. The Stowaway 125
81. Taking in Sail 125
82. Man Overboard 128
83. The same theme 128
84. Lifelines 129
85. Hard Weather 129
86. A Labour of Love 132
87. A Whale and a Distant Ship.. 132

88. The *Gwydyr Castle* in the Doldrums 133
89. The *Gwydyr Castle* becalmed.. 133
90. The Grievance Committee 136
91. The Lady from the Mission 137
92. Reeling off the Knots 139

93. Furling the Main Upper Topsail 140
94. Going Aloft 140
95. A Difference of Opinion 141
96. The Kill 141
97. Running before the Gale 142
98. Cape Horn 143
99. The *Wanderer* 144
100. Up Aloft.. 144
101. Reefing the Main Upper Topsail 145
102. Another sketch of the *Pequod* 145

103. The Wandering Albatross 146
104. Running her Easting down 147
105. Burial at Sea (1) 148
106. Burial at Sea (2) 149
107. The Weather we signed for 151
108. Songs of Home.. 152
109. A Scene from *Moby Dick* 152
110. The Survivor's Tale 153
111. The *Pequod* at Sea 153
112. Morning Mist 155

113. Dinner for the Afterguard 156
114. In Trouble 156
115. The *Gwydyr Castle* hove to off the Horn 157
116. New Bedford Whaling Types 157
117. The Artist. 159
118. The New Hand.. 160
119. Illustration of First mate confronting Puerto Rican stokers .. 161
120. Flask's boat is over-turned (from *Moby Dick*) 161
121. Furling the Mainsail 163
122. American extreme Clipper in a Gale 164

123. Topsail Weather 165
124. A Barque making her Departure 166
125. Home Again 167
126. 'Home Again' – The Fischers' 1947 Christmas Card 167
127. Clipper Ships Racing 168

128. The *Shenandoah* 169
129. Making a Fine Departure 170
130. Safe Harbour 170
131. Towing In. 171
132. Coming Alongside 171
133. Fair Wind in the Moonlight in a Rising Gale 172
134. To the Rescue 173
135. A Steamer in Peace-time Paint 174
136. Butting into it 174
137. War-time Encounter 175

138. Ice-bound in Argentia.. 176
139. The *Campbell* puts to Sea 177
140. A U.S.P.H.S. Doctor being pulled to a Tanker 178
141. Tallying the Convoy 179
142. After the Storm 180
143. A Tanker in Heavy Seas 181
144. The Errant Tanker 182
145. The Fischers' Christmas Card, 1944 182
146. Signalling a Corvette 183
147. Fate of a Straggler 184

148. Abandoning Ship 185
149. Survivors on Deck 186
150. Torpedoed Tanker 187
151. Star Shells. 188
152. Firing Depth Charges 189
153. The Wake of the Convoy 190
154. Passing the Papers 190
155. Fight to the Last. 191
156. The *Campbell* sights the U-boat on her Starboard Bow 192
157. The *Campbell* sinks the U-boat 192

158. The Little Beaver Squadron 193
159. Worsening Weather 194
160. Sighted at Last 195
161. The Same Theme as an Advertisement 196
162. The *Bon Homme Richard* engaged with the *Serapis* 198

163. The *Constitution* engaged with the *Java* 199

164. The Engagement of the *Constitution* and the *Guerrière* 202

165. The Flight of the *Constitution* 203

166. Reefed down for the Banks 204

167. A Passing Grand Banker 205

168. The 'Christmas' Marine. 206

169. Berg on the Banks 207

170. Grand Bankers Racing in Close Company.. 208

171. A Gloucester Knockabout Schooner 209

172. Beating Home from the Banks 210

173. From *The Third Man in the Boat* 210

174. Moonlight Magic – A Gloucesterman waltzes through the Night 211

175. Terns and the Sea 213

176/7. Tug-Boat Annie 214

178. Mr. Glencannon 214

179. The Fight 215

180. Mr. Gallup 215

181. The s.s. *Inchcliffe Castle* 215

182. One of A.O.F's earlier and typical character illustrations. .. 217

183. An Old Barque.. 218

184. In the Red Lion 219

185. The *Eclipse* hove to in the North Sea 222

186. Report us 'All Well' 223

187/8. Louise Schofield posing in Salvation Army costume 224

189. Crew of damaged submarine, unable to dive in enemy waters .. 225

190. Bound for the Fishing Grounds 226

191. Cattle Ship leaving Boston 227

192. Louise Schofield posing for Plate 190 228

193. Louise Schofield and A.O.F. posing for Plate 197 228

194/5. Two scenes from Robert Louis Stevenson's *Treasure Island* .. 228

196. Dr. Wilfred Grenfell's Mission Trawler 229

197. Emigrants boarding the s.s. *Alaska* 232

198. Emigrants on deck aboard the s.s. *Alaska* in the North Atlantic 233

199/201. Illustrations from Joseph Conrad's *The Shadow Line*. .. 235

202. Customers in a Negro's snack bar 236

203. The *Bessie Pepper* beats out to the Fishing Grounds 237

204/6. Illustrations from Joseph Conrad's *The Partner* 238

207. A Glencannon Illustration from *The Toad Men of Tumbaroo* .. 239

208. Mr. Glencannon – A Prey to Preoccupation off the Spanish Coast 239

209. A Ship in extremity and almost on her Beam Ends 240

210. A Close View of a Dismasting. 241

211. North Atlantic Convoy and Escort 242

212. Saved! 243

213. Fisherman's Luck – an Advertisement 244

214. The Catwalk 244

215. The *Trevessa's* boat in calm 245

216. Pulling away from a Blazing Tanker 246

217. Fate of a Banks Schooner 247

218. Running before the Gale 248

219. Woodland Brook, Shandaken 249

220/1. A.O.F's rough sketches in the North Atlantic War 250/1

222. The *Pequod,* questing Moby Dick 252

223. Moby Dick dealing with the *Pequod's* boats 253

224. The Fischers' Christmas Card, 1930 254

225/6. Cappy Ricks, in contemplation 254

227. The Fischers' Christmas Card, 1932 255

228. Battling with the Horn 255

229. Ideas Translated into Steel 256

230. The *Burza* screening the *Campbell* 257

231. Hailing a Schooner 258

232. Heavy Weather.. 258

233. Sunset over the Catskills 259

234. Overlook Mountain, Woodstock 260

235. The Ocean Swell. 260

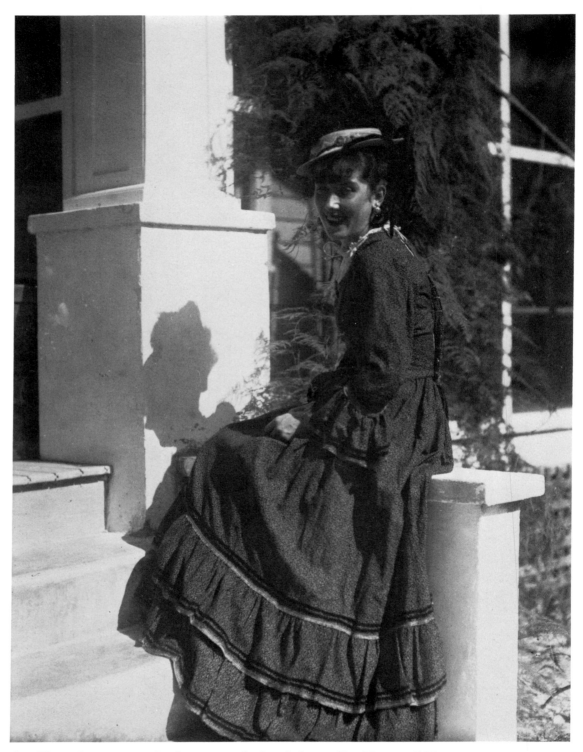

1. *The author, Katrina Fischer, posing for her father at Key West in 1937.*

AUTHOR'S NOTE

The opinion has frequently been expressed in many quarters that the Life and Work of my father, Anton Otto Fischer, should be produced in the form of a book befitting to his accomplishments. It is a project which has been exercising my own mind ever since his death although, initially, I was constrained on account of my own close relationship with the subject. However, the popular demand for such a book, coupled with the enthusiasm which greeted the news that this volume was actually to be published, overcame any scruples which I may have had on that score.

Whilst I might comfort myself with the thought that some excellent biographies have been written by women, the fact is that I am not a professional author and am also fully cognisant that, amongst my potential hazards, I face on my starboard hand the many-headed monster Scylla, ready to devour me should I not write sufficiently dispassionately of a man who was so close and so dear to me and, on my port hand, the whirlpool Charybdis, waiting to suck me down to the depths for daring to attempt the Life and Work of a man who was primarily a marine artist—and formerly a professional seaman, to boot—with all the technical jargon and knowledge of the sea and ships which is implied thereby. As to this latter count, I must confess to having no practical experience of the sea whatever, apart from a short cruise in a ketch in the Caribbean in the days of my youth, but I hope that Alex. Hurst's collaboration has solved this problem.

This has been a happy and fortunate relationship for, whilst we have never had any precise definitions of our respective responsibilities in the writing of this book, we have nevertheless emerged from it as very good friends! In fact he has, *inter alia,* contributed much to the various commentaries about the Marine subjects.

In all the years that I knew my father, after he had settled ashore with all the harder and, as some may think, more "romantic" parts of his life behind him, he was unassuming, often reticent about himself, and very much a family man. Since I believe that I now possess or have had access to almost all the records and documentation relating to him, I determined to brave the twin dangers after having taxed as many of his friends as possible in order to obtain their help and their opinions of him as a man. So far as the more technical aspects of his marine life and of his pictures are concerned, I must also acknowledge my indebtedness and sincere thanks to Os. Brett (who also effected my introduction to the publishers), to Derek Gardner, Capt. Archie Horka and to all those other kind people for the benefit of their knowledge, advice and help which was always so freely and gladly made available to me. I hope that the efforts of all these kind friends will have so steadied the course of my barque that it may have avoided those navigational hazards which, at first, appeared to be so daunting.

In consequence, and certainly gratefully, I find myself as much an anthologist as a biographer, and have generally refrained from any expression of my own private opinions of my father's work. I believe it is better thus.

Since my father always signed himself 'Anton Otto Fischer', that is how he was generally known, but it tends to be rather a mouthful if repeated very often and, as the words 'my father' might strike the reader with equal monotony, I shall refer to him as 'Otto' as a young man, and usually by his initials, A.O.F., by which he was known to many of his friends and acquaintances who were on familiar terms with him in his later life.

Katrina Sigsbee Fischer.

BIOGRAPHICAL SKETCH

ANTON OTTO FISCHER

'The seas are mine' said the Lord above
 When the work o' the world began;
He gave them Hate, and he gave them Love,
 Hard-graft and the sailorman.

He made them wide and he made them deep,
 With a seaport here and there,
And plenty of rain and salt to keep
 The Deeps and the Shallows clear.

(From *Sally Brown* by E. J. Brady.)

Of these two verses, I often think that the first epitomises my father's time at sea for, in those years, he saw much of the sea itself, whilst absorbing a deep love for it, and he certainly drew his meed of 'hard-graft' in his calling as a sailor. Having acquired his deep love of the sea, he somehow caught the spirit of that second verse on so many dozens of canvases, and perhaps it is due to its very immensity and fascination that those with an interest in it, and in the whole historical panoply of shipping which has passed across its surface, are bound by few international barriers. Indeed, there has always been some sort of free-masonry amongst those who follow the sea which was not *parceque nous avons tous les mêmes misères,* as an old French *Capitaine au Long Cours* once remarked.

In principle, marine books and marine pictures are as acceptable in one country as another although, possibly due to that insularity which seems to pervade national frontiers ashore, or perhaps as a result of an individual artist's life-style, it has often occurred that some of the greatest artists have been little known outside their own lands within their own lifetimes. Such

lack of international fame has usually been of more loss to the discerning public than to the artists themselves, but the fact remains that the last two or three centuries have produced many great marine painters whose reputations have barely extended beyond their own native lands.

It is fruitless to argue about which were the greatest of them all, since the spectrum of their work was so broad, and since those in the higher echelons worked with so many different styles and approaches to their subjects, that comparisons are sterile.

In England, for example, it is commonly said that Turner was the country's greatest marine artist, and it would certainly be hard to improve upon—say—his *Calais Pier*. He did produce a large number of marine works ranging from enormous oils which were sometimes almost over-powering to exquisite little water-colours, and it is often held that he was, indeed, the finest of *all* British artists. This contention is probably true, though whether he ranks as a *marine* artist may be another matter since his range of subjects was enormous, and although some of them are concerned solely with the sea and ships, it must surely be accepted that marine artists, by definition, must be those who devote the greater part of their work to this subject. Many great artists have produced some classic marine works, but they were not primarily marine artists. Equally, the great marine artists could—and did—turn their hands to almost any other subject when they wished, thereby creating a difference between themselves and their lesser brethren, even down to the pier-head artists, who found themselves restricted by both style and subject.

Of those who did fall into this category, many excelled at one or another of the aspects of the sea. The great Dutchmen of the seventeenth century need no introduction here. After their demise, there was a long period during which many fine pictures appeared although, in them, the sea itself frequently ceased to appear to be wet and fluid and, so often, a ship would be *on* rather than *in* it, for it gave an impression of being moulded from putty rather than being of constant movement. Then, of a sudden, marine painting seemed to burgeon into so many blooms, and names of many men spring to the lips, while their pictures are conjured up in great profusion.

Some, like Thomas Somerscales*, tended to concentrate on a sailing ship in all the immensity of the sea: Tuke, on the whole, concerned himself with sunlight and shadows amongst sailing ships anchored in Carrick Roads off his beloved Falmouth: the Swedish admiral, Jacob Hägg, is most

* In later years, my father said: 'I am familiar with Somerscales' painting *Off Valparaiso*. I like his paintings enormously. Like most English painters of the sea and ships, his paintings breathe realism.'

remembered for his naval scenes in the days of the Swedish wooden walls; Briscoe, above all, for his studies of men in action either on board or around ships. In the United States, the versatility of Winslow Homer is well-known but, although he produced some memorable seascapes, he was not primarily a marine artist, while Charles Robert Patterson may be held to rank amongst the greatest of all ship-portraitists. To take names at random may be invidious, and so one could continue almost indefinitely, but it is true to say that many who did achieve international fame lacked versatility and tended to produce works within limited themes.

It is generally held that my father probably stands unsurpassed within his own particular fields. Not only did he render the very run of the sea and the movement of ships through the water superbly—(and these are two aspects which have eluded so many of the greatest artists)—but above all he somehow expressed on his canvases the very emotions and souls of the men, whether in times of tensity in North Atlantic convoy battles; in small boats, in the sing-song of a windjammer's foc's'le, or elsewhere. Although he illustrated a multitude of books and articles which were not concerned with the sea, from about 1920 onwards all his professional work, which included some for advertising purposes, was purely marine. He often painted landscapes for pleasure and many of these sold in the 1950's to a degree that many of the local people who purchased them did not even think of him as a marine artist! Most of his reputation rests on his better known marine work. Sometimes he would divert himself by painting a portrait, usually of a friend, and there is little doubt that, had he wished to pursue that path, he might have become an outstanding portrait painter.

Let there be no distinction drawn between an 'illustrator' and an 'artist'. There have always been good and bad illustrators, as there have always been good and bad artists, and so there will always be. The fact is that the great illustrators were also good artists. There is not a shred of difference between them, except in choice of subject. It is only the hack illustrators at the lower end of the scale who cannot be deemed to be artists. There are many rare books today which have increased their value purely on account of their illustrations and without regard to their texts. Certainly the illustrating artist needs iron self-discipline and immense versatility and, as will be seen, it was only towards the end of his life when he was an official war-artist, that A.O.F. really allowed himself un-trammelled choice in his subjects, other than those painted for his own amusement or those for his book *Foc's'le Days,* about his experiences in the

barque *Gwydyr Castle*. Of course, as will become apparent, some pictures *were* painted for permament exhibition, but the foregoing remarks are true for the greater part of his output.

That A.O.F. should have become so great a marine artist and found so deep a love of the sea is most remarkable, for there was nothing in his family history nor in his early environment to foster this interest. Yet, for all the domesticity of the greater part of his life, he was obviously—and his pictures alone provide the evidence—a man with a great interest in people. That fact bespeaks much for his character, since it is difficult to suppose that his early life was such as to encourage close relationships or to have contained many elements that any reader would have wished for himself.

His maternal forebears had, in fact, been tilling the same small plot of land on a high Bavarian plateau, far from all sight of the sea, for generations past, but the man who was to become his father was a tapester who had already been married previously and who was suffering from advanced tuberculosis—'galloping consumption' as it was then commonly called—and which was an occupational hazard of his trade. For this reason, and because he was considerably older than Katherina Kandlbinder, her family raised strenuous objections to the match when it was learned that they wished to get married.

The Kandlbinders lived in the hamlet of Asang, near Ratisbon (called Regensburg today), and were essentially of yeoman farmer stock with the stable attached to their house, although they were, by then, a family of a certain substance. One of Katherina's brothers who lived at home was a tailor, and two others were brewers: one, whom we shall notice, in Regensburg, while the other later became the brew-master of the *Spatenbräu* in Munich.

Notwithstanding all the objections, Katherina did marry Anton Fischer, of whose antecedents practically nothing is known at all. They lived in a very small and run-down apartment, long since demolished, between Lederer Street and the *Hofbräu* in Munich. My father was born to them on February 23rd, 1882 and into circumstances which can only be described as being of extreme poverty. He was named Anton Otto—Anton being after his father, who was too ill by then to undertake much work, while the mother, delicate herself, was over-burdened with concern for her husband; for the child and, indeed, with the very provision of their daily bread.

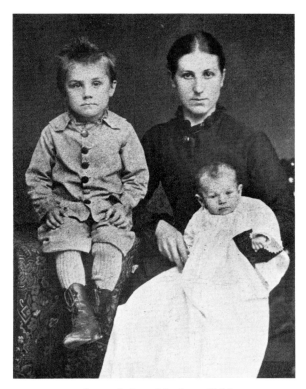

2. Otto, Julie and their Mother, 1886.

They were devout Catholics, and it seems that the local pastor, named Huhn, drew the attention of the Baroness von Lassberg, a local benefactress, to the plight of the household, while suggesting that perhaps she and the Baron, with some of their friends, might be able to alleviate the unhappy plight of the Fischer family.

In the event, the von Lassbergs did a great deal. They produced welcome food parcels at intervals—a joint of veal once bringing Katherina round to their house with tears of gratitude in her eyes, since she had never had such a one before—there were toys for the child and the Baroness arranged for his mother to take in such sewing as she could manage, for she had also contracted tuberculosis. Then, in 1885, the father died of this disease, leaving a sick wife, who was by then four months pregnant, and a three year old son with no visible means of support whatever. Called in from outside to pay his last respects to the corpse, little Otto saw only a huge nose sticking up from the bed-clothes and,

3. *Kloster Indersdorf – the orphan asylum.*

terrified, he dived under the bed. That, regrettably, was his only lasting recollection of his father.

Five months later, the second child, Julie, was born. Martin Kandlbinder, Katherina's brother in Regensburg, sent small sums of money for a time: the Roman Catholic local parish of Steinbach contributed three marks a month, while the Baron and Baroness continued to alleviate the miserable distress of the widow until, realising herself to be in a dying condition, Katherina returned to the family home in Asang in May, 1887. She took Julie with her, but Otto was left in a foster-home arranged by the Baroness von Lassberg. Under the dire circumstances, her family accepted her back grudgingly but, two months later, on July 4th or 5th, she died at the age of twenty nine.

When it had become clear that death was approaching, the Baroness had promised Katherina that care would be taken of the two children, and she was as good as her word. Thus, when this unhappy event took place, Julie, barely a year old, was formally adopted by a Frau von Selby (who subsequently died in 1902), while little Otto had already been placed with an elderly cobbler named Poehlmann and his wife. This man had long been shoemaker to the Lassberg family, who knew the couple to be sound, reliable and a God-fearing household, and paid them twelve marks a month for the boy's board and lodging.

The Baroness continued to keep an eye on the two children and,

indeed, Otto was sometimes brought up to their house to play with the Lassberg children but, when he was five, he was placed in the orphan asylum at Indersdorf, near Dachau, which was run by the Sisters of Charity of the order of St. Vincent de Paul. The Baroness, who was a devout Catholic, was a patroness of this institution, and it was her aim that the boy should enter the priesthood. Frau Poehlmann had become attached to the lad, and was very sorry to see him go.

The food at Indersdorf was simple but wholesome. In later life, my father described it as consisting of 57 varieties of bread soup, embellished on special occasions with a little browned onion and, on very rare and high days, with a morsel of meat. At Advent, a patron would distribute gifts amongst the boys—oranges for those with good reports, and a stick for those with bad. The oranges were the only ones that they ever saw, and were eaten complete with skins! It was obviously a Spartan atmosphere and a boy, guilty of bed-wetting, was made to walk bare-foot through the goose-pond. Whether this was a form of discipline or a vestigial trace of some forgotten witchcraft is anybody's guess but, at all events, it was considered to be a cure!

It seems that he did well in the school classes, spending seven years, from 1887 till September 1894, under the sisters and, not only did he learn to play the piano, but such good reports of him were sent to the Baroness that she arranged for him to be admitted to the Arch-episcopal Seminary of Scheyern to take up a scholarship place, then vacant, which had been endowed by an uncle of hers*.

In the event, he passed in well but, although the Benedictine friars were kind enough, the discipline was strict and the boy quickly realised that he had not the slightest inclination or vocational call for the priesthood. As a result, he was constantly in trouble and it was not long before the friars, too, appreciated that the lad had been cast for a role that he could not, and should not, play. Indeed, the abbot, writing to the Baron in 1896, said:

> "We, the entire staff at Scheyern, are agreed that there is no longer any sign of vocation for the priesthood to be found in Otto. He moves always in extremes: today wildly happy; tomorrow sad unto death. In the past year he has given us much trouble. may his knowledge of music and drawing stand him in good stead. . . ."

One wonders whether there ever had been a sign of vocation, since the idea of the priesthood had not come from him!

* Much of this information is derived from a letter written to my father by Baron von Lassberg in 1907 in reply to one he had written enquiring about his antecedents. The Baron clearly had a meticulous mind, recording, a little inconsiderately, the sources and amounts of the various monies raised or contributed to meet the expenses of his upkeep—now a parish contribution of nine marks a month: the von Lassbergs paying the difference between this and the scholarship grant—and so on!

4. General view of the Kloster Scheyern seminary.

In the meantime the Baroness von Lassberg had died and, although there is not much evidence that my father had actually seen her a great deal, he felt that he had now lost the one person in the world who took a personal interest in him. By his own telling, one result of this was that, becoming more and more aware that he was, in reality, an object of charity, his resentment showed itself in the form of an increasingly rebellious attitude. He admitted that, at this time, he was difficult and given to fits of insensate rage which left him physically exhausted.

Although there seems to be no direct record of the fact, he must have had both an interest and a flair for drawing at this time. Indeed, in this day and age, when so many youngsters are brought up to watch other people doing things, whether on the ubiquitous television screen or elsewhere, it is easy to forget that a certain competence in drawing and painting was almost a stock-in-trade of most educated persons in the latter half of the nineteenth century, and there is every reason to suppose that the education provided by the monks was excellent. He also did well at his piano lessons and received a thorough grounding which stood by him throughout the rest of his life. The methods used were sometimes

unconventional. The students were made to play with a board covering the key-board, and were given a cuff about the head that sent them flying off the stool if a wrong note was hit! Apart from Greek, Otto was in fact at the top of all his classes, but that did not affect his attitude towards his situation and, finally, in a spirit of desperation, he burst in on the abbot in his room one afternoon and begged to be allowed to go away—to go anywhere. The abbot, who was a kindly and worldly-wise man, tried to comfort him and told him that the Fathers had realised long ago that he was not suited for the priesthood but asked, reasonably enough, where they could send him. Otto, sobbing, suggested that he might be able to study art instead of theology, and this is probably the first tangible evidence of his latent interest in this direction.

The upshot of this conversation was that he was sent to the Baron von Lassberg with a portfolio of his drawings, but this gentleman had by that time received so many bad reports of the boy—fairly enough, no doubt, though probably no-one had seen fit to probe into the reasons for the deterioration in his attitude—that he was not inclined to show any further interest in him. However, he did take him to the studio of a friend of his who was an artist and who looked at the drawings. Possibly the boy had not developed his talents sufficiently; perhaps the artist could not be bothered or, conceivably, he could not recognise talent when he saw it but, whatever the reason, his verdict was unfavourable and the boy, in stark despair, was sent back to the seminary.

This incident, if it did not channel the lad along his predestined way, did have its effects, since the Fathers realised that it was useless to keep him any longer and they contacted his uncle, Martin Kandlbinder, at Regensburg, who was his legal guardian. He reluctantly agreed to take him, although he never made the slightest pretence that he had any desire to have his nephew in his house, whilst his wife's attitude was openly hostile—'positively venomous', as A.O.F. described it in later life.

————————————

Due to the background of the seminary, the uncle found it possible to place the lad as a printer's devil with a clerical newspaper—*Der Bayerische Volksbote*—but this period was certainly the most unhappy of his whole life, mainly due to the fact that he was such an unwelcome addition to the household and that his uncle and aunt were so resentful and bitter at his presence.

Now, more than ever, he felt himself to be an object of charity. At both Indersdorf and Scheyern the feeling had been more impersonal and, although the Sisters at the one place and the Fathers at the other had been kind enough in their own way and, although he had experienced some measure of affection from Sisters Philomena and Arcadia initially, and from Fathers Anselm and Ulrich latterly, there was now no question of any form of affection and the charity was made very personal. A boy who is orphaned so young must inevitably lose a certain amount which is taken for granted by so many children who lead a normal family life, even if he is fortunate enough to be adopted by kindly relatives or friends, but the atmosphere in which Otto was living at Regensburg was piling Pelion upon Ossa. He was utterly miserable and, to add further gall to his cup, he loathed the printers shop and the foreman who was in charge of it with an abiding hatred.

It was at about this time that a meeting was arranged between him and his sister, their ages being 14 and 11 respectively. It was arranged by relatives in Regensburg, but it was not a success. In letters which my father subsequently wrote to her, there are references to Julie being shy and 'stand-offish', and also to the presence of the 'nasty aunt'*. Although they did correspond intermittently for some years, this was the only occasion, since they had been parted when Julie was still an infant, that they ever actually met in their lives.

The sea could have played little part in his thoughts in those days, for he had never seen it and Bavaria is a long way from any coast or deep-water shipping. Nor was there any hereditary background to lead his thoughts seawards. However, the workings of Fate are as strange as they are inscrutable and, one raw, drizzling day in January, 1898, he was sent out on an errand by the detested foreman. Turning a corner out of an alleyway into the main street, his eyes alighted on a large poster in the window of a travel agency, which showed a sailing ship under a press of sail running under wind-driven clouds in an azure sky through an ultramarine sea. Gulls, circling the ship, lent enchantment to the scene for the unhappy boy on that miserable winter's afternoon and he was drawn to it as if by a magnet to stand in reverie, feeling 'free' as he himself expressed it, 'as one of those gulls', imagining himself sailing in such a ship across the far and limitless horizons to—who knows what foreign lands?

Probably this reverie lasted longer than he supposed since, on his return to the printing shop, he was rewarded for his tardiness by a cuff

* Not Martin Kandlbinder's wife.

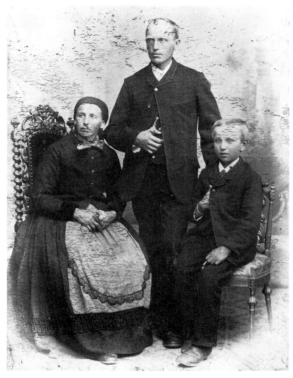

5. *Martin Kandlbinder and his wife at Regensburg
with their own son (older than Otto).*

about the head for the long time he had taken but, going home at the end
of the day, he returned to his uncle's house by way of the travel agency
and feasted his eyes on that magic poster once again. There is no evidence
that the picture was any work of art. Its attractions lay in the visions
which it conjured up in his imagination.

It is difficult to imagine a worse reason for wanting to go to sea in a
sailing ship than basing one's desires on a calendar-like painting which
smacked of 'Romance'. It is undeniable that experience of the sea and sail
could exert a fatal fascination on a man which would last him all the days
of his life, but both are hard mistresses which make demands upon him and
create hardships never guessed until discovered in practice, and which have
proved bitter disillusionments to many a youngster who had based his
assumptions on such pictures in the days of sail. However, young Otto
knew little enough about *that*. He was looking for an escape from his
present lot and he became determined to go to sea, although it took him

some time to summon up the courage to broach the subject with his uncle. Finally, one particularly bad day at the shop gave him the necessary stimulus. On the face of it, it might be supposed that his uncle and aunt would have jumped at the suggestion, if only to rid themselves of an obviously unwelcome charge, but people are seldom actuated by the right motives in life. Martin Kandlbinder supposed that his nephew had taken leave of his senses. He himself was the *Braumeister*—the head-brewer—of the principle brewery in Regensburg and considered that he had a position to maintain and that, by getting rid of the boy in such an 'extraordinary' fashion, he would invite adverse criticism and gossip to be directed at himself! In other words, his refusal was based purely on 'what people would say', or be thought to say, and was in no way connected with his nephew's future or happiness. Many parents and guardians have advanced excellent reasons, given *bona fide* according to their own lights, against a boy going to sea, but this was not such an instance.

There followed some weeks of argument, trying to break down the uncle's persistent refusal, for Otto was determined to get away at any cost. He began to haunt the quays of the Danube, where he was fascinated by the movement of the Hungarian tugs and barges, for Regensburg is the final port up the long reaches of that great artery. It all added to the lure of distant places—none of which, he felt, could offer anything worse than his life in Regensburg.

Then, one day, he was setting the type for a report on a girl's attempted suicide, when a rather startling idea came to him. Why should *he* not stage a suicide attempt? It might break his uncle's resistance and, the more he considered the idea, the better it seemed to him. He was familiar enough with the banks of the Danube, and his uncle's house was situated close to it. There were warehouses and coal-yards along the banks there, with enough men around to be sure of rescue.

With his plan formulated, he left the shop one morning and walked down to the river and then, after strolling up and down several times to attract attention to himself, he jumped into the water. He had thought that he would be safe enough since (oddly enough) he could swim, but he had grossly under-estimated the strength of the current and the mid-winter temperature of the water, and was swiftly carried downstream. However, the people on the bank soon saw his predicament and, with a long hook kept ready for such emergencies, he was fished out and, wrapped in blankets, put in a baker's oven to thaw out!

The affair created much more publicity than he had ever expected, and he himself soon realised that he had caused his uncle a good deal of embarrassment, but the ruse worked. The upshot was that his uncle at last consented to him going to sea, adding that he had made his bed and could lie on it, and that there would be no question of returning if things did not work out as he hoped. Martin Kandlbinder did accompany him to the railway station and said 'Good-bye'. That, perhaps happily, was the last that they ever saw of each other.

Hamburg was his destination. His uncle had given him the address of a sailor's boarding house master in the St. Pauli district, who proved to be a kindly, honest man who treated the boy well and kept him until he had a ship, whilst taking him out to buy a good and proper outfit with money which his uncle had provided for the purpose. The St. Pauli district has not a very salubrious reputation today and, if for slightly different reasons, it has ever held a rather tarnished one. Certainly seamen's boarding houses have been the subject of a good deal of lurid literature, much of it fully justified, but it is always the bad which makes the sensational reading and it is easy to forget that many boarding houses were run by exceptionally fine men and women, who often helped sailors beyond reason. These are seldom mentioned in books or diaries. A.O.F., then only sixteen, was certainly lucky to land on his feet in one of the good ones.

Now, dressed in a roll-necked seaman's jersey, the continental sailor's vizored cap, and with his sheath knife ostentatiously displayed in his belt, he felt himself to be the 'real thing', and invested in a pipe and some tobacco, though a few draws on it were all that he could manage! He was veritably in the presence and atmosphere of ships. Hamburg's *Segelschiffehafen* would have been a mass of yards and towering masts and cordage of lofty ships of all nations discharging and loading cargoes from, and to, the ends of the earth. Indeed, one of the sailors in the boarding house had just paid off a ship newly arrived from Calcutta, and told the lad such enthralling yarns that his impatience to be off to sea reached fever-pitch. One can imagine his excitement at seeing the odd four-master or full-rigger drying her sails in the port, besides which the very smells and sights of sailing ships did exercise a fascination over almost everyone who saw them.

Quite apart from British, Norwegian and square-rigged ships of other

nationalities, it was the age of the great Hamburg sailing ship companies—Laeisz: Wencke; Knöhr & Burchard, Siemers and the like, whose ships could vie with the finest in the world, and there were always a number of them up the Elbe at that time.*

The sight of them must have been all the more grist to the young man's mill. One can almost sense the moment when, at supper one evening, the boarding house master finally announced that a ship had been found for him, though Otto found it a little mysterious that she was lying at a place called Horumersiel, of which he had never heard. Certainly he knew of the greater ports all right—Hamburg, Bremen, Lübeck, Stettin and so forth, but this was a new name to him, and the boarding house master was a little evasive when questioned about it, merely vouchsafing that the ship was preparing to proceed to Norway.

However, still full of enthusiasm, he boarded a train next morning, being seen off by the boarding house master and then, understandably, felt very much alone for, from now on, he realised, he was completely on his own. No doubt the feeling was enhanced by the discovery that everyone else in the carriage spoke *Platt-Deutsch,* of which he could not understand a word! Nor did the flat, uninteresting countryside all about the train compare with the incomparable magnificence of his native Bavaria, which all helped to sap his earlier enthusiasm.

However, in due course he was tapped on the shoulder by the conductor who said something unintelligible to him, but he picked up the word 'Horumersiel' and, shortly afterwards, the train drew up at a station, if the small building by the line could be so described. It all seemed terribly remote and unimportant, with the only people in sight three old men at the other end of the platform. One of these detached himself and walked over to Otto, who stood uncertainly, and proved to be a wizened little man with a grey, clipped goatee. Once again, language was a barrier, so the old fellow pointed to the lad's sea-bag and indicated that he should follow him. In silence, they took a road which seemed to be leading nowhere. One could see for miles over the flat landscape, but in no direction was the skyline broken by the towering masts of a sailing ship. Eventually they turned off the road into a grassy lane and, in due course, came to some pilings driven into the mud where, lying heeled over on a mud flat, was a small galleass. The tide was out and the gulls, circling overhead and scavenging in the mud, were mewing raucously, as if mocking at the sheer disappointment engendered by the sight of the vessel, which

* In later life, he recalled the deep impression made on him by the great five-masted barque *Potosi.*

was the veriest anti-climax to all the boy's dreams.

In order to appreciate his feelings, it might be well to describe a galleass. The word has slightly different meanings in different languages, since the rig is not always the same, but we can be pretty sure that she was typical of her type in that area, namely: a small ketch-rigged craft with, usually, rather bluff lines. In contra-distinction to the Baltic galleasses of Sweden and Finland, which were really schooner-rigged with brailing lowers, the German version had lowering gaffs and, sometimes, a square yard on which a square sail was set flying—but this was not always the case. However much they may have lacked in 'Romance', they did represent an excellent initiation for a boy going to sea for the first time.

The boarding house master had acted with singular wisdom and thought in selecting a vessel of this sort for so raw a recruit although, sadly, she fell far short of the stately ship on the poster of the travel agency, or of the threshing nitrate barques and sail-crowding full-riggers trading round the Horn which he had seen in Hamburg. In the boy's adolescent eyes the *Renskea*—for such was the name of the galleass—was no better than a barge,* and he stood aghast, struck dumb with sheer disappointment at the sight of her.

Taking no notice, the old man descended to the deck down a couple of slanting planks and beckoned the lad to follow him, whereupon a big, red-bearded man came out of the deck-house and, after an animated conversation with the wizened one, he took hold of the sea-bag and threw it into one of the bunks in the deck-house, which was half-sunk into the deck. The arrival aboard a first ship, be she big or small, is seldom heartening. The *Renskea* proved to be no exception to this generalisation. The deck-house was little better than a large cubicle, containing two bunks, a provision locker, and, in the forward end, space for spare sails and cordage. Since it was also the galley, it contained a small stove, on which the supper was already simmering. It consisted of sow-belly†, cowpeas and a kettle of tea. It proved that the old man was the captain (and owner) of the galleass, and had his quarters below decks aft. The red-bearded man was the mate, and Otto was the hand-cum-cook. That was the total (and usual) complement of a galleass. She was mainly employed in the timber trade between Norway and the East Friesian ports.

Supper was not a success. Still in a daze of disappointment, the smells of the cooking, the surrounding mud and even the close proximity of the cordage combined to nauseate him and, although the red-haired man finally

* The *Renskea* was registered at Rorichsmoor and was a wooden vessel built by G.H. Aden at Ihlowerfehn in 1863, measuring 50 tons gross (46 nett) and 66.4 x 15.9 x 6.3′. Her owner at this time was Capt. H. de Veen from Collinghorst. In fact, although Fischer described her as a 'galleass', she was listed in the Germanischer Lloyd first as a 'kuff' and then as a 'galiot'. The kuff was a beamier craft than a galleass, and of Dutch origin. The galiot was generally a bit finer and faster, and often found in that area. Since Fischer did refer to her 'mud-boards'— could he have meant 'lee-boards'?—it is most likely that she was not a true galleass.

† Fatty salt pork.

persuaded him to have some tea, a few sips of the bitter brew, which bore no resemblance to anything he had tasted before, caused him to run for the rail and almost to fall overboard into the mud! He also learnt that the ship sailed on through the night when at sea, which came as a shock! This absurd belief that ships somehow stop or bring up at night is really a very common one amongst longshoremen, laughable as it may seem, and certainly not a facet of the sea learnt from beholding a fairy-like clipper ship on a travel agency's poster!

The next morning he was called at dawn, when the mate showed him how to light the fire in the stove. As soon as the tide served, the *Renskea* got under weigh *en voyage* for Krageroe and, directly afterwards, Otto was told to put the dried peas on the stove for the midday meal, which he did by setting them in sea-water. Of course, they did not soften at all, and the skipper was livid. By the time that he had corrected his mistake there was a bit of a lop, which made him feel squeamish and, when they got clear outside, he was sea-sick with a vengeance. Sea-sickness is a horrible thing which it is virtually impossible to control, but to be sea-sick when one's berth is practically on top of the cooking stove is more than a little hard. In fact, Otto was utterly useless that first trip and, unable to abide the idea of the deck-house, he simply curled up inside the waterways,* little caring what happened to him. Only when the snow-capped mountains showed up on the starboard bow, and the galleass was under the lee of the land, did he start to perk up and to display some interest in sustenance again. Then he was soon up and around trying to make himself as useful as his ignorance permitted.

Not only had the boarding house master in Hamburg found him this small vessel in which to begin his sea-going career, but he had found him one in which the skipper and mate were both intrinsically kind and decent men and, when they saw that he was at least willing, they made every allowance for him. One suspects that, for all his longing for the deep-watermen he had seen, his initiation in one of them would have been a good deal worse.

At Krageroe, the *Renskea's* cargo of logs was brought out to her on rafts, and they were loaded and stowed by the mate and Otto without any other assistance. It was heavy work, but the lad rather enjoyed it, if only to prove that he *could* be of some use. Whilst he did not go ashore on either this trip or on the two subsequent voyages to Krageroe he made in that craft, he was always allowed to take the dinghy to go fishing in the

* The gutters along the sides of the decks, which take off any surplus water by means of the scuppers (drain holes).

6. *No photograph of the RENSKEA has been traced. This
vessel is very similar to her.*

clear waters of the harbour, and enjoyed this amongst the kelp-covered
rocks. He was earning about ten marks* a month, which was little enough,
and there is no question that that first trip was a disillusionment. In fact,
on his arrival back at Horumersiel he swallowed his pride to the extent that
he wrote to his uncle to ask if he might return to Regensburg. The reply
was a polite refusal which, in fact, left him indifferent and wishing that he
had never penned the letter at all.

Although able to keep the deck after his first outward trip, A.O.F.
never conquered his sea-sickness completely in the *Renskea*. She had
certainly rubbed off some of the glamour with which he had been filled in
Hamburg, but he had now acquired a certain confidence in himself. During
the summer he had met the merchant who chartered the vessel, since he
often came aboard with his two daughters, aged ten and twelve, at
Horumersiel, and he had been asked to their house for dinner on several
occasions.

* Say 10/-, or $2.38.

After eight months, by which time three trips had been made to Norway, the season was over and he was paid off with the sum of about eighty marks, which was obviously insufficient to keep him through the winter. The merchant had told him to come up and see him when the *Renskea* was laid up, and Otto took him at his word. The result was that he stayed *en famille* in the house all the winter in exchange for doing the accounts and tutoring the two daughters, with whom he was soon great friends; working about the yard and, occasionally, driving the merchant's four-horse team to Wilhelmshaven and elsewhere. His employer was a widower, but the whole atmosphere of the household, and the companionship and friendship of the two girls, was something outside his experience, and he found himself happier in the merchant's home than he had ever been in his life before.

Nevertheless, on the advent of the following spring, he became restless and thought that he would go back to sea. The merchant said that he must know his own business best, but that he could always come back if he wished, and he gave him his ticket to Bremerhaven and a sufficiency of money to tide him over until he found himself a ship. Once again, he put up at a sailor's boarding house and started haunting the waterfront to find himself a berth as a deck-boy. Seeing a Norwegian barque discharging ice, he went aboard on impulse and, interviewed by the master through his German-speaking wife as interpreter, he was in fact taken on as deck-boy but was, one suspects, mainly employed as cabin-boy.

This barque was named the *Agustina* and hailed from Christiania, as Oslo was called in those days. Although she may still have been small in comparison with the big Cape Horners which had filled the docks at Hamburg and which were even then in the port of Bremerhaven—for she was 869 tons—she was certainly no mean sailing ship when she had been built in Portsmouth, New Hampshire, in 1869, and she was a nice-looking wooden vessel mainly manned by Norwegians with a few Russian-Finns. Now he felt himself to be in a proper ship, and she proved to be a very happy one, while Mrs. Johanneson, the master's wife who was childless, treated him almost like an adopted son. Since he was barely seventeen and rather small, this did not cause any resentment amongst the rest of the crew. The lift to his morale was such that he experienced no more seasickness, and he found the food both excellent and plentiful.

After carrying a cargo of coke to Kronstadt, the Russian naval base, the ship loaded three successive cargoes of lumber at Kotka in the Gulf of

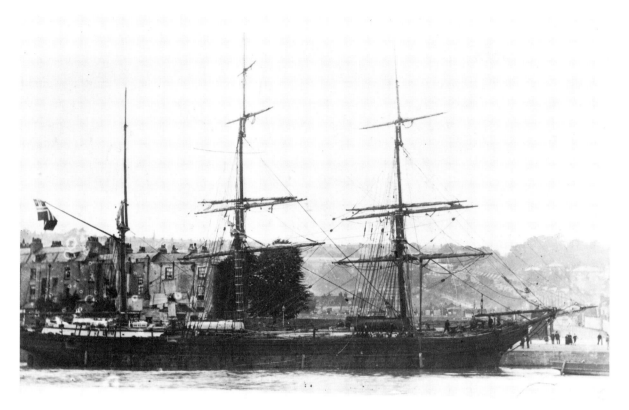

7. The AGUSTINA.

Finland for London but, on the third voyage, she ran aground and became water-logged. This was no unusual event for an old, soft-wood ship, but a Swedish torpedo boat hauled her clear and towed the barque into Karlskrona where the damage was found to be so great that the crew were paid off—Otto remaining aboard for a couple of months as watchman*.

Soon becoming restless once again, and hearing of a Swedish short-sea steamer which had a berth, he asked Capt. Jules Johanneson for his discharge and joined the Swedish s.s. *Ruth* on January 3rd. 1900. After visiting Libau, she proceeded to Hamburg, which was really the object of joining this particular vessel, and he signed off there at the end of the month.†

Apart from accomplishing his object in returning to Hamburg, he was not sorry to leave the vessel, since some half-witted shipmate had suddenly gripped him by the throat and all but strangled him. He might well have

* The *Agustina* had been built as the *William Ross* in 1869. She was 170.3 feet in length. She was owned in Flekkefjord from 1893-97, when she passed to Stavanger owners. She passed to Sigurd Feiring of Christiania in 1900: and was sold to France in 1909 and was out of the register in 1911.
† The s.s. *Ruth* had been built as the *Ethel* in 1878 and was owned by G.T. Schabe of Hamlstad at this time. She was 872 tons and 210.6 feet long.

19

succeeded if Otto had not managed to force his back against the almost red-hot foc's'le stove!

At the boarding house in Hamburg he became friends with a sailor from the North Sea fishing fleet who had been recovering from an injury and, a fortnight after his arrival, the two joined this man's previous trawler, the *Schillig Horn,* under the command of a Dane named Bonniksen. This skipper was, my father recalled, a hard taskmaster, but he worked like one of the crew and, come fair or foul, the fishing went on like clock-work, hauling in the trawls every eight hours, emptying them and setting them out again. Then there was the dreadful job of gutting, cleaning and storing the fish below, often in temperatures below freezing. He was just over two months in this vessel, making two trips, and he reckoned that it did more to harden him as a sailor than anything else, but he left her because, by the end of the second trip, the back of his hands and fore-arms had become such a mass of running sores, due to the combination of the fish, the salt-water and the cold, that he had to stay ashore for medical treatment.

At this time the Boer war was in progress and, like most Germans, Otto's sympathies were all with the Boers, so he thought he would join one of the Woermann Line steamers which ran to South Africa, and would then desert out there to join up with them. In the event, he could not get a berth with this company, and so signed on the s.s. *Chios* of the Levant Line, and made three trips to the Levant, Black Sea and Mediterranean ports as ordinary seaman, visiting all sorts of places, both great and small, which held a certain glamour:– Malta; Algiers: Saloniki: Constantinople: Odessa; Batum, Novorosisk and a host of lesser ports along the coast of Turkey and elsewhere. He finally signed off in Hamburg on Christmas Eve, 1900.

At this time there was a widespread dockers' strike in progress, and the consequence was that ships were hard to find. Thus he came to join a sea-going tug called the *Blitz,* partly lured by the hope of salvage should she become involved with any wrecks, and partly for the simple reason that she represented a job. As it turned out, the matter of salvage never occupied the *Blitz* during the few months he was in her, and he soon tired of towing barges between Hamburg and the Scheldt, besides which he did not get on well with the mate and, after having quite an altercation with this gentleman, he signed off in March, 1901.*

The longshoremen's strike was still paralysing Hamburg and other North Continental ports, with the result that seamen were not, on the

* The *Blitz* was built in 1894 and was 161 tons N.R.T., with a length of 90.5 feet. She was German built and owned by the Verein Bugs & Frachtschfart.

20

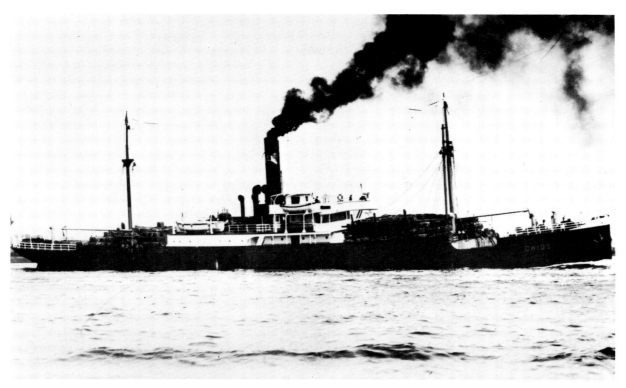

8. *The s.s. CHIOS of the Deutsche Levante Linie, built in England in 1890, and of 1644 tons net.*

whole, able to find ships. Whilst carrying his sea-bag to the boarding house where he had put up previously, he met an ex-shipmate from the *Chios,* who persuaded him to come instead to his boarding house. Situated in a private house on the St. Pauli waterfront, it is worth recording, if only as further evidence that only relatively few of these establishments, which have hit the sensational histories, were of that order. This one was run by a Frau Behrens, who was a ship-master's widow, and who let out some rooms to permanent residents, and others to sailors. The latter slept on the ground floor, and boarded with her. In the basement was a laundry, with five female helpers, who were quite prepared to fraternise with the sailors. The laundry also served as dining room and kitchen—the sailors, laundresses, Frau Behrens and her little grand-daughter (aged ten) all eating together, as it were, *en famille.* All had a very soft spot for this landlady, who had an equally soft spot for sailors, and she would always keep them on credit if they were unable to find a ship. She averred that they always

9. Anton Otto Fischer at St. Pauli, 1900.

paid her back when they could—a fact which is possibly at variance with the popular conceptions of both boarding houses and sailors, but none the less true for that!

It was a happy enough household, centred socially to a large extent in the laundry room, but searches for a ship were unavailing. Finally the man who had introduced Otto remarked that he had heard of a British barque, shifting round to Cardiff, which wanted a crew, but neither he nor any of the others were interested in a Limejuicer.* The British are by now well aware, from the number of reminiscences which have been written, of the defects in the conditions in so many of their sailing ships, with the poor food, but it is perhaps not so fully appreciated in what contempt they were held by the majority of Continental sailors, who were all well aware how badly they compared with those of other nations in their feeding scales alone. When Otto toyed with the idea of joining her, they told him he was crazy.

* British ships were known as 'Limejuicers', owing to their practice of issuing lime-juice after the tenth day at sea as an anti-scorbutic.

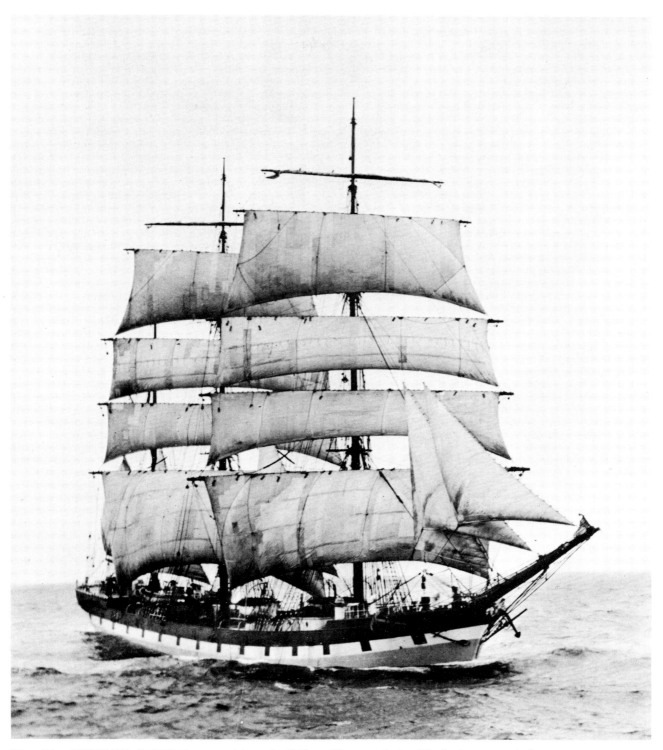

10. *The GWYDYR CASTLE outward bound off Cape Flattery during Fischer's voyage in her.*

It was, of course, common to find Finns and Scandinavians in British ships, largely because their own countries did not, on the whole, and up to that time, possess such a great number of deep-water sailing ships trading all over the world, but it was less common to find Continental seamen signing on them if they could join any other vessel.

However, despite all advice, A.O.F. (as I shall generally refer to my father henceforth) had made up his mind that he would sail in her and went down to the shipping office next morning to find the ante-room crowded with sailors seeking a ship to suit their own purposes. When the call came for men for the British barque *Gwydyr Castle,* there was scant response, and only he and six other men bothered to go through to the inner room to see the captain. He had rather a shock to find that he would be signing articles for three years, but he would be rated as A.B. at the princely wage of £3* per month, and they were to join immediately. With him, one other German, two Finns, a Swede and a Frenchman also joined. Before the Germans could sign on, they had to get a permit from the German authorities, stipulating that they must be back to do their compulsory service in the Imperial German Navy, but there was no difficulty about that. It is worth mentioning because, in the event, it subsequently had quite an influence on my father's whole life and career.

Nearly half a century later, he wrote a book about his experiences in this barque†, largely as a vehicle for a series of pictures about the voyage. This was much acclaimed as a factual and breezy work, and it is not proposed to detail the voyage in this biographical sketch. Parts of it will appear as explanations of the relevant pictures within the body of this volume.

Most square-rigged voyages had something of an epic quality about them, and this one was no exception, though it was not particularly unusual. If his friends had thought he had made a mistake in joining a British ship due to the quality of the food in Limejuicers, he had made a double mistake in joining a Welsh barque, in which food was, in those days, generally and if possible, even worse! (See Pl. 90).

Nearly twice the size of the *Agustina,* the *Gwydyr Castle* was a fairly average deep-sea barque of the times, and she proceeded from Hamburg to South Wales to load coal for Panama. Since the Canal was not yet in being by a number of years, this involved the arduous beat to the westward around the Horn. After discharging, she went up to Esquimault for orders and then loaded grain for Callao, in Peru, where she loaded sugar in a

* About $14.28. † *Foc's'le Days.*

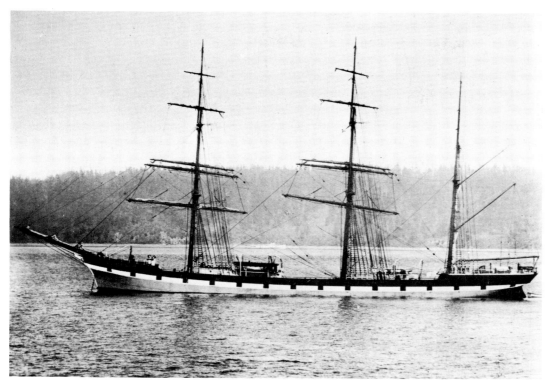

11. The *GWYDYR CASTLE* lying off Tacoma. Built in 1893, of 1408 tons, she was originally named *NEWFIELD* and owned by Brownells of Liverpool, passing to the management of R. Thomas & Co. of the same port in 1900. In 1916 she was owned in Newfoundland and, later, in South Africa and Mauritius, where she was ultimately hulked.

number of small ports and roadsteads for New York, having taken so long on her outward passage that she had lost her charter to load grain in Puget Sound for Cape Town.

When the *Gwydyr Castle* arrived in New York, it was announced that anyone who wished might be paid off, and most of the crew, including A.O.F., elected to leave, though it was only when they arrived at the British Consulate that they realised that, by being given this grace on their three-year articles, of which only two had expired, they would forfeit two months wages!

Being by then twenty years old and liable for German naval service, A.O.F. went to the German consulate to apply for a year's deferment—or *Ausstand*. He was, naturally, attired in the conventional sailor's garb and, when the pompous and orgulous young official realised what he was, he became supercilious and arrogant. This was his mistake. He was talking to a young man who had created an independence within himself and who

knew that he could make his own way in the world. He had sailed, for brief or longer periods, in the ships of four nations and he had, to some extent, 'seen the world' whilst, most important of all, he had no roots whatever in Germany. Indeed, it had struck him forcibly before he joined the *Gwydyr Castle* that he had nowhere that he could call 'Home'. Thus he looked the over-bearing young official straight in the eye and told him to 'Go to Hell'! Not long afterwards he had filed his papers for American citizenship!

Thus do the mills of Fate grind men's destinies. Perhaps those who love fine Marine paintings should give thanks to that puffed-up young German official for, had he not touched my father's pride on the raw, his whole life might have taken a very different course.

The trouble is that, although Anton Otto Fischer, the seaman, is well enough documented in the period from 1898 to 1903, any aspirations as an artist seem to have been locked in obscurity. No-one can say whether he occupied his dog-watches or other spare time with sketch pad and paints. It is difficult to suppose that he could have done so in the *Agustina:* the *Ruth* would have been constantly in and out of port, on the whole, and any idea of painting in the *Schillig Horn* would have been laughable.

We know that, when under the tutelage of the friars, he had asked the abbot whether he could not learn art instead of theology, and that he had taken his portfolio of drawings to the Baron von Lassberg. Clearly, at that time, he knew less than nothing of ships and the sea, and his interest must surely have been in Art in its widest sense, and certainly not that of a small boy with a fixed, one-track mind who so loves ships and the sea that he can think of drawing nothing else.

He himself asserted in later years that he did not draw in the *Gwydyr Castle*. I believe that he must have done so. When the ship was lying in Tacoma, a photographer named Wilhelm Hester came aboard, as was the custom in the ports of that area, to take pictures of the crew members. These were generally set round a picture of the ship herself in the final enlargement which would be brought down for sale. In—say—San Francisco, there was no difficulty, since the photographer could easily take the ship at anchor, free of the shore, but at Tacoma, with the vessel usually alongside, it was not so easy, and often enough he had recourse to photographing some painting of the ship under sail which frequently hung in the saloon. The *Gwydyr Castle* had never acquired any such picture, nor had Hester succeeded in catching her with his camera as she came up Puget

Sound. A.O.F. recorded that the difficulty was resolved by the mate remarking that there was a 'Dutchman'—a term which, with the somewhat opprobrious 'square-head', embraced almost all nationals from Holland round to the Baltic in British ships—called 'Bismarck' who was always messing about with water-colours, and suggested that he might be able to produce a picture of the barque. It is thus clear that he *was* drawing and painting aboard the ship.

The sequel was that A.O.F. said he would do a picture—and mark that he had no lack of confidence on this score—if he could have some water-colour paper and the captain would give him a day off. These conditions were met, and he not only produced a picture which filled the bill, but one which impressed Hester tremendously. He took it to Seattle, photographed it, and sold prints of it like hot cakes to the crew at a dollar apiece (including to A.O.F. himself!), but he also saw his potential and offered him a job, there and then, to go and work for him in Seattle.

Hester himself was a German, who originally hailed from Hamburg, but who had settled in Puget Sound about 1893 and, for some twenty-two years, he built up a great collection of the ships, their men and their working in that area on 8″ x 10″ plates. It must have been no light matter carrying this great camera with its tripod and all its appendages around the ships. He did not process his work himself, but sent detailed instructions for printing them once he had seen the finished plates, which were ferried back and forth across the Sound almost daily by local steamers.

How Hester came to Seattle, or where he learnt such proficiency as a photographer, is not known. When Weddell Foss, of the Foss Tug and Launch Co., read *Foc's'le Days,* he wrote to A.O.F:—

'You mention the old scallywag photographer. He, too, is still alive. He is too mean to die. He lives not very far from our office in an old, dilapidated six-roomed house, all alone with dirt and filth indescribable, with several dogs and two or three cats, not to mention the hard liquor he seems to thrive on, in spite of his age. In his inebriated condition he boasts of the time when he used to rob the sailors coming to Puget Sound. The only reason I ever go to see him is because I am trying to locate where he has hidden 2000 or 3000 photographs or prints he has of the ships that came to this country. He has hidden them in two or three apartment houses that he owns, but can't remember where*.'

The idea of settling and working in the United States had not occurred to A.O.F. and, although by this time the rigours of sailing ship life had

* These are happily now in the San Francisco Maritime Museum, thanks to the efforts of Robert A. Weinstein, who managed to arrange for their acquisition when a purchaser moved into one of Hester's properties after his death.

long since wiped away all the romantic ideas with which the Regensburg poster had imbued him, the life still had an appeal for him and he refused the offer, much to the surprise of Wilhelm Hester and, no doubt, to most of his shipmates. It was the attitude of the German consular official in New York, once again for quite the wrong reasons, which cast the die and changed the course of his life.

He was still in touch with his sister, and wrote her two letters from the *Gwydyr Castle* which still survive. They are mainly a recapitulation of the experiences of the voyage; surprisingly fulsome in expression of brotherly affection, while one adds that when they do meet again he hopes that she will not be so shy and proud as she was when they last met in Regensburg (she being then eleven!). As already recorded, they never did meet again. From Cardiff he had sent her a post-card on which he had made a water-colour picture of the barque, but this is certainly not the work of budding genius. In all, these years represent a maddeningly blank passage both as to my father's artistic work and ambitions in this direction, though it is clear that the idea of an interest in art was dormant in his mind.

As soon as he had left the *Gwydyr Castle,* he had taken up residence at the Episcopal Seamen's Mission located at 52 Market Street, New York. People reading this account of his life may have the impression that, with his Catholic background and with his reliance on missions, my father was rather religious. In fact, although a man who maintained high moral standards, he was not a church-goer. Certainly he disliked drunken-ness, and seldom had joined his shipmates ashore in the various ports where, for the most part, they got themselves rip-roaring drunk. He would usually help them aboard when the occasion arose, or smooth out such temporary crises as their drunkenness precipitated, but he himself never wanted any part in it. Perhaps of necessity, the trait which seems to have been most marked at this time, and for some years to come, was his innate sense of responsibility.

In that summer of 1903 the only things about my father to indicate the beginning of a new chapter in his life were the first papers for American citizenship in his pocket. He was still, perforce, a sailor, and he looked around for employment in the only calling he knew. Nor was he averse to it. Anyone who has served in such a ship as the *Gwydyr Castle* could point to a multiplicity of disadvantages about sailing in such a vessel, but A.O.F.

took a broader view of the sea, and saw it as a career which offered a certain freedom of choice with a modicum of variety of ports, routes and ships. Although it was undeniably a life which offered sights and sensations more marvellous than ever experienced by any landsmen—(when in the Trades, for example)—it could also offer the very acme of discomfort. Even then, there were momentary treats of elemental wonder for those who had eyes to see them, and it is clear enough, from his written reminiscences, that even in freezing Cape Horn 'snorters' with flooded decks, he gloried in the sheer emerald in the troughs of the seas and in the very grandeur of the arching sails.

At the Seamen's Mission he heard glowing tales of life aboard the yachts racing on Long Island Sound, and he soon found a job on the 60-foot sloop *Eileen,* spending the rest of the summer with her and, when the yachting season drew to its close, he found a berth for the winter in the old school-ship *St. Mary's* which was administered by the Board of Education and moored at the bottom of 23rd Street. 'As instructor in seamanship, if you please', he always added in recounting the story to my brother and myself subsequently.

In fact, the New York Nautical School who ran the ship directly, had been opened in 1874, and at that time the *St. Mary's,* a 20-gun sloop, was allocated to them. She had been built in 1844 and was a very bluff looking craft when seen afloat although, out of the water, she could be seen to have really quite fine lines and a big dead-rise*, almost like a yacht. She had seen active service both in the Civil War and in the Moroccan War, but was taken off the active list in 1871 and laid up until taken over by the New York Nautical School. The term 'sloop' is often misleading and she was, in reality, full-rigged. Later, in 1909, she was felt to be too old to justify further expense being made on her (for she made cruises each summer) and was then replaced by the barquentine *Newport*.

The following two summers A.O.F. went back to racing. In 1903 he was in the *Queen Mab* and, in 1904, in the 70-foot *Yankee†*, being in charge of the headsails, which involved the handling of the big balloon jib and spinnaker. It was a pleasant, exhilerating life with good pay, and was a far cry from all the terrible hardship aboard the Welsh barque. The wages which he received seemed to him to be munificent, and there were bonuses whenever they won a race. He had spent the winter of 1903 with the *St. Mary's* again and, by the end of the 1904 yachting season, he had saved a little money and, with bare existence now assured, my father began

* The angle made by the midship frame with the horizontal plane at the keel.

† See Plate 15.

to have serious thoughts of the future. The latent desire to become an artist stirred, though without direction.

It was at this point that the Fates again stepped in and took a hand. One rainy Sunday in November he was sitting in the Mission, idly reading the 'help-wanted' advertisements in the newspaper, when he noticed one from an artist out in Convent Garden, New Jersey, who needed a model and handyman. My father replied to it, in spite of an admitted lack of general qualification. The artist was A. B. Frost, a well-known illustrator, though unknown to A.O.F. Something about the straight-forwardness of the application appealed to Frost and he replied, enclosing the train fare for my father to come out to Convent Garden for an interview. The results were mutually satisfying and A.O.F. found himself employed in a real artist's studio. In his own words:—

> 'Mr. Frost did not engage me solely as a model. I had quite a lot of other jobs. I was general handyman and factotum; took care of the furnace, swept out the studio and did whatever there was to be done about the place. I lived right there and had a nice, comfortable bed in the studio. Frost's two sons, who were quite a little younger than I, were greatly impressed by having a real sailor who had crossed the ocean and been in rough water as an intimate friend. I was only a boy myself, remember, so I got them in quite a few scrapes, which I also promptly got them out of.'
>
> 'Of course, I had always been interested in drawing and painting and this atmosphere was very pleasant to me. Mr. Frost was encouraging and urged me to try to develop my talents along artistic lines during my time off. I made quite a few efforts at various forms of painting and drawing, but received no formal criticism or instruction.'

This pleasant association lasted a year and a half until, in the summer of 1906, Frost decided to move his family to the artistic climate of France. He wanted his sons to study in Paris and, recognising the talent of his young employee, he urged him to do likewise. This was the direction A.O.F's life needed. He was now sure that he wanted to set out on an artistic career, but realised that he needed real instruction to begin. He also needed the funds and, after the Frost family had departed, he returned to yacht-racing, this time in a sloop owned by the Dominick family of Greenwich, Connecticut. This was a wealthy family in the brokerage business and one of the sons, Everett, was about the same age as A.O.F. They became good friends and kept in touch, on and off, for the rest of their lives. From my father's point of view it was a splendid summer, and

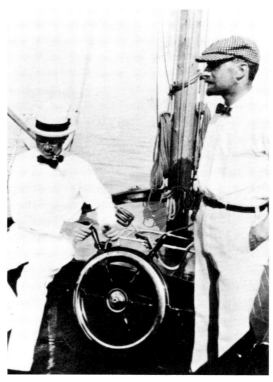

12. *A.O.F. in Paris as a student.* 13. *Everett Dominick and A.O.F.*

by the end of the racing season he had accumulated about $700 in the Seaman's Savings Bank. These funds he took to Brown Brothers and had them transferred to their Paris branch. He then boarded the French liner *La Bretagne* and set sail for France 'as a paying passenger'—he always added. His sailor days were over except on canvas.

In Paris, he took a room in the Latin quarter and enrolled in the Académie Julian to study under Jean Paul Laurens. He had roughly $600 in the bank, then the equivalent of about 3000 francs, and he intended to stay as long as he could make this money last. Frugal living was a habit and, by dint of putting himself on a weekly stipend of 20 francs, this was to be two whole years! A.O.F. withdrew the 20 francs so regularly every Friday afternoon that the bank teller finally just pushed the amount through the window when he saw him coming!

A student could get along on very little in the Paris of those days and A.O.F. was adept at making the maximum use of a small amount of

money. His evening meal was usually bought from a street vendor—roasted chestnuts in winter and fruit in summer, to be consumed in his room over a book and accompanied by a large pitcher of water. The morning meal was at the corner *boulangerie* where he breakfasted on *café au lait* and *croissants* hot from the oven, about which he waxed poetic for the rest of his life. His sailor habits stood him in good stead and he washed his clothes himself—even his suits which he pressed under the mattress of his bed. A.O.F. was conspicuously clean among art students—a notoriously shaggy lot—and my mother, who was living in Paris with her first husband and infant son at the time, later recalled A.O.F. as the only art student amongst their acquaintances who radiated the effects of soap and water!

A.O.F. had an aptitude for picking up languages, supported by being an omniverous reader of books and daily newspapers. Aboard the *Gwydyr Castle* he had read Dickens assiduously, to his great enjoyment and to the great benefit of his English and now, in Paris, he turned to Balzac and his French was soon fluent. Indeed, his reputation on this score was such that he was often called upon to act as interpreter and spokesman for his less linguistically-gifted friends when student revelry led to brushes with the *gendarmerie*. Here again, he was an old hand at this sort of thing, from all his experience of shepherding shipmates along their unsteady courses when in port. However, his studies were his chief preoccupation and he pursued them with characteristic concentration. It was not long before he began to develop that mastery of his talent that was to be his greatest asset in his career in later years.

During the winter of 1907, A.O.F. made one last effort to probe his past, and it was then that he wrote to the Baron von Lassberg, asking for information about his parents. Most of the Baron's reply has been included in the earlier section of this biography. It is clear that my father had written to him before going to sea—presumably to tell him what he was doing—and the start of the Baron's reply is amusing, since it reads:—

> ' . . . Since Dec. 31st 1896, you have been lost to my view. On that day you wrote to me for the last time from Regensburg, congratulating and thanking me on the New Year and wishing me. . . . Good Luck and Good Health in my advanced age. (I was at the time 49) '

There is not a great deal of record of A.O.F's time in Paris. We know he visited the Frosts at Giverny in the summertime and he seems to have spent a good deal of his time there gathering snails for the cook to prepare!

14. *Julian's Academie – Jean Paul Laurens on chair in centre: A.O.F. over his left shoulder.*

Judging by the way that he went out after nature's wild bounty by my observation later on—(berries, nuts, mushrooms and so on)—I am sure that the Frost *ménage* was well supplied with snails.

Most artists, especially in their student days, develop a particular admiration for the work of one or more of the masters, which is not to suggest that they necessarily use them for their own inspiration, nor that they model themselves upon their work. The question has sometimes been asked about A.O.F, in endeavours to discover who his folk-heroes may have been. In view of his propensity for crowded scenes in boats or on ships' decks, together with his treatment of them, the theory has been advanced that perhaps Delacroix or Géricault might have come into this category.

I very much doubt if he was subject to any such influence. He was a man who enjoyed galleries when he visited them but, although no-one today

can speak for these student days, in later life he made little distinction amongst his predecessors or his peers. It is certain that he had a deep admiration for the Dutch and German schools, especially the Dutch masters of the Marine school, but it is possibly significant that the one old master which hung in his studio was a detail from Velasquez' *Los Borrachos* (*The Drunkards*) which must rank as one of that Spaniard's great *tours de force,* with those marvellous heads which, in another century and in different circumstances, might well have found themselves, for example, in the foc's'le of the *Gwydyr Castle* rather than tending sheep for the *mesta* as, indeed, they probably were in life. The other picture permamently hanging in the studio was by Winslow Homer—his famous *The Fog Warning*—which, superficially, might almost appear to have provided a source of inspiration to many of A.O.F's later pictures. That Homer ranks as one of the greatest of America's artists there can be no gainsaying: that when he produced a major seascape it was generally superb is equally without question. Yet Winslow Homer was not primarily a marine artist, but one who did produce, amongst his variety of subjects, some seascapes that rank amongst the best in any land, though it is generally true to say that he was rather more concerned with achieving his effects by large masses, and that, as in *The Fog Warning, The Herring Net,* and many others, he was less interested in details of characterisation. When he did concentrate on this aspect where ships and the sea were concerned, the marine scenario was used rather as a back-cloth, as may be seen in most of his pictures around Gloucester Harbour and the North-East coast of England. Thus, although examination of the works of Homer and of A.O.F. in later life do sometimes overlap in their subject matter, their approach and treatment of it was usually very different. Nevertheless, the presence of *The Fog Warning* in my father's studio cannot have been without its significance.

No doubt A.O.F. paid all due attention to the Masters while in Paris so far as his funds and circumstances permitted, but he was always more interested in painting than in 'Art' in its historical sense as, indeed, he was more interested in making music than in listening to it. It was all part of his character. Yet the detail of *Los Borrachos* may have had a deeper significance than the marvellous characterisation of the heads. Of course he admired Velasquez. Only the most impercipient could fail to do so yet, as a Court painter in the seventeenth century, in despite of the restrictions imposed by convention and accentuated by his own personality, Velasquez (who was by no means a prolific artist), was not only a man who painted

34

the features of his subjects together with their whole characters ingrained on them*, but he generally foreswore movement or, at all events, any violent movement.

It is not generally appreciated by those who have never visited the Prado nor had the opportunity to see original Velasquez paintings, but who know them only from the pages of a book, just how vast his canvases were. It is not my intention to draw the slightest comparison between my father and Velasquez—invidious or otherwise—and certainly A.O.F. never attempted canvases on that scale. Moreover, he worked on a far greater range of subjects, some of which never included people at all. In some, as in Plate 17 of the debris of fruit and humanity being swept aft as a hurricane all but overwhelms the schooner, there is, to say the least, a certain violence of action, though it is a motion which is imparted to the characters and not natural to them. Of course, he both drew and painted pictures which portray human action, as in his studies of *Furling Sail* (Plates 93 and 121), but it is true to say that most artists develop some *forte* at which they are the most successful, and in A.O.F's case it was undoubtedly the whole characterisation and—often enough—intensity of expression in a group of men set against a ship or the sea, when they are relatively static. Examples lie in Plates 108 (*Songs of Home*): 91 (*The Lady from the Mission*) and 189 (*Men on a Submarine's Deck*) and so on. His contemporary on the other side of the Atlantic, Arthur Briscoe, whose path he had barely missed crossing at Julian's in his Paris days, produced work which is sometimes rather similar and, on occasions, the two men painted pictures which momentarily touched at a tangent. Generally, they chose different types of marine subjects and, when they did use common ground, the treatment was different, for Briscoe's undoubted *forte* was the portrayal of seamen in action—as borne out by such etchings as *The Heaving Line, The Wheel* and such water-colours as *Clewlines and Buntlines*. In him there was an element of the flexing and tensing of muscle.

No-one will deny that A.O.F. brought his men to life. Thus his astonishing success as an illustrator, since it may be argued that he created some of the characters he produced as much as the authors of the stories, but as an artist he reached his greatest heights when he portrayed a group of men, often close together, in one situation or another. Of course, he showed motion (*vide* Plate 211 in which the escort vessel seems to be flying through the sea) but, like Velasquez, he preferred his men to be in relatively static positions, albeit in a composition which generally stands on its own

* When he painted his portrait of Pope Innocent X, which must rank amongst the greatest of all portraits, the Pope commented sadly that it was *troppo vero*. (He had so satanic a visage that it almost weighed against him at the papal election during the cardinal's conclave!)

merit as a seascape. Inspection of his work reveals that he must have had a deep interest in people, and that the characterisation of subjects in such masters as Frans Hals, Rembrandt, Vermeer and the like would have had as much appeal for him, if not more, than the Dutch marine artists.

———————

In 1908, A.O.F's capital was down to $50 and he returned to the United States and New York City. To find employment was his first need and he found it with Albert Herter, owner of the Herter Looms and a well-known mural painter and decorator. A.O.F's job was up the scaffolding, doing what seemed to him to be most of the painting! A few weeks of this convinced him that he wanted to be on his own, so he rented a hall-bedroom on Lexington Avenue that could also serve as a studio, and painted his first illustration. It was a black-and-white marine subject showing two sailors on a beach, gazing out at the wreck of their ship. With this under his arm, he set out to make the rounds of the publishers. The first place he went to, the old *Harper's Weekly,* took it and, although they were considered 'The Dump' by illustrators—a graveyard in which to get rid of paintings they could not sell elsewhere—my father was much encouraged and the $40 he received for his picture seemed to him to be a fortune. As a result of this sale he received several commissions. Years later, in an autobiographical sketch for the *Saturday Evening Post,* he wrote of this time in his life:—

'It would be nice to say that things went on in a constructive manner from then on, but that would not be true. Things were very tough. I moved to Wilmington, Delaware, where I found a barn big enough and cheap enough and here I laid the foundation of whatever success I may have made. At one point my finances got down to where I had only $5 left and I seriously considered giving up my artistic career and going back to sea. Remember, I was a foreigner, a stranger in the United States with no family and nobody to turn to or borrow from. Evidently I was not destined to spend my life on ships, however, for, just as everything seemed hopeless, an unexpected commission came through, and the few dollars it brought me made it possible to carry on.'*

This was the era of 'subject pictures'—paintings telling a human interest story. They were very popular and the magazines used them both for covers and inside as full-page and double-spread reproductions. Though commissions may have been few and far between in 1909, A.O.F's

* A.O.F. did not study with Howard Pyle in Wilmington as many people believe. It is a question often asked.

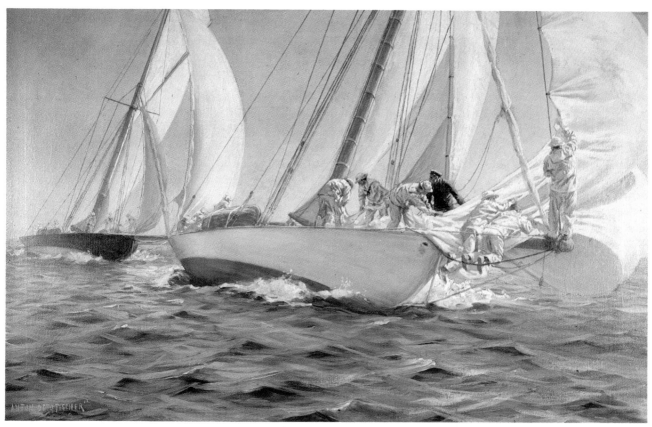

15. *Yachts VIRGINIA and YANKEE (painted white) coming up to round a mark when racing off Long Island. The balloon jib is being taken in before the beat to windward. A.O.F. was bowsprit man in the YANKEE in 1903. The yachts were 70-footers – the class below the America Cup defenders. (This picture was acquired by Professor Harold W. Webb, a former measurer of the New York Yacht Club.)*

freelancing in subject-pictures became more and more successful, judging by the number of these I find in old files.

He found an unlimited source of ideas in a rather odd friendship he struck up with the residents of an Old Peoples' Home in Wilmington. He invited the old ladies out to dinner and provided the wherewithal for surreptitious suppers they held in the Home with all the glee of school-girls. All of this may have been done out of a lonely need, but it provided A.O.F. with a wealth of subject material and a host of willing models, all of which his facile brush treated with a sympathetic and tender humour. *The Anvil Chorus* (Plate 16) is just such a one. These paintings seem to have found a ready market in *Harper's Weekly*. If the remuneration was not great, my father's industry was enormous. Editors began to notice him and commissions started coming in. In 1910 he moved back to New York City and took a room at 15 West 29th Street. The autobiographical sketch continues:—

> 'Then I got my first big break. Ray Brown of *Everybody's* (magazine) sent me a story by Jack London to illustrate. It was a narrative of the South Seas called *The Heathen,* to be done in full colour, and I put everything I had into it.'

It was an embarrassment of riches when, while working on the London story, his first manuscript from the *Saturday Evening Post* arrived. In 1957 A.O.F. commented on this to the editor of *Keeping Posted:*—

> 'Incredible as it seems, I returned it with regrets because I did not want to let anything interfere with the London job. I got my reward when *Everybody's* published the illustrations in full colour—at that time an almost unheard-of thing. Mr. Lorimer* must have understood my situation, because shortly afterwards I received another manuscript from him.'

Jack London was at the peak of his popularity, and to become associated with him was a break indeed, especially as A.O.F's talents complemented those of Jack London so well. In the October *Cosmopolitan* of 1911, the editor wrote enthusiastically of the 'team' of London and Fischer with photos of the two men: that of my father as a yacht-hand and that of Jack London relaxing in a hammock at his home in California.

Jack London was delighted, too, and wrote to my father on October 7th 1911:—

* George Horace Lorimer: editor of the *Saturday Evening Post* from 1899 to 1936.

16. *The Anvil Chorus. Based on the old ladies of Wilmington, the reproduction shows the fold in the double magazine spread.*

'Dear Anton Otto Fischer:– For the first time in a weary, weary while I find myself delighted with the illustration my work is receiving. So much so, that I wrote to that effect to the *Cosmopolitan* the other day. Since then I hear that you are a socialist. Hence I am writing to you.

There is no use talking by letter all that you and I could talk. Don't forget where we live. We've got some awfully nice country here, horses to ride, and in the summer-time a swimming pool and in the winter-time a yawl on which Mrs. London and I go cruising. It all depends on what time of year you come to visit us, as to what we can pass out to you. Two things, and both the same, we can promise you: Whether on the ranch, or if you go with us for a cruise on the boat, you will get plenty of opportunity to work. You see, I work every day, as does Mrs. London, and anybody who's visiting us has the same opportunity.

Please find enclosed a circular telling you how to get here, which is correct except the time-tables, which *have changed*.
Sincerely yours Jack London.'

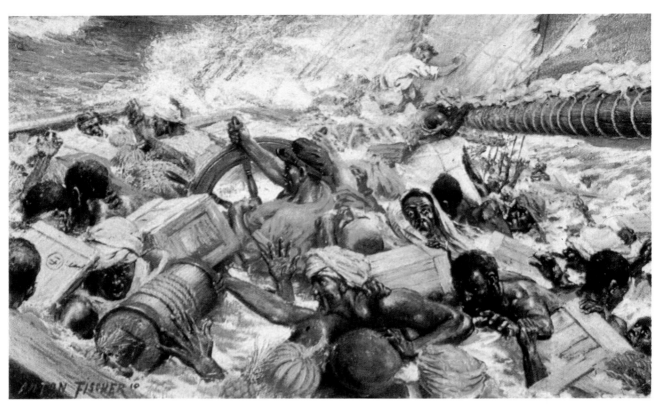

17. Illustration from Jack London's THE HEATHEN. *(p. 38)*

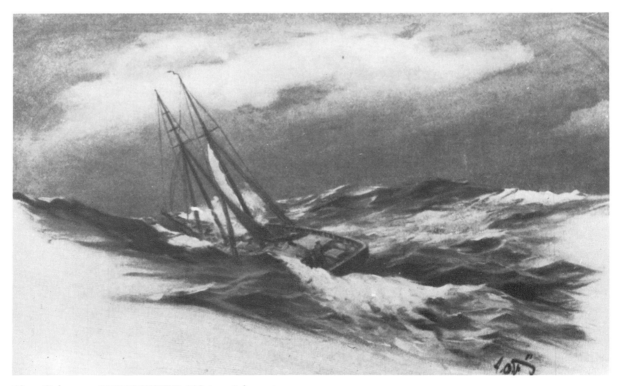

18. Schooner HENRIETTE *(13 tons)* hove to
on George's South Shoal, July 28th 1911.

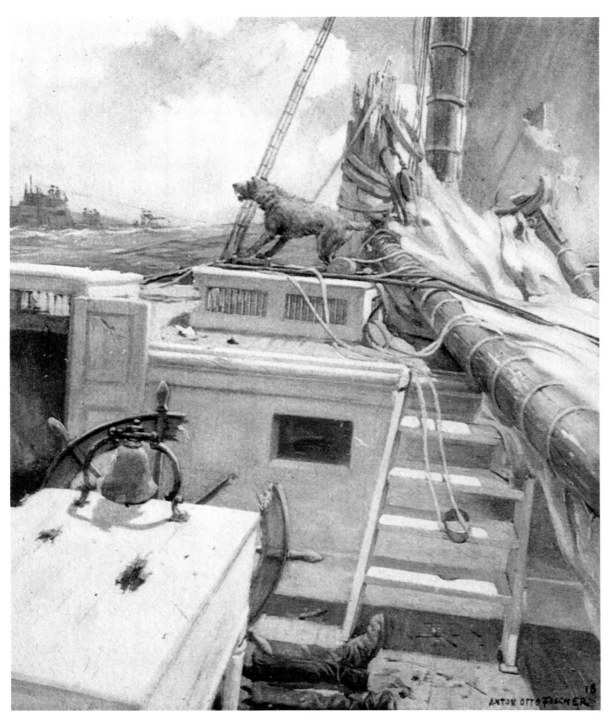

19. *The Irish of it. Painted in 1918, this is a sorry tale of the First World War, with the schooner's sole survivor barking defiance at the submarine which has killed the rest of the crew: shot away her mainmast and reduced her to a veritable wreck. One senses the same spirit in this Irish terrier as in the gun's crew portrayed in Plate 155.*

A.O.F. never did visit Jack London but, somehow or other, seemed as at home illustrating his tales of the Yukon and Klondike as he was with his sea stories. This ability to project himself into a locality and situation, in addition to having the kind of observation that picked up what it needed from every possible source (and some impossible—see posing photo, Plate 38) was a large part of his talent as an illustrator. Once Jack London wrote to him that he could name every man at the bar in an illustration showing a Klondike saloon—yet the men were all actually natives of the upstate farming hamlet of Bushnellsville, New York, where my parents had bought a home when they married in 1912!

Until Jack London died in 1916, my father illustrated his stories for many of the magazines. *The Sea Gangsters* ran in *Hearst's* as a serial from February to July, 1914, and, among *Saturday Evening Post* clippings for 1911 I find: – *The Goatman of Fuatino* – *An Account with Swithin Hall* – *The Pearls of Parlay* – *A Goboto Night* and *The Feathers of the Sun.*

Among the numerous books illustrated by A.O.F. at this time were three of Jack London's:– *South Sea Tales, The Mutiny of the Elsinore** and *A Son of the Sun.* The preponderance of Western titles on which he worked is surprising to me, but this was undoubtedly a reflection of his association with London.

By 1912, A.O.F. was in general demand as an illustrator and his output was prodigious. I found in the studio after his death in 1962 a mouldering pile of magazine sheets from the period 1909 to 1920 that must contain well over 1,000 different proofs. What astonished me even more, however, was the range of subject. I was used to my father being in demand professionally almost exclusively for men and the sea, but here were pretty girls, women and babies: dogs and horses: jungles and the Tropics: the far North: the West: both city and country life; the Navy, the Sports world and, of course, ships and the sea. All of it was depicted with the same fidelity and finesse. It was an almost incredible versatility, expecially in the light of A.O.F's background—German institutional life and the foc's'le.

Besides Jack London, A.O.F. was illustrating the work of such diverse writers as Rudyard Kipling, Joseph Conrad, Rex Beach, Ben Ames Williams and Albert Payson Terhune. Peter B. Kyne's *Cappy Ricks,* who appeared on the scene at about this time, became the first of the salty and colourful characters with which he became associated pictorially†. A list of the authors whose work A.O.F. was illustrating at this time reads like a roster of the writers of the day. Nevertheless, as I sorted out the proof sheets by

* Some of the characters in this book were based on those he knew in the big steel 4-masted barque *Dirigo,* in which he, with his wife Charmian and one of his Japanese, Yoshimatsu Hokata, and their dog voyaged from Baltimore to Seattle. The mate, Mortimer, is certainly taken from life, with some aspects of Capt. Omar Chapman, her master, who became very ill and died of stomach cancer only days after arrival. A.O.F. was on old, familiar ground with this book!

† Followed in the 1920s by Norman Reilly Raine's *The Dandy Man, Mr. Gallup* with *Tug-Boat Annie* and Guy Gilpatric's *Colin Glencannon.*

years, I noticed that the sea and ships were assuming an ever greater prominence.

Jack London's information about A.O.F. being a Socialist was not entirely accurate. Certainly he inclined towards socialism and did work for the party's publication, *The Masses,* but it was my mother-to-be who could more correctly be defined as a Socialist (although even she never actually belonged to the party.) She took courses at the Rand School of Social Science (a Socialist and Labour College maintained by the American Socialist Society) and A.O.F. was often to be found there, waiting for her outside on a park bench or in the school's restaurant which in those days was a meeting place for artists and intellectuals as well as for Socialists.

In Paris, A.O.F. had met Mr. and Mrs. William Balfour Ker, two young American professional artists who had packed up their savings and infant son David in 1907 and had gone to Paris to paint.* They returned to New York at about the same time as A.O.F. and the friendship continued there. When the Kers were divorced in 1910, my mother went back to her maiden name professionally and, as Mary Ellen Sigsbee, spent the next years in the uphill struggle of being both a mother and a bread-winner. She was predominantly a painter of women and children, and much of her work carried a social(ist) significance. From 1909 until 1917 she worked under Arthur Brisbane on the *New York Evening Journal,* writing and drawing columns of a social nature.

By 1912, the friendship between A.O.F. and Mary Ellen Sigsbee had ripened into something more, and they became engaged. Her father, Admiral Sigsbee, who had been captain of the U.S.S. *Maine* when she was blown up in Havana on February 15th, 1898 (the event which precipitated the Spanish-American War) remarked to her:- "You don't know a thing about this man. He could be an escaped criminal." This was said purely in consequence of A.O.F's lack of documented identification at the time, and was as far as his objections went. Later in life, my mother became estranged from her father (though for quite different reasons) and I myself never met him.

At all events, my father and mother were married on October 2nd, 1912, when she was thirty-six and he thirty—the day after David's sixth birthday, much to that young man's delight. When he had been told of the impending event, he asked his mother earnestly whether she 'had got it in

* Mary Sigsbee Ker was one of the few Americans to have a painting hung in the 1908 Paris *Salon.*

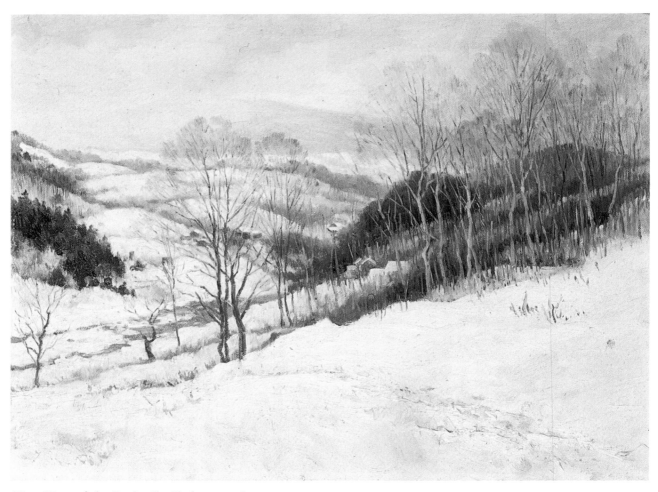

20. *View of the Bushnellsville home under snow.*

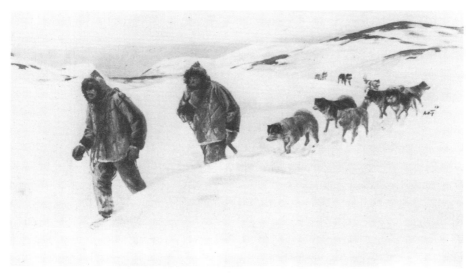

21. *A Jack London 'Yukon' illustration.*

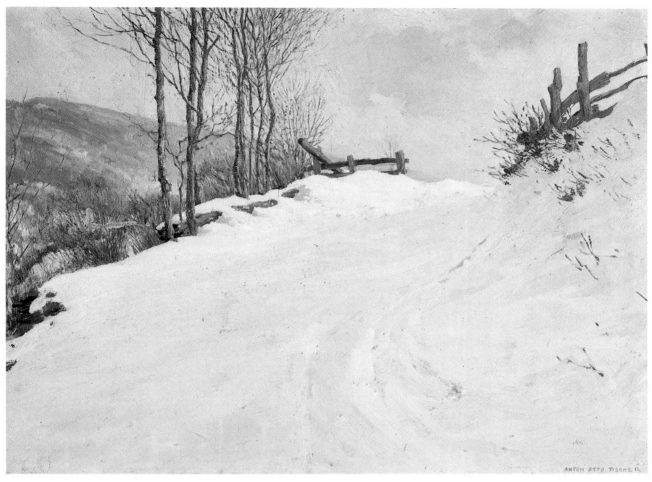

22. Locke's Road, near the Bushnellsville home, 1938. (It is a bold man who will paint so much snow in a canvas: a brilliant one who can pull it off!)

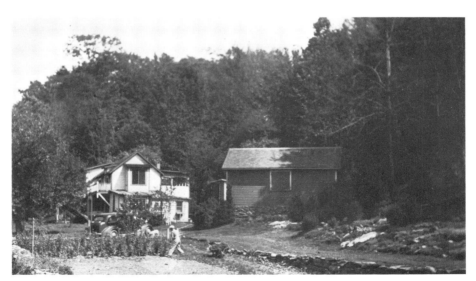

23. The Bushnellsville home and studio.

24. A.O.F. circa 1901/10. *25. Mary Sigsbee Ker at about the same time.*

writing, so he won't forget'—writing being something of which he was beginning to learn the importance. The affection was mutual, and it became a real father and son relationship.

The year before, in 1911, my mother had been advised by the doctor to take David out of the city for his health. He was a delicate boy and the doctor feared that he might develop T.B. Dr. Crump suggested the Catskill Mountains where he himself had a mountain-top retreat, so my mother and David spent the next year in a country boarding-house in Bushnellsville, N.Y.; a tiny farming community situated in a lovely Catskill Mountain valley about 100 miles north and west of New York city. (The summer cottage she rented the next year was infested with bats, of which she was always terrified, and the family story always was that the bats played a large part in making her agree to marry A.O.F!) When my parents married, they bought an old farm-house to which my father added a studio, and for the next two years they lived and worked in Bushnellsville,

contending with such professional hazards as the post-mistress being prone to overlook Special Delivery letters (with commissions in them) which she had put behind the pickle jar for safe keeping! Then it was seven miles to the nearest railway station, served by horse-drawn stage which switched to oxen every heavy snow-fall. Yet, if life was primitive, it was also idyllic, and the Fischer family, to which I was added in the spring of 1914, put down deep roots. For the next 28 years, Bushnellsville was home, no matter where else we might be located. (A little later on the post-office was changed to Shandaken, a slightly larger hamlet two miles down the road at the foot of the Bushnellsville Valley. The name Shandaken·came to be used more and more, but in these pages Bushnellsville and Shandaken are actually the same place.)

By the fall of 1914, David's health was considerably improved and the Fischer family moved back to New York City for the winter months (140 West 13th Street in Greenwich Village). However, after the *Lusitania* was sunk on May 7th, 1915 and we returned to Bushnellsville for the summer, my parents decided to remain there for the coming year. They knew that it was only a matter of time before the United States entered the war against Germany, and A.O.F. was still a German subject.

When in Paris, his pocket had been picked in the Café Dôme and, while the thief got nothing of value to him, he did take all A.O.F's papers, including those of identification as well as the first papers for U.S. citizenship. Until now, he had done nothing about it, but it was clearly time to begin. With the help of friends who vouched for him and a sub-poena issued to one of the original witnesses (Everett Dominick) to appear in court in Catskill, N.Y., (capital of Greene County in which Bushnellsville was located) the whole process was rushed through and, on February 6th, 1916, Anton Otto Fischer became an American citizen. (It turned out later, when the 1920 census refused to include my mother, that she was still considered to be a subject of the Kaiser—a rather amusing state of affairs when one considers that she was the grand-daughter of one of the founders of the United States Naval Academy—General Henry Hayes Lockwood, who was both a Brigadier-General in the Army and a Commodore in the Navy, as well as the daughter of Admiral Charles Dwight Sigsbee, mentioned previously. She never did anything about the matter and, eventually, the law was changed so that, somewhere along the line, official bumbledom automatically restored her own citizenship!)

During the winter of 1917-18 my parents tried New York City again

26. *David, 1920.*

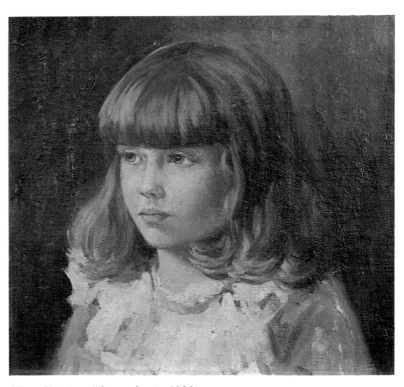

27. *Katrina (the author), 1923.*

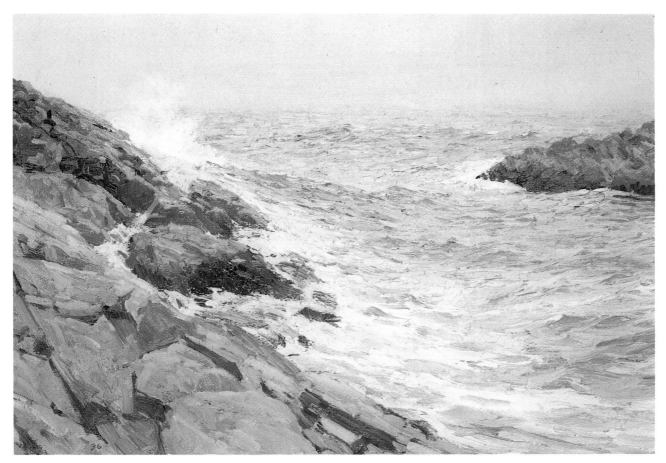

28. *The rock-bound coast of Maine, near Ogunquit.*

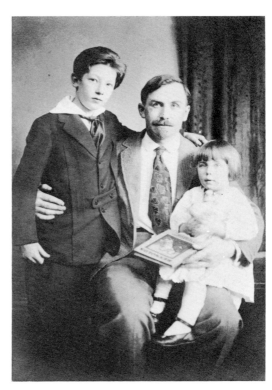

29. A.O.F. with David and the author, 1915.

and rented an apartment at 1 West 85th Street. My mother found it during the summer when the building was more or less in a state of siesta but, when in the fall the family rolled up to the door in a Model T Ford, laden down with luggage, paraphanalia of one sort or another, two children and a country collie, they were unprepared for the liveried doorman and general aura of Central Park elegance. My mother was always a lady to take such things in her stride if need be, but my father hated ostentation and he and David sought out the rear entrance and used it for the whole time they lived there!

The feeling against Germans was very strong in the city at this time and A.O.F. felt the pinch professionally. After war was declared, one editor had recalled his manuscript and, although others remained more friendly, the number of commissions coming in dwindled to the point where it was no longer economically feasible to live in the city, so the Fischer family moved back to Bushnellsville, leaving New York City for good.

There was much less feeling against Germans amongst the country people. They assessed a man rather by what he could do and the sort of person he was than by his background. Although suspicious of 'city folk', they had already come to respect A.O.F. for his homesteading abilities and industry. He may have been 'that German up (or down) the road', but it was a remark that implied identification and not condemnation. That he was an artist was more difficult to understand but, with the tangible results appearing in their periodicals, A.O.F. had many willing models.

The life was primitive in those early days, but it was also, to a great extent, self-sufficient. Water came into the house by gravity (when it was not frozen up in winter or dried up in summer. Then it had to be carried from a spring across the road!) Wood stoves required only hard work (and considerable attention); oil lamps cast a mellow light that made us resist electricity when it became available until the farmers stopped cutting ice and it was no longer possible to have the ice-house filled. At that point, a refrigerator became a necessity.

A.O.F's vegetable garden was second to none as a result, no doubt, of his peasant blood re-asserting itself together with his innate sense of competition. With a well-stocked root cellar, half a beef hanging in the ice house (from which he hacked off unheard-of cuts!), chickens, and even a Holstein cow for a while until mother rebelled at the gallons of skimmed milk it gave, our sustenance was well taken care of. The countryside abounded in wild offerings: berries, nuts, mushrooms, game and an excellent trout stream flowed right in front of the house. A.O.F. took advantage of it all and my mother, who was in no sense a farmer's wife, was often hard-pressed to cope with the excess produced by father's zeal. Fortunately I inherited a lot of A.O.F's peasant blood and quite a lot of his energy as well, so that later on Mother was able to sit back with a clear conscience and let 'those Kandlbinders' go at it together. (Kandlbinder, it will be recalled, was A.O.F's mother's family name, and it came to signify in our family a certain Germanic propensity for work!)

The winters were solitary, but summer-time came to include more and more friends and relatives on my mother's side who rented, bought or built summer homes in the valley, and there was much pleasant sociability. In fact, A.O.F. had to be protected from sociable holiday-makers when he was working in the studio, and Mother was often forced into the un-characteristic role of 'resident dragon'.

A.O.F. had added a tennis court which was a very popular spot. He

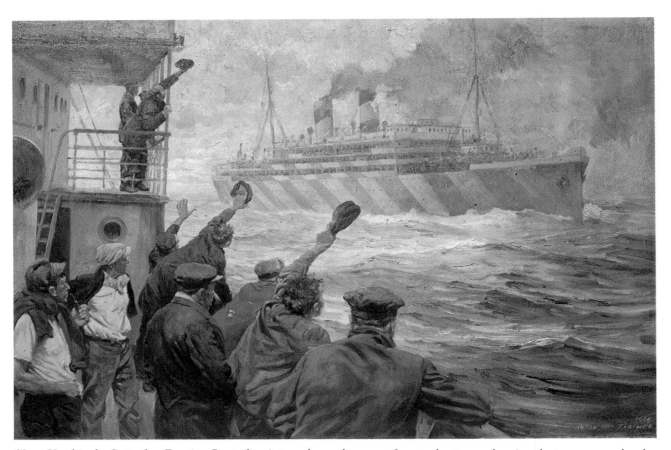

30. *Used in the Saturday Evening Post, the picture shows the crew of a merchantman cheering the troops on a dazzle-painted trooper, her decks literally crowded with khaki-clad figures bound for the Western Front in the First World War.*

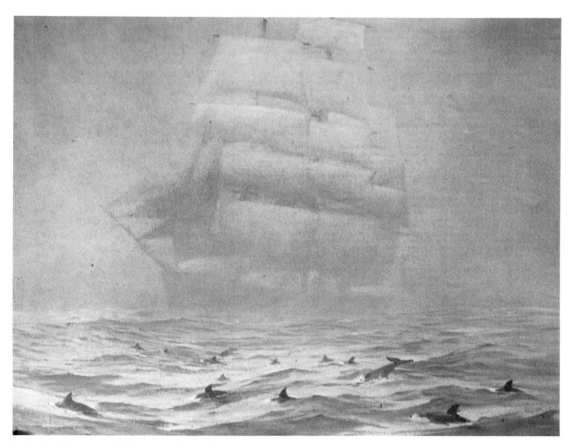

31. Sailing out of the morning mist.

was a very good player and for a long time maintained a standing offer of $5 to any boy who could beat him. None of them ever did, though some tried very hard from one year to the next. The adult games were equally competitive and Father's particular partner, Franklin Harris, was an even match. (Franklin Harris was a musician and composer who, with his wife and two sons, spent as many summers in Bushnellsville as we did*). The games were great fun to watch and often colourful to listen to. Once, aged about six, I came up from the tennis court and Mother asked how the game was going. "Oh", I replied, "Daddy says it's thirty-forty: Uncle Harry says it's thirty all, and then they both say 'Jesus Christ'!"

Perhaps my most nostalgic childhood memory of Bushnellsville is of going to bed out on the sleeping porch and listening to A.O.F. playing the piano down in the living room. There was a contentment I have never been able to recapture. He played often during the day, in between the daily round of painting, gardening, the newspaper, tennis and so on, but it was not like listening in my cot on the porch at night, with the stars overhead and the mountains close around: the undertone of the brook running in front of the house and the rustle of night sounds on the bank behind me. Perhaps it was that the only lullabies A.O.F. knew when I was a baby were the *andantes* from Beethoven sonatas but, equally I think, it was the harmony and wholeness of our life there together, expressed without words in the music.

It was an Utopian existence. Few things disturbed the tenor of the family life and, in retrospect, it seems perhaps a little odd that A.O.F. should have been so good at games, since those who do excel have usually started to get their hand in when very young, whereas he had had no opportunity for that, and time at sea certainly does not further skills in that direction. Of course, he was a very fit man and had an excellent eye. He also had various guns and used to go hunting† and take part in clay-pigeon shoots with great success.

On one occasion he let it be known that he was going to shave off his moustache and goatee, which he had worn since his Paris student days, but it was I, then aged six, who was so distraught at being faced by a stranger, and who wailed: "I want those whiskers back!", which led him to grow them again, and they remained with A.O.F. all the rest of his life. He was a blue-eyed man, of medium height and very well-built although, being broad-shouldered, later on in life gave the impression of being thick-set.

My brother David was not strong, but was fascinated by all games,

* Harris had studied music in Berlin and in Italy under Sqambati and Mascagni. He was a good tennis player—playing savagely while pouring a most imaginative invective on his opponents! Later, he joined the staff of Miami University where he became well-known, helping it through its early, more difficult years.

† Used in the American sense. In English 'shooting' (Ed.)

32. *A.O.F., Bushnellsville, 1919.*

especially boxing, and had formed a boxing club of the local boys. He even wrote to such celebrities as Jack Dempsey, Jim Corbett and Jim Jeffries for autographs, and usually got them! The French Revolution also held a particular fascination for him and A.O.F. made him a working model of a guillotine out of an old axe-head, which reposed on the centre of our dining-room table for a long while. The victims were items of fruit, which took on the representations first of characters who figured in the Revolution but, later, almost anyone to whom the Queen of Hearts might have said:– 'Off with his head!' Indeed, with some merriment, the persons named might equally have figured in Ko-Ko's list of society offenders . . . '. . who never would be missed' from *The Mikado*. (Gilbert and Sullivan figured in Father's repertoire along with Bach, Beethoven, Haydn and Mozart.)

David had suffered from endo-carditis since 1917. Modern drugs can cope with this heart condition, but that was not the case in those days and,

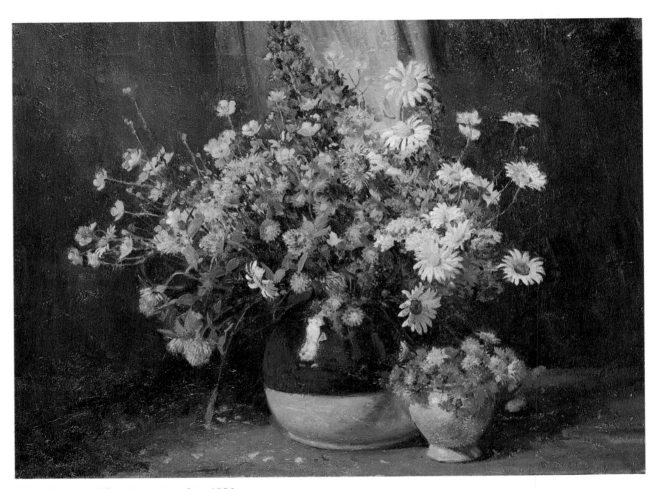

33. *Summer Flowers, painted in 1923.*

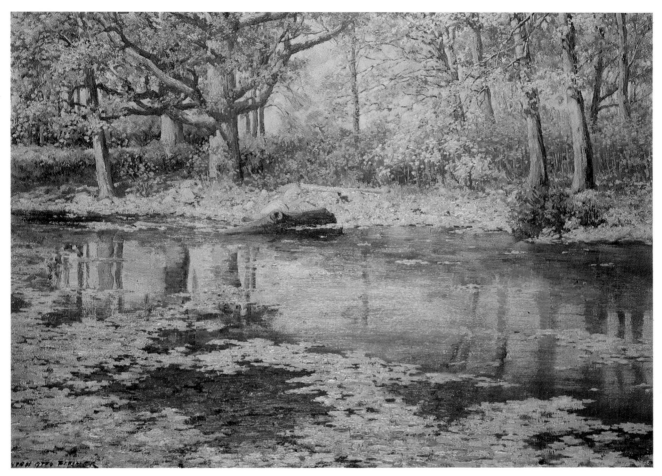

34. *Autumn Pond, Wilmington, 1921.*

by now, he was tending to become an invalid. Mainly for the benefit of his health, the family wintered in 1920-1 at Daytona Beach, Florida, in a cottage which faced right on to that incredible stretch of fine, white sand with, beyond it, the unbroken line of the ocean. This, of course, was before it became a motor-racing track. A.O.F. used one room as a studio, carrying on with his illustrating work and painting sea- and sky-scapes, and he also spent a good deal of time fishing from the docks and pier, keeping the family well supplied with fish. The next year, again to find a mild climate for my brother, we went to Wilmington, Delaware, but the following summer David died. Oddly enough, in view of his pre-occupation with the French Revolution, before his death, which actually occurred on Bastille Day, he kept asking about the sounds of gunfire which he alone was hearing.

During this period my father had sent a certain number of his pictures into exhibitions in various places with great success. However, he gradually gave up exhibitions almost entirely. Perhaps this may have been a pity in some sense, but there were probably three contributary and overlapping reasons. First, at this period, he was kept very busy with his illustrations: secondly, in those days he was pre-occupied with all that country living entailed and in his garden; his games, his shooting and so forth also took quite a lot of his time, and last but by no means least, because, in living at Bushnellsville, he had isolated himself from the so-called 'Art' world, and thus he let it pass him by. Years later, his landscapes which were done for pleasure were so popular that he did a number of them purely to satisfy the demand. Although the greater part of his marine work was done for illustrating purposes, he was given a pretty free hand with the composition: the editors requesting only 'A Fischer Marine'. In fact, there was no discernible difference between those which he produced in this wise and those which he would have done for his own pleasure or if he had produced them for exhibition. This enforces the point, made previously, that the difference between the top illustrators and artists is purely illusory. The fact was that the work came to him—it was not a matter of having to create it. In fact, all his life he would say that he had not the time to paint, meaning that he had not the time to paint on his own account but, when he did, it made no odds whatever, since the results were precisely the same.

The great disadvantage of illustrating was that he tended to find long serials—often pounced upon eagerly by millions each issue—to be tiresome.

Indeed, when *Tug-Boat Annie* was at her peak in the thirties, a certain gloom settled over our household when another manuscript about her arrived in the post.

In the autumn of 1923 it was felt that I should start a formal education and the family rented a house at Kingston, N.Y., about thirty miles from Shandaken, for the winter. This was a small city of considerable colonial charm, originally settled by the Dutch in the seventeenth century and, in the following winter, the family bought a house there, wintering in Kingston for the next twelve years and moving the studio back and forth twice a year between there and Bushnellsville in a removal van. A.O.F. joined the Kingston Club, mainly composed of local professional and business men, and spent many evenings there playing cards. He was an excellent and keen player, thereby keeping the house full of flowers either from his winnings as a matter of conscience, or because the local florist was a less successful player! He also joined the Mendelssohn Club—a men's choral group whose annual concerts were gala events and, at the same time, he joined the golf club.

A.O.F. never excelled at golf, though it stood him in good stead when he became too old to play tennis, and there was a family bonus in the opportunity it provided to keep an eye on the mushrooms off the fairway! (Certainly he was often up with the lark to gather them in season!) His family; painting of course: the good earth, games and music were the driving forces in his life and, as to the latter, we made good friends in Kingston with a musical family named Knauth, and many evenings were spent with them 'making music'. Eduard Hermann, an eminent violinist in his younger days, was a frequent houseguest at the Knauths (Plate 56).

The 1925-6 winter was a memorable one, since we were offered a house at Coconut Grove, Florida, about five miles south of Miami, by friends— the Fairchilds. They travelled a good deal and were going to Java. Marion Fairchild was the daughter of Alexander Graham Bell, the inventor, and a cousin of Balfour Ker, my mother's first husband. Her husband, David, was a naturalist who was in charge of plant importation to the United States and he had used the grounds of The Kampong, as his home was called, for experiments in plant introduction. It was a sort of botanical wonderland, rampant with exotic varieties from all over the world.*

Once, while A.O.F. and I were fishing from the inlet which came in from Biscayne Bay at the foot of The Kampong, I hooked a moray eel. At the time we did not realise just what this vicious and venomous creature

* Fairchild's fascinating story is written in his autobiography *The world was my garden.*

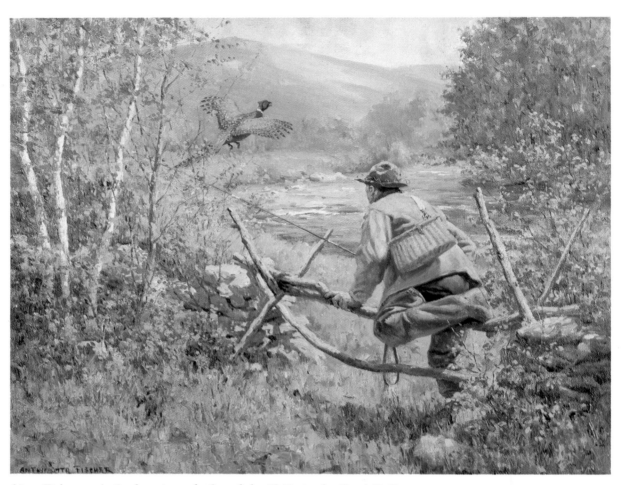

35. *Fisherman's Luck – A pot-boiler of the 1940s in the Catskill Country.*

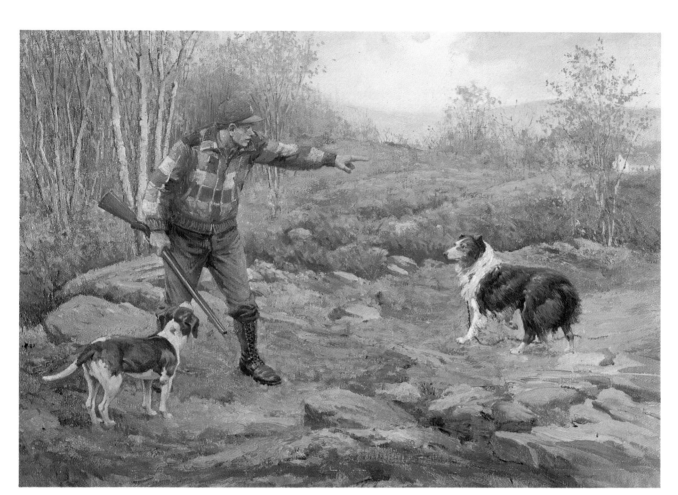

36. *Every Dog has his day. (A.O.F. could paint canine emotions no less than those of humans.)*

was, but soon had the sense to cut the line and to get rid of it!

The following summer we rented a cottage at Ogunquit, Maine, so that my father could paint there, and he was fascinated by the restless and often furious activity of the sea about that rock-bound coast. He produced many seascapes that summer and was painting the Maine coast from memory for years afterwards, though unaccountably neither my mother nor I could ever persuade him to go back alone to paint the Maine coast in after years. On that holiday, he entered a local tennis competition and, reaching the finals, defeated the local champion despite a grandstand filled with elegant supporters of the champion and ill-fitting new tennis shoes forcing him to finish the match bare-foot. On his side were only my mother and myself with two girls who were evidently tender-hearted.

No book could cope with A.O.F's output in all these years. Perhaps the ensuing section, of his paintings, may be deemed to be reasonably representative of some aspects of it. Like many illustrators, he had an amusing habit of posing for his own pictures, with my mother or myself taking the photographs. Once, on a boiling day, he wanted a boatload of sailors with a shark playing around, and he posed for everything but the shark—wearing oilskins and finally emerging at the end of the session more like a grease-spot! In the same way he posed for *all* the characters in the second *Burial at Sea* (Plate 106). My father was generally in such a state for the twenty four hours until the photographs were returned that it was very difficult to live with him! He did not copy these photographs, but used them as a check on positions, falls of light and the way the clothes creased, and so on. First he would lay in the outlines in charcoal, and he always painted the sea last in one sitting—'to keep it moving'. Due to the difficulty of obtaining skilled models, he continued this practice of being his own perhaps longer than he should have done. As his figure aged, so did the figures of his men!

By this time the inter-war depression was in full swing, but it was a time of great professional prosperity for A.O.F. and, since the family life-style did not change with the increased revenue, he made a number of investments on the stock market which all provided him with a comfortable income in his old age. He subscribed to investment services, though often went against their advice and backed his hunches. (Only once, as I remember, did he blunder badly. In the late twenties, he invested $10,000 through a friend of Franklin Harris in the so-called 'Florida Boom', and the 'friend' turned out to be a swindler.)

37. As Glencannon.

38. Falling.

A few photographs of A.O.F. posing as his own model.

39. 'Tug-Boat Otto' (For Tug-
 Boat Annie).

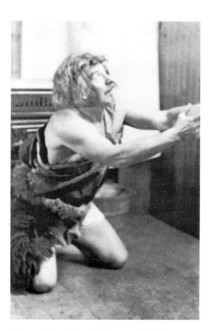

40. For Ben Gunn, in Treasure
 Island.

41. With the author.

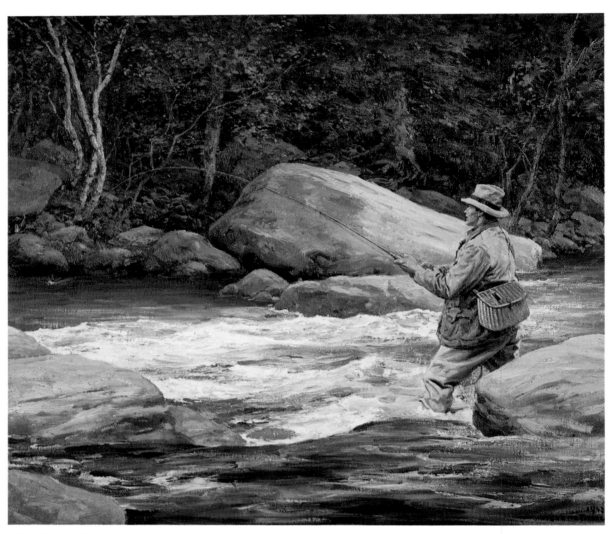

42. *Trout Fisherman working a pool. Painted in 1944.*

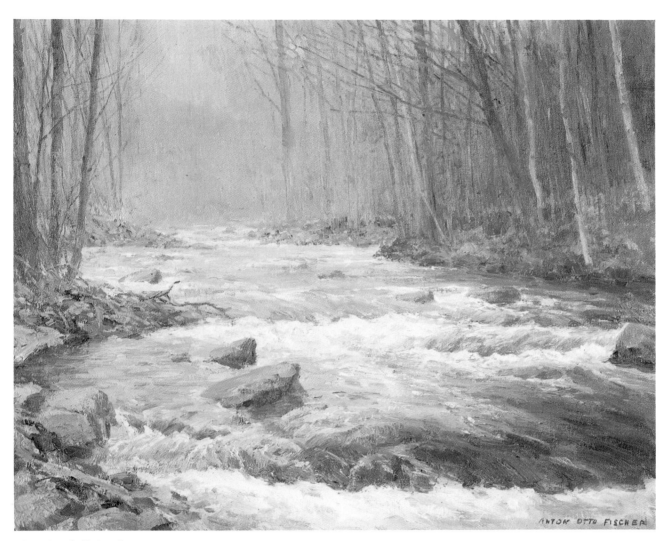

43. *Sawkill Creek, 1952*

In June, 1930, he went to New York to see the Jack Sharkey-Max Schmeling heavyweight fight at Madison Square Garden. Oddly, perhaps, it was the only time he ever did so, though he always listened to such contests on the radio. Neither my mother nor I shared his enthusiasm for sports but, in the last year of his life when his health was failing and even listening to the broadcasts was too exciting, I would listen in the kitchen and come out between rounds to give him a 'calmed-down' résumé of events!

In 1930 there started in the *Saturday Evening Post* the series of Glencannon stories by Guy Gilpatric, about a somewhat inebriate and reprobate ship's engineer, and these continued for years, followed in 1931 by the famous *Tug-Boat Annie* stories by Norman Reilly Raine. At the same time there were more and more advertising commissions coming my father's way and, although these were extremely remunerative—I think he was often paid $1000 or more for each painting—they were frustrating and not really the sort of work he enjoyed at all. This is one of the penalties of illustrating and doing commercial work, as distinct from working as an artist on speculation. I recall a whole series which he did for the A. & P. (The Great Atlantic and Pacific Tea Company), which called for a series of paintings showing the sources of various comestibles which they marketed— coffee, tea, eggs, oranges, canned salmon and the like. It involved much quibbling about detail, and the egg painting came back three times to achieve the Company's own particular vision of chicken wire!

It was in this year that Arthur Brisbane of the *New York Journal* approached Mother about working for them again, and she did a certain amount of cartooning for the *Advice to the Lovelorn* column but, after a couple of years, she tired of commuting to New York and, the incentive to earn a living being no longer there, she gave it up once more. However, she did produce the odd painting, working under her maiden name and, for the December 22nd 1934 issue, the *Saturday Evening Post* used her *The Christmas Mouse** for their holiday cover. Mother was extremely pleased with herself to have penetrated, on her own, what had seemed to be A.O.F's exclusive territory!

My parents had given me a Ford convertible as a graduation present in 1932. It was one of the happier Ford models and so dashing that I christened it the *Lesotto,* which was actually a contraction of 'lesser Otto', but a name often confounding the uninitiated, who thought it must be some unknown and exclusive make! In 1934 we all three made the trip to

* Plate 46.

44. 45.

A.O.F. posing for fishing photos.

Europe in the Nord Deutscher Lloyd liner *Europa,* taking the *Lesotto* with us. I had elected to spend a year in Germany instead of continuing in College, and my parents decided to accompany me to Europe and to re-trace A.O.F's childhood with the car.

It was the first time that A.O.F. had been back to Germany since signing on the *Gwydyr Castle* in 1901, and he found that he had virtually forgotten all his German, so our initial hours were fairly hilarious. The first necessity was to get some fuel for the car but, when the attendant approached, A.O.F. looked distinctly unhappy and finally blurted out:– "Fullen sie the damn thing auf". (Fill the damn thing up.)

After a few days of *faux pas,* his German re-asserted itself, which was just as well, as Mother's was non-existent and mine still much of the student's variety. We made leisurely progress down the Rhine through an enchanting countryside which was new to all of us and into Bavaria. Kloster Indersdorf, the orphan asylum where A.O.F. had been from 1887

46. *Christmas Mouse. (By my mother, c.f. p. 66).*

47. The courtyard of Kloster Indersdorf.

till 1894, was out in the country near Dachau, some 30 kilometres from Munich, and there we found the sisters very cordial and anxious to show us round the whole establishment. A.O.F. found remarkably little change. Indeed, to both my mother and myself, it seemed that there could have been little change in centuries unless that the hollows worn in the great stone stairway might have gradually increased. It did seem that the boys now had individual toothbrushes, towels and face-flannels—toothbrushes had been non-existent in his day. His favourite sister, Arcadia, was now the prioress but, although she sent messages of goodwill, she was unfortunately indisposed.

On the way to Regensburg we visited Kloster Scheyern, the Benedictine Monastery where A.O.F. had spent two years studying for the priesthood. The two monks he remembered best—Pater Anselm and Pater Ulrich—were still there and remembered him equally well. Indeed, they knew something of his career, as one of his contemporaries was now a priest in Philadelphia

48. At Kloster Scheyern.

and had sent them clippings at intervals. Here, too, we were shown all
round, even being shown the study hall seat at which he had sat—in direct
line with the peep-hole through which the monks could keep an eye on the
boys!

Both Scheyern and Indersdorf were self-contained units with a butcher's
shop, bakery, dairy, cobbler, brewery and so forth (which served the
surrounding country besides the Klosters), all grouped round a central
courtyard. Before leaving Scheyern, the Fathers insisted that we be
refreshed with the black bread of A.O.F's child-hood but I, fresh from my
first experience of a Bavarian chapel with its saintly relics, did not relish the
bread's mustiness at the time, though I came to appreciate it later on.

In Regensburg we drove down into the oldest part of the town,
clustered on the right bank of the Danube, and parked the car near the
12th century stone bridge off which A.O.F. had jumped in 1898 in his
successful, if ill-considered, attempt to secure his freedom. The Danube is

49. The Fidelgasse.

narrow and swift at that point, and it was not hard to imagine that he got more than he bargained for in that current in the middle of winter.

We set out on foot (the only way possible) to search the mediaeval tangle of alleys for the Fidelgasse: the one in which A.O.F's guardian uncle and hated aunt had lived when he was their unwelcome charge from 1896-8. There was a timeless immutability everywhere and we found the Fidelgasse just as he had left it. It ran down towards the Danube and was such a narrow alley that, with outstretched arms, one could touch the walls on both sides in some places. There was no dearth of the curious from whom to enquire, and we were told that the Kandlbinders had lived at 31A, a doorway a short way in, but that the uncle was no longer living and that his wife, now a very elderly woman, was residing with relatives further along the alley. My father had no desire to pursue her further, so we went back to the car and proceeded across the Danube and out into the country to track down Asang, the village that was the 'ancestral' home of the

50. The Kandlbinder homestead at Asang.

Kandlbinders and where A.O.F's mother had been born and whither she had returned to die.

Asang was such a tiny village that it was not even on our map and the local inhabitants along the way, of whom we asked directions, were so dumbfounded by the car and its occupants, in addition to their dialect being so broad that even A.O.F. could understand little of it, were not of much help. We found it, nevertheless, and the house, still with its stable attached and with a large pile of manure in the front yard (a sign of Bauern prosperity). Only a little man with a decided limp, of about my father's age, was at home, and A.O.F. remembered that, although the family wanted none of him, at about the same time they had taken a crippled child to live with them. The family had greatly opposed A.O.F's mother marrying his father for the reasons already stated, and they never forgave her. Although they had let her come home to die, they had laid her out in the stable—(A.O.F. remembered the rabbits in the hay better

than he did his mother's corpse)—and wanted nothing to do with her children.

The little cripple was much excited when A.O.F. identified himself and immediately set off to fetch the old uncle who was playing skat* with some cronies somewhere in the neighbourhood. He looked like a romantic old brigand when he arrived: lean, with strong features and a large gold earring in one ear which was doubtless a fetish against some evil, but most effective as a decoration.

We were conducted into the spotlessly clean main room which was obviously not only where they lived, but where the tailoring was done. (I think the crippled foster-son was the one doing that by then.) There were a number of long tables of unfinished wood, like the floor, all scrubbed and sanded within an inch of their lives! The benches along the walls soon began to fill up with curious neighbours, for it was incredible how quickly news of our presence always spread. We all just sat for the most part, and looked at one another, as the uncle's dialect was on a par with that we had encountered on the way, so little conversation was possible. The uncle did manage to imply, looking the while out of the window towards the car, that it must have cost as much to bring it along as to buy a whole farm!

The one who was really thrilled and excited to see us was the cripple, and he insisted on accompanying us back to Regensburg to show us the things along the way that we should properly see. These consisted mainly of the graves of assorted kith and kin. The mother's grave was long since gone, but he was indefatigable in ferreting out from the sacristan where it *had* been. In Regensburg he pointed with pride to the prosperous brewery where the guardian uncle had been Brewmaster. Our eager and dedicated guide had obviously become a real member of the family and he left no stone unturned. Ample reward for all this time and effort was, I know, the ride in the *Lesotto.* It was patently the thrill of a lifetime for him.

We had been informed that the widow of the third uncle, who had been Brewmaster of the *Spatenbräu* in Munich, was still living there, so on our return we paid her a visit. Here we found very different people: comfortable German burghers of sufficient urbanity to bridge the gap between us. We were welcomed most hospitably and soon one of the younger members of the family was sent out to a nearby *Spatenbräu 'Ausschenk'* (retail dispensary—they were not exactly 'pubs') to have pitchers filled with beer and to bring back hot *Leberkäs.*† The old aunt had lifetime privileges at the *Spatenbräu,* and it seemed that our visit had coincided with

* A card game. † Liver-cheese—a Munich speciality, more like meat-loaf than sausage.

the proper moment to obtain the *Leberkäs* hot from the brewery dispensary. When we left, I was extended a cordial invitation to call again, though I do not recall that I ever did so.

During the month my parents were in Germany, we covered most of Bavaria and A.O.F. saw more of it than he had ever done before. It was a lovely land from which to have sprung, with its great rolling countryside of well-tended fields and forested hills, punctuated at frequent intervals by tiny, fairy-tale villages.

We branched as far down as Oberammergau to see the Passion Play which was being presented that year, and up to Bayreuth to attend a performance at the Wagner festival. One thing we did *not* do was to pay a visit to my father's sister.

He had heard from her in 1920, after an interval of five years due to the war. She was the only relative with whom he was on any terms, and was living in Zürich where her husband had worked before the war, from which he had emerged unscathed. Thus she wrote full of joy.

Why we did not visit her defies rational explanation, unless it is the simple one that A.O.F. did not want to do so. Later on, when I visited her myself, he was delighted, but he apparently wanted no part himself of rousing such a remote connection. If my mother and I had realised at the time that he had kept in touch with her to a certain extent until the early twenties, we should have insisted that he go to Zürich to see her. But we did not know, and we did not go. Oddly, my mother and I were both under the impression that A.O.F. knew nothing about her, except that she had married a man named Oskar Lindner, a goldsmith, and that they were last known to be living in Zürich. Why Mother knew so little I never fathomed: perhaps it was the language barrier, since such correspondence as there had been would have been in German. Maybe, having let the correspondence lapse, A.O.F. had a guilty conscience, which always made him evasive. At all events, he had effectively closed his sister out of his life, and she no longer existed for him. My parents sailed for home on August 31st and never visited Europe again.

For the record, I did visit *Tante* Julie on my way to Venice the following spring and established a lasting friendship. She and her husband, a genial man whom one liked on sight, were tremendously pleased to see me. It seemed she had always regretted that my father had dropped the correspondence. She looked on him throughout as some sort of a fairy-tale brother, and had longed to introduce him to her husband. The Lindners

51. *Julie and Oskar Lindner.*

had a lovely apartment overlooking the Wesendonk Park in Zürich—(they had taken out Swiss papers). They were both extremely fit and seemed much younger than their actual late forties, due partly, I am sure, to consciously keeping in trim all the year long for their winter ski-ing holiday. However, when my aunt heard that A.O.F. had been in Germany the previous summer and not even given her the chance to come and see him, she sent him a letter full of reproach. This was hardly calculated to produce a spirit of penitence in her brother and they never did meet again, although I visited them whenever I was in Europe and corresponded with them until the end of their lives.

The winter of 1935-6 we spent once again in Coconut Grove, this time renting a house (with a studio, since A.O.F's work followed him wherever he went). He held a one-man exhibition there—his first and last! It was quite successful, although Miami was no area for anything serious in the way of art, and I recall the number of times I was asked if they were

'hand-painted' pictures! A.O.F. made a trip to Nassau at this time, hoping for subjects to paint, but the colours of the Bahama waters defied all his sense of reality.

The following two winters were spent at Key West, which is the last of a chain of keys stretching south-west from the tip of Florida and into the Gulf of Mexico and boasts the southernmost house in the United States. At this time the city was a ghost town. The cigar and sponge-fishing industries had moved away, leaving about 8,000 people—mostly 'Conchs*, Coons and Cubans'—in what had once been a city of some 40,000 souls. A.O.F. loved Key West and, in a letter to me, wrote:–

> 'Mother is after me all the time to paint this water and these skies . . .
> Mixing illustration and painting is rather difficult. One is the means of making a living and with the other you just invite your soul, or express yourself or your sub-conscious, or what have you. Anyway, it is in the luxury class with me. I must admit, though, that I wouldn't like anything better than to have the leisure to explore this painter's gold-mine. There is the water and the marvellous skies: the waterfront and the fishermen: the back-alleys in the Cuban and Boogie quarters; there are those incredible types of humanity along the water-front and the old niggers and all those pretty Cuban children and girls. There is enough to last a painter a life-time. All it needs is the will and some way to make your living. It really narrows down to the last, anyway.'

The truth of the matter was that A.O.F. tended to 'play safe' financially all his life—possibly as a result of his childhood—but the response to his marine paintings should have convinced him that he could have thrown illustration to the winds and taken up the role of a conventional artist any time he wished. Had he done so, his overall results might have been finer still, since there is much to be said for an artist painting *his* ideas rather than those of someone else, and the results are generally better.

In Key West there was a certain amount of winter tourism—mostly the retired and idle—and a small colony of artists and craftsmen. It was a most picturesque place with a distinctly Cuban atmosphere and the abandoned houses completely taken over by bougainvillaea, the whole surrounded on all sides by water of astonishing brilliance.

A.O.F. found the inevitable social calendar rather trying. There were constant cocktail parties, dinners and artistic soirées. He found it

* Poorer and lower-class inhabitants of the Bahamas, so-called since they were prone to eat the conch varieties of mussels.

52. *A.O.F. in 1928.*

impossible to keep himself clear of all these 'entanglements' as he termed them. Once he heard a Frenchman speaking on modern art and he wrote to me:–

> 'They all, and more than half the people there, were parlour communists, and that always prejudices me right away. I respect the communist who wants to change things because he has been a victim of capitalism, but not the parlour kind, who are radical because it is the fashion in literary or artistic circles. They have not much in rebuttal when I advance the opinion that undoubtedly a free society is possible only under democracy, but a well-ordered society demands a totalitarian set-up like Germany or Italy has. Liberty and freedom, as we know them, would perforce be curtailed under a Nazi or Facist régime. That is the price society pays for a system in which the whole economic set-up is run by the state, where capitalism cannot exploit labour and where everyone gets a share of the National wealth. Freedom of speech, which means, in that case, criticism of the state, doesn't exist then because the powers that be won't tolerate what they consider to be sabotage of their plan. Another thing they don't seem to visualise in their eulogies about the communist state so fervently wished for, is the fact that Communism—as well as National Socialism or Fascism—inevitably means dictatorship. They just don't think the thing through and they make me tired.'
>
> 'The Trevor affair was in a way a literary cocktail party. Most of the guests were newspaper publishers from Georgia and Kentucky and Hemingway was there too. It was the first time I had met him. I didn't get much of a chance to talk to him, and perhaps it was just as well, as we are at opposite ends of the pole on all modern questions. He hates Hitler and Mussolini. I see, at least, what they have accomplished in spite of their mistakes. He likes the Loyalists in Spain, and I am all for Franco. He is a Communist, or sympathiser at least, and I am frankly not. He is a brilliant writer, though, just the same. He is a big fellow with shoulders broad as a barn door. . . .'

The above is the merest excerpt of a typical letter I would often recive from my father. He was a most faithful correspondent when parted from any of his family.

Hemingway had a home in Key West quite close to us, but was then in one of his brawling periods and spent much of his time being thrown out of the local 'Sloppy Joe's'. However, we were on very friendly terms with his younger brother, Leslie, and his wife Patsy, who were part of the set of young people with whom I associated.

Perhaps A.O.F's apparently broad-minded comments about Hitler and Mussolini need some clarification. He felt that Hitler was the logical product of all that the League of Nations tried to do to Germany after

World War I. In addition, the atrocity stories turned out by the propaganda mills in that war were still fresh in his mind and he simply did not believe the Jewish horror stories until considerably later, when he amended his opinions radically.

Despite all efforts to prevent it, a State Highway had been driven through the Bushnellsville Valley in 1938—a wide, ruthlessly straight track designed to be a short-cut for heavy commercial traffic on its way to New York City. Its construction devasted the valley and so we decided to move. After considering quite different areas, we settled again in the Catskill Mountains and bought a home in Woodstock, New York, an art colony about twenty five miles away.

The new house needed a certain amount of alteration, so we spent a last winter at Shandaken. It proved to be a memorable one, with magical, record-breaking falls of snow that transformed the valley into the fairyland it had been before the planners drove a State Highway through it. We therefore moved to Woodstock in June of 1940. It was a lovely spot in its own right, though very different from Shandaken.

Situated in one of the broad Hudson River valleys it lay at the foot of a large and imposing mountain which dominated the valley and was appropriately called Overlook. Originally Woodstock had been a quiet farming community with side occupations such as bluestone quarrying, which had provided most of the side-walks* to New York City. In the early days of the century, a wealthy Englishman named Ralph Radcliffe White-head, who was a friend of Ruskin and William Morris, had chosen Woodstock as the place in which to found a colony of artists and craftsmen dedicated to working in harmony with nature. This grandiose idea, like so many of the same sort, was never fulfilled, but Woodstock *did* remain an art colony.

At the time we moved there, the wintertime population was about 500, which increased in the summer to 1500 or more. (Nowadays the range is more like 1500 to 5000!). Many well-known writers, painters and mus-icians, as well as people prominent in other fields, made their homes in Woodstock and in the summer it bustled with the added activity of a resort. Much of a cultural nature went on, besides certain Bohemian activities.

We already had friends there and soon settled in and became an integral part of the community. My mother became involved with the Woodstock Guild of Craftsmen and the Library, and I made friends with the local chamber music group. A.O.F. was welcomed in golfing and

* Called 'pavements' in England. (Ed.)

bridge-playing circles. He also started to transform the new grounds into a garden show spot. We had only had about three and a half acres at Shandaken, most of which was almost perpendicular, but now, in Woodstock, there were some thirty acres of which, fortunately, about twenty five were woodland. The other five was an immediate challenge. Quite apart from the possibilities of shrubs and flowers, a vegetable garden expanded into a means of feeding us all around the year, taken in conjunction with my own canning and freezing activities in the kitchen. In a good year there was sometimes half a hundredweight of *shelled* green peas, my father doing more than his share of shelling when there was a ball game being broadcast on the radio!

Oddly, perhaps, the place where A.O.F. was *not* warmly welcomed was the Woodstock Artists Association. Painting in Woodstock tended towards the ultra-modern and he found little common ground on which to meet them. This lack of appreciation was mutual. Many of the artists were undergoing the financial struggle common to 'painters', and A.O.F's success in this direction branded him—doubtless with a measure of sour grapes, albeit with a measure of truth—as a 'commercial artist'. The situation was not improved by the fact that, during the W.P.A. (the federal assistance Works Project Administration which helped many of the Woodstock artists over the worst of the depression) A.O.F. had been asked by the town fathers of Kingston to make a choice of W.P.A. paintings to be hung in municipal buildings. Woodstock artists had not liked a commercial artist sitting in judgement on their work. In any event, when we first moved to Woodstock, A.O.F. submitted paintings to the shows at the local gallery but they were always rejected and he stopped sending them. 'A prophet is not without honour, save in his own country.'

During this year and the next A.O.F. was not only producing his usual illustrations, but working on the oils (illustrated in this volume) for his projected book, *Foc's'le Days,* about his time in the *Gwydyr Castle* and, in addition, was working on propaganda war posters for the Government. When these appeared, they had a dramatic and powerful effect on the people. Then, in August 1942, he was asked by the U.S. Coast Guard to accept a commission as Lieutenent-Commander to serve as 'artist laureate' and act as an official war artist.

At almost the same time, my mother was asked by the Secretary of the Navy, Frank Knox, to sponsor the destroyer *Sigsbee,* named in honour of her father, Admiral Charles D. Sigsbee, which was to be launched at

53. *The Fischers' house at Woodstock.*

Kearney, N.J. on the anniversary of Pearl Harbour (December 7th.). (Since there seems to be some difference in terminology about the word 'sponsor' in this context, British readers should note that this did not mean that she was expected to finance the vessel, but merely to christen her!)

Naturally, in war-time, all information of this sort was being kept quiet, and an incident which occurred the following month is best prefaced by an extract from a letter Mother wrote to a namesake niece in Washington. This niece was married to a Colonel then stationed with the Marine Corps in Samoa. She wrote:–

'. . . What do you hear from Lester? Or can't you hear? Samoa seems to be mentioned so seldom—for which we are profoundly thankful. I do so wish that sometimes I could talk to someone who had a realistic point of view on this sort of thing. Here, in Woodstock, the patriotism is of the 200% variety—people falling all over themselves at war-work (much of it utterly unintelligent) and burning to express a patriotism that has a large mixture of unconscious

egotism. Since I agree with Edith Cavell* that 'patriotism is not enough'—I don't find much in common with my fellow townspeople.'

This was part of her view, and it was only a year previously, when my mother had been visiting in Washington, that I find Father writing to her:–

> ' . . . I . . . came to the conclusion that so long as men think along material lines only, they'll fail. More and more I become convinced that spiritual regeneration ought to be the ground-work, for without real compassion and sympathy, any economic changes (and, God knows, the world needs them) will be accomplished in a spirit of hate, distrust and envy and inevitably breed an organised violent opposition, even if it is forced underground.'

However, in war-time a dispassionate viewpoint is not often to be found, and it happened that two very dedicated and zealous women had taken over the observation post in Woodstock, and made it a very efficiently organised part of the local Civilian Defence. The post was manned round the clock in four-hour shifts, men being asked to take the night-time watches. A.O.F. said that he could not possibly do this and work the next day. His war-time posters had not, at that time, appeared in the Woodstock Post Office, and the general feeling locally about his war effort was that he stayed in his rose-garden and gave cheques to people when asked. The two observation post ladies did not take kindly to Father's refusal to man the post.

Then, one day in September, a West Point station waggon drove into our yard and two army officers stepped out, followed by these two women. It seemed that the officers wanted to speak to A.O.F. and they were asked in, the two women 'preferring' to stay outside. It then transpired that A.O.F. had been reported as a 'suspicious' person and that the army had been asked to investigate him!! It only took a few minutes for the officers to realise that they had been led along a wild-goose chase and, as A.O.F. was able to impart to them the still confidential news of his commission with the U.S. Coast Guard and of his wife's sponsorship of the *Sigsbee,* the gathering grew friendlier and friendlier. As they emerged, to the astonishment of the two women, to whom the confidential information could not be imparted, the officers accompanied Father to his studio, while Mother and I did our best to meet the social demands arising from the continuing presence of the now thoroughly bewildered ladies, who had to be left with their mystification!

* British nurse executed by the Germans in the First World War.

54. *At the launch of the U.S.S. SIGSBEE, Kearny, N.J. Dec. 7th 1942. Front Row: Mrs. Robert T. Small, younger sister of Mrs. Anton Otto Fischer who is next to her (centre) and A.O.F. Back Row: Winifred Haile (daughter of Eugen Haile, the crippled musician Pl. 55) : Mrs. Edward Schofield, the author, Mrs. Charles D. Sigsbee (wife of Admiral Sigsbee's son) and Edward D. Schofield. The Schofields were great friends.)*

Possibly that afternoon was not altogether a surprise since, when A.O.F. had been at the U.S.C.G. head-quarters, he had been asked: "What kind of a place is Woodstock?" and was shown letters from the most surprising people who had written to the government to report him as a 'suspicious person'. There is a lot of surplus mental energy running loose in Art colonies, and some of it gets channelled into strange courses. It is perhaps significant that the real 'local' element in Woodstock—the natives—always thought A.O.F. to be a grand man both as a person and as a painter as, in fact, had been the case in both Kingston and Shandaken.

No doubt the ladies of the observation post came to rue their zeal when they read the splash of press coverage about A.O.F's commission and when the *Sigsbee* was launched. One photo of the ship going down her ways was captioned:– "'We avenged the *Maine*: now we are avenging Pearl Harbour!' cried Mrs. Anton Otto Fischer as she launched the destroyer *Sigsbee* " Actually, Mother said nothing of the sort, but it probably

55. *Eugen Haile.*

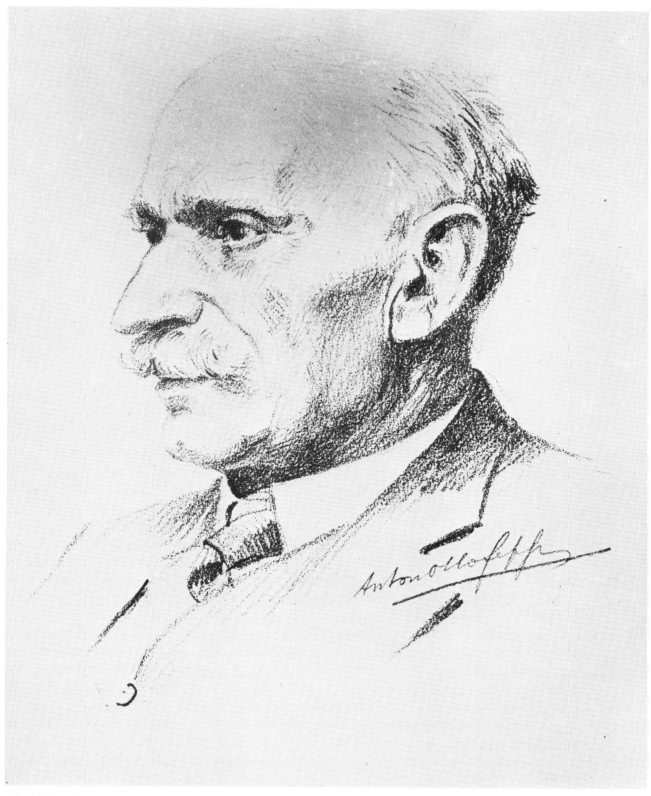

56. *Eduard Hermann.*

made good reporting! The papers not only gave a résumé of her father's career: how he had previously served under Admiral Farragut at the age of 18 in the Civil War: how he had been captain of the *Maine* when she blew up in Havana Harbour; his promotions: how, in 1905, when in command of the battleship *Brooklyn*, he had brought the remains of John Paul Jones from Paris to their final resting place in the Naval Academy, and so on. Then the press expatiated on A.O.F's new appointment and I quote from the initial letter sent to him:–

> ' . . the Coast Guard, as well as, I imagine, all sailormen, regard you as the outstanding artist of the day, with the rare advantage of intimate knowledge of your subject, the Merchant Marine. The Commandant's desire was to tender you a commission in the Coast-Guard which would involve neither duties nor compensation (unless you desired otherwise) but which would afford you complete access to any and all Coast Guard activities, ashore or afloat. I know he feels that it would be a distinct feather in the cap of the Coast Guard if you would accept such a position.'

It was, of course, known that A.O.F. had opted for the active role.

In the event, he made only the one cruise, and left home for an 'unknown destination' on January 10th, 1943. In fact, he went to Boston, and was there assigned to the U.S.C.G. cutter *Campbell*. The cruise turned out to be both exciting and first-class initiation into all the sheer beastliness of the North Atlantic convoys in winter-time. He kept a log of the trip, but much of this is personal and, as for his sketches, unlike many artists, his were the roughest form of composition reminders, and are scarcely worth the reproduction. It is a never-ceasing source of wonder that they were the bones of such powerful and accurate paintings, but it is unquestionable that he had a computer-like memory. Although the cruise was relatively short, it bore such artistic fruit that it is worth relating, and the following account is a summary of his log, although certain incidents will be related more fully in connection with the reproductions of the pictures which they inspired when the convoy paintings are dealt with later in this volume.

There is little doubt that A.O.F. was enabled to experience the Western Ocean—and its convoys—in its more dramatic moods. He joined the *Campbell* in Boston where she was lying with her sister-ship, the *Spencer,* and near the big battle-waggon *Massachusetts* which had just returned from

Africa after collecting a nine-inch shell in her superstructure. He himself berthed aft with the doctor, who was making his first trip to sea, and found himself not only one of the senior officers aboard, but old enough to be the father of any of them! He said that he felt more like the grand-father of some of the youngsters who had just come from the Coast Guard Academy at New London, and the captain, an Irishman named Hershfield, was only forty three. A.O.F. at this time was sixty.

On his first night aboard he found himself the senior officer in the mess, and thus had to take the head of the table and to do the honours— an undertaking which he managed quite successfully to his surprise and pleasure. (It was a little unexpected and he was not, of course, entirely familiar with quasi-naval procedure of this sort.). Also on board was a young man named Wilcox who was on his way to Africa and was then the war-editor of *Life* Magazine.

The first day or so was complete bedlam, with the ship fuelling, storing, and with the noise of the pneumatic riveters of the workmen and this, combined with the heavy menus, so much at variance with the balanced diet and preponderance of salad to which he had been used, had a dire effect on him. One good reason for not retailing his diary verbatim lies in the constant reference to his constipation!*

However, his age made no odds with his shipmates and his reputation with *Glencannon* was sufficient to make him *persona grata* but, apart from that, he was soon found to be an asset in the bridge and poker schools, and it seems that he and the other officers held each other in mutual esteem. He joined the ship on January 13th, 1943, and she sailed for Newfoundland early on the 16th with the *Spencer*: the two ships keeping close company, but they ran into real wintry weather on the Grand Banks with a cold wind, bad visibility and, often enough, snow flurries. Often they could not see the *Spencer* at all. The diary starts on this day with notes for pictures accompanied by very rough outlines. The notes are equally meagre, and it might seem astonishingly sparse to a layman when he looks at the finished canvas, completed long afterwards. For instance one, which is not reproduced here, reads:– 'Officers on bridge with glasses, one with earphones talking to gun crew, which is on the alert—fog and gulls flying around.' This is followed by comments on the costumes worn, which he found picturesque—the parkas with hoods: sheepskin-lined coats, blue zipper shirts, mufflers, watch-caps, fur caps, trousers of all descriptions, salt-caked arctics, rubber boots, fur-lined boots—any combination is

* As a result of an operation, badly executed, soon after he had left the *Gwydyr Castle,* this sort of condition was anathema to him.

possible. Officers may wear their caps, khaki-covered. Then we proceed to the menu for the day, followed merely by one word—'Whew!!' which completes the entry.

After a bitterly cold and rough night, the two ships arrived in Argentia, in Little Placentia Bay at the southern tip of Newfoundland*. However, they left at 5.0 p.m. to pick up the convoy which they were to escort. It was rated as a fast one and, with a following wind, was making good progress, so the two cutters raced towards it at full speed in a glorious evening with an almost tropical sunset, which was followed by a perfectly mild and moonlit night.

At 3.0 a.m. A.O.F. woke and secured himself in his bunk as the ship was by then rolling and pitching abominably, and it was bitterly cold with a north-east wind. A big sea was making up and the ship was caught in snow squalls, the bow diving into the seas and the No. 1 5-inch gun was already iced up and out of commission. In due course, around noon, the convoy was sighted, and he was thrilled by the sight: fifty nine merchant ships with a Norwegian destroyer and five Canadian corvettes, apart from the U.S.C.G. cutters.

By the next morning, the bottom had almost dropped out of the barometer and it was blowing a howling gale from the Sou'east. 'A magnificent sight' he wrote, 'North Atlantic weather at its worst. It is so thick that at times one can't see 50 yards beyond the ship. It's a driving blizzard with mountainous seas in layers gradually disappearing in nothingness. Seas always have a bottle-green undertone near the crest. Towards noon the *Spencer* approached and we took the papers from her—one of the most beautiful sights I have ever seen'. Thus the artist. One can imagine that some of the diaries for that day may have been couched in different terms!

Within twenty four hours nine of the merchantmen had dropped out of the convoy due to engine trouble, sad to relate. The convoy was heading north for Greenland, and thence towards Iceland, to gain the maximum air protection, and daylight was now only about six hours of the day. On the evening of the 21st the *Campbell* dropped back to assist a steamer which had been in collision, and stayed with her until she had the incoming water under control, when the lame duck put back to St. John's on her own. Then she raced at full speed under a very pale moonlight with wind-driven clouds scudding across the sky. The next afternoon she passed alongside the forty nine ships now in the convoy. It was a clear day with a big swell but little

* See Plate 138.

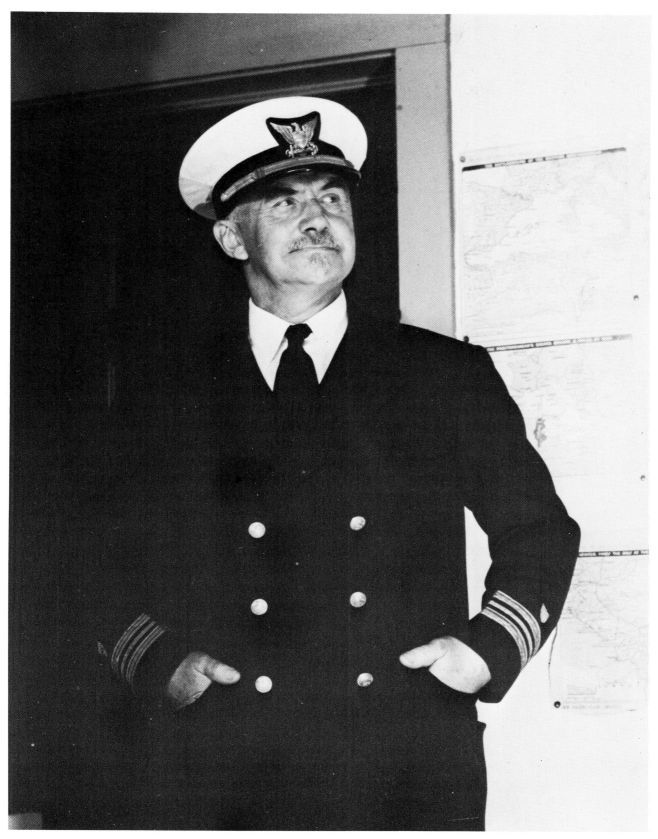

57. *Lt. Cdr. Anton Otto Fischer, U.S.C.G.*

sea, and the merchantmen were silhouetted against a blood-red sunset, each, as A.O.F. noted, acting like a small boat in that swell.

That night a sudden gale sprang up and brought with it an 80 m.p.h. wind – Force 12 with a vengeance! The diary records that it was as though the cutter was in the grip of some huge monster that was shaking her like a rat. He was on deck early to see a possible sunrise and was well rewarded, though the convoy was sadly scattered. Only 21 ships were in sight, and 30 others were scattered over the sea and had lost touch. Perhaps it puts the conditions in perspective to quote again:–

'Got beaned badly this morning when the pitching dislodged a chunk of ice from the mast and it came down on my head.'

The *Campbell* tried to round up part of the convoy, passing two of the freighters at close quarters but, after moderating somewhat, the wind came back at hurricane force, with seas some fifty feet high. There seemed little hope of re-forming the convoy, and the cutter was steaming through a sea littered with landing barges, life-rafts, life-boats and so forth, all adrift. The wind, it is true, moderated around 11.0 p.m. and A.O.F. went on deck to find a clear moon and a display of the Northern Lights to the north.

Soon the gale was back, with the *Campbell* zig-zagging and making about two knots. So much for convoys when Weather calls the tune! A tanker broke in two and asked for an escort to stand by, while another vessel broke radio silence to report that she was making water fast.

By January 25th the sea was calmed down, though with a huge swell and a very moderate wind. They were still within 100 miles of Greenland, and the *Spencer* was in sight shepherding five ships, while two more were visible on the horizon. The *Ingham* was believed to be with five more, and that was all that was known of that convoy which started with 59 vessels. Of course, 9 had become stragglers and dropped out on the first day: one was in collision, one broke in half and one sprang a leak. Thus only fifteen ships could be accounted for. Three submarines were known to be trailing them, and two dozen more were plotted in the general area between Iceland and Scotland. For aught the escort knew, some of their flock might already have been torpedoed.

Certainly A.O.F. was religiously noting motifs for paintings in his diary, though he is equally concerned with his bowels!

'The food gets my goat. It is too heavy for me and I am cutting down my eating – even go regularly without meals. If a man wants he can eat meat three times a day and meat sandwiches in between.'

They spent all the 25th trying to round up stragglers, without result. This was demoralising, as was an incident when they passed a landing barge with three crates of aeroplanes lashed to it. They tried to sink it with depth charges and gunfire, but did not succeed. Wilcox was quite shocked at this failure.

However, the next day they came on 25 of the convoy being herded along by the *Ingham* and the five Canadian corvettes which, with the 9 of them, made 34. That night they all waited up till 11.0 p.m. to hear a special radio announcement of special importance, and were hoping for news of some sort of peace terms. When it turned out to be that Churchill and Roosevelt had been meeting in Casablanca, it was greeted with sounds which would hardly have gratified those gentlemen!

Next day, the 27th, a reconnaissance 'plane reported 10 more of the convoy 20 miles ahead, and the next morning the U.S.S. *Ingham* detached from the convoy with two tankers for Reykjavik, and a corvette took in two of the freighters which needed to repair storm damage.

In the meantime, the barometer was dropping right down again, and before long all Hell broke loose which, after all the efforts at re-forming the convoy, was really bad luck. By the morning, although the weather had moderated somewhat, only 7 ships were in sight! However, they rounded up 21 of the lost sheep and were then detached from the convoy towards their base at Londonderry, entering the Foyle on the 31st, after a 13 day trip which had crowded more dirty weather into it than might often be encountered in several crossings. The diary records how impressed he was with the Irish countryside, and notes how the lights blazed on the Eire banks, whilst a total blackout obtained in Ulster after dark. The next convoy after them lost 14 ships, including 5 tankers, through enemy action.

The *Campbell* had not escaped weather damage. The circular guard round the forward 3-inch gun was bent back like tissue paper, and part of it was torn from the steel deck. The ship also had to have a new secret radio detecting device fitted, and thus was to be in port for some time. A.O.F. thought he would work up some paintings, but he found that the general noise and bustle made this impossible and, in fact, had quite a social and sight-seeing time whilst in Londonderry. He was meeting the

men from the American, Canadian and British escorts, and all knew that he was German, but that did not make a particle of difference, the more especially as he was soon identified with *Glencannon* and his marine pictures, and they could not have been nicer. The American ships, as a legacy from Josephus Daniels' term as Secretary of the Navy, were at the disadvantage of not having bars aboard, and the diary notes that, from his conversations, he found that the British were not liked by either the Americans or Canadians, for all sorts of reasons. He notes:– 'They just seem to rub each other up the wrong way.' There were only escort vessels in Londonderry, and normally forty odd of them at one time. After a bit A.O.F. simply could not take the shore life any more – the hard drinking and the only two conversational subjects – sex and drink (apart from war) – and stayed on board, where there was a piano, and played himself Beethoven sonatas! He also gave much pleasure by making sketches of some of his ship-mates and the friends he made ashore.

For the homeward trip, he moved in with the captain, taking Wilcox's berth. It was more comfortable, though he felt he would miss the ward-room congeniality. Lieutenant Stewart, who had been in London, told my father of his impressions there, which prompted him to record in his diary:–

> 'I wasn't sorry to leave Londonderry. It is all very depressing over here. Lt. Stewart told me of his London impressions and it makes one wonder how long this *entente cordiale* between the U.S.A. and England will last. There is very little evidence of good feeling. I noticed it here in Londonderry, and Stewart says it is even worse in London. . . .'

It was fair enough comment though, when one considers the treatment Germans received from their allies, the Japanese, in Tokyo: the way the Germans then felt about the Italians and the British about the French, let alone how everyone seemed to feel about the Russians, it is perhaps a comment that should be kept strictly within its context!

When leaving the Foyle, he recorded that the *Campbell* passed a destroyer which signalled that she had 40 U-boat prisoners aboard:–

> 'which seemed to make everybody happy. These people here, who have seen so many ships and crews go down and have seen tankers become living torches, have no sympathy to waste on submarine crews. One can easily understand their attitude. They don't want to recognise the fact that these German boys are just as much victims of circumstances as anybody else.'

The stewards and mess-boys were all coloured, and A.O.F. made a further comment in his diary, as a sidelight on the war:–

'The captain's steward, a coloured lad from Louisiana, is very nice to me, but I am suspecting that I'll have to be circumspect in my sympathies. You can sense it amongst all the coloured boys aboard, that they don't hate the Japanese. It is all mixed up with the race question and I'm afraid that one day there will be a grand explosion. These darkies don't go out of their way to lay up good will. They are inclined to be sullen and rather truculent, and the fact that there is no difficulty in Ireland in finding white girls to have intercourse with them doesn't help matters either.'

After a couple of battle practices in the Foyle, the *Campbell* sailed again on February 12th, going out into a Sou-westerly gale and making immediate contact with her convoy of 58 ships which was supposed to steam at $9\frac{1}{2}$ knots—a faster one than the normal. Before long the wind was gusting at 75 knots, and the cutter was back on the same old dance. After a good deal of bucketing about, she put back into the Foyle to calibrate her high frequency radio detector. It was not clear to A.O.F. why this had not been done before sailing, but she was anchored close to the Irish coast in a big sea, which made everything most uncomfortable. Maybe they were lucky to be there at all for, when passing over the anti-submarine minefield outward bound, they came across eight floating mines which had broken adrift. Luckily, it was day-time and they were spotted.

By the time the cutter re-joined the convoy it was short of 18 merchantmen, due to the weather. In the two days, the convoy had averaged 75 miles per diem! It was still blowing great guns, and it was known that there were some 45 submarines located in an area some 600 x 800 square miles ahead of them. A.O.F, perhaps unaccustomed to the violent motion and still out of tune with the menu, was regretting that all green vegetables were exhausted. Another entry:–

'In England and Ireland you can't get a thing of that sort during the winter. As a matter of fact, our Navymen and Marines stationed in London-derry give you almost anything for oranges, grapefruit and celery or lettuce.'

This may not accord with the popular British idea of American tastes!

She had sailed again on February 14th, and on the 16th they picked up U-boats talking to each other in code. The wind momentarily eased and

shifted to the south, with poor visibility, which was felt to be a good thing, but before long it was piping up from the west again. So it went on: 42 merchantmen and 4 escort vessels (including the *Campbell*), but still only with the 75 miles per day average. Sketch notes still figured in the diary, and Mr. Green, an official photographer, was also taking a number of pictures under A.O.F's direction.

Still they were aware of the U-boats around them and then, on the 21st, the *Spencer* made an attack with depth-charges, and soon afterwards the *Campbell* did the same, though there were no positive results on either occasion.

Soon after dark the *Campbell* made another depth charge attack, again without positive results. She had just changed course and gone up to full speed to rejoin the convoy which was by then well ahead, when sky and water became illuminated by star-shells, meaning that the convoy was under attack. The *Campbell* was then some ten miles astern and could do little about it. It was a marvellous sight, if depressing, and perfect conditions for a U-boat attack: clear, with a full moon. As soon as she resumed station, the Commodore signalled the *Campbell* to make a wide sweep, as two vessels had been torpedoed. Soon the lookout spotted one of them still afloat, and the cutter made a lee for her three boats to come alongside with 50 survivors, being herself then a stationary target well lit by the moon (and presumably in perfect silhouette on one side). The sinking ship was a 14,000-ton Norwegian tanker. Three men had been killed in the engine room and, as they had left the ship in a hurry, the master had left all the confidential papers relating to the convoy aboard*, so the *Campbell* approached to sink her by gunfire. As she approached, she was attacked by a submarine which fired a torpedo that missed her stern and exploded only a few hundred yards beyond. The submarine was on the surface, so the *Campbell* gave chase but, when the sub. realised that she was gaining, she crash-dived just as the searchlights were being trained on her conning tower. As the cutter passed over the U-boat, she dropped depth-charges which must have jolted it badly, to say the least, but once again there was no evidence that it was damaged, let alone sunk.

Having driven off the submarine, the *Campbell* opened up on the tanker with her 3″ and 5″ guns, and finally set her afire when the ammunition boxes on the after deck began to explode. A.O.F. wrote:– 'The shooting was very erratic, however, and I'd hate to think what would happen if the *Campbell* was engaged in a gun duel with one of the larger

* These were normally weighted and should have been thrown overboard.

German submarines!' Three more attacks were made within the next twenty four hours, the last being when a U-boat was sighted ahead and on the surface 400 yards off. Once again, depth-charges were dropped without much hope of success.

All this had kept the *Campbell* some 50 miles astern of the convoy and she was finally catching up and about 12 miles off when the whole sky on the port bow was illuminated by star-shells, signifying another wholesale wolf-pack attack. The *Campbell* increased speed to maximum, when suddenly a submarine running awash appeared on the starboard bow. The wheel was put hard a-starboard but the sub. scraped down the starboard side. The searchlight came into action and, at the same time, the cutter attacked with depth-charges once again, together with both 3″ and 5″ guns, pouring a murderous fire into the conning tower.* The sub. gradually dropped astern, completely wrecked. The whole ship's company aboard the *Campbell* was crazy with joy at their victory, but their joy was short-lived. Word quickly came up from the engine room that the ship was making water faster than it could be controlled, and it seemed that, in her death throes, the U-boat while scraping down the side had ripped a gash with her port diving wing some eight inches wide and twelve feet long in the *Campbell's* hull. In little time, the engine room was flooded and the dynamos ceased to function. There was no more electric power, and the ship lay on the water as a sitting duck, stationary and with the moon rising!

An S.O.S. to the convoy commodore resulted in the Polish destroyer *Burza* being sent to screen the *Campbell* and to stay with her until the situation was clarified. On the morning of the 23rd Capt. Hershfield decided to transfer the fifty Norwegian survivors; all those crew members making their first trip, and the supernumeraries to the *Burza,* the transfer being made in lifeboats. Naturally, A.O.F. was amongst those transferred.

Incidentally, after the attack the previous night, the cutter had sent a boat over to the submarine to pick up survivors. It came back with four prisoners, of which one was an officer, and reported more around the conning tower. The *Campbell* tried to launch her motor-boat, but the after fall carried away and the boat broke adrift, awash, and they had to launch a pulling boat to pick up her own men, while signalling to the *Burza* to pick up the remaining survivors aboard the U-boat. They picked up four of the eight, and one drowned during the rescue. Twenty were trapped in the hull and could not be saved.

* See Plate 157.

All this occurred on A.O.F's 61st birthday, and he found himself pretty shaken by the succession of dramatic events after so many years of very quiet domesticity. His diary reads:–

'What a contrast between the *Campbell* and the *Burza*. The *Campbell* was like a yacht in her interior arrangements and her fare was like hotel fare, compared to the atmosphere in this destroyer. It's the utmost in discomfort and the food mostly canned meats and potatoes. These people think an orange or lemon the height of luxury. They carry their fresh water in tanks and don't have a distilling plant like the *Campbell*, which has fresh water to waste. But there is a deadly grim battle efficiency about this ship, spurred by an abiding hate of anything German which is, of course, easily explainable. I was, in fact, surprised that the *Burza* consented at all to remove the Germans from the sinking submarine.'

The next evening the Canadian corvette *Dauphin* came and took oil from the *Campbell,* and remained to screen her until a deep-sea tug could arrive from St. John's.* (The *Dauphin* had 100 survivors of merchantmen sunk in the convoy, aboard.)

So, grossly overcrowded, the *Burza* made for port. News came that her convoy was again under attack from twelve submarines, but she had no fuel for more fighting. Men were crammed into every space, and A.O.F, as the highest-ranking officer, at least had the dubious comfort of the Polish captain's cabin! An aeroplane reported a boatload of survivors 20 miles away, but, once again, fuel was a priority and she steamed on through a concentration of another 27 submarines lying in wait for the ill-fated convoy. The sea was smooth, and it was bitterly cold. Many of the transferred men, and the Norwegian survivors, were terribly cold, not having been able to take their clothes, and the sea was covered in ice. The Polish destroyer herself was all iced up as she passed through the commanding cliffs of St. John's harbour in a blizzard. Before long the decks were crowded with representatives of the American and British navies: Red Cross and photographers, and A.O.F. began to realise the pitfalls of being a celebrity when they discovered his presence!

So far as A.O.F. was concerned, the entire *Campbell* cruise had taken about six weeks, which was not long by any standards, but it had been a crowded six weeks and the pictures which it engendered, mostly canvases measuring 36″ x 24″, were superb. He started work in his studio the day after he returned. On May 9th, a *Life* photographer spent the entire day

* The tug did steam the 800 miles to the Campbell, unescorted, and subsequently brought her into port.

58. A.O.F. with his wife, 1943.

photographing A.O.F. and the entire Fischer family in their home in every form of activity until they had all reached a point of exhaustion. Some of these photos, together with reproductions of the pictures which they had commissioned, were included in the issue for July 5th, 1943. In November, the paintings went on exhibition at the Corcoran Gallery in Washington, arousing great interest.

Until this time, Winslow Homer had been regarded as the greatest American marine painter, and it was clearly intended as a compliment when a reviewer stated that the scenes were such as Homer might have recorded them had he been on the *Campbell's* bridge. As has already been mentioned (page 34), Homer was not primarily a marine artist and, in those Marines which he executed, generally employed a quite distinctive approach to A.O.F. Had Homer been on the *Campbell's* bridge, there is no question that some marvellous pictures would have resulted, but there can be little doubt that his treatment would have been quite different.

59. *A.O.F. at the piano with the author.*

After the exhibition, A.O.F. presented the paintings to the U.S. Coast Guard* who exhibited them all over the country before they came to rest at the Coast Guard Academy in New London, Conn., having drawn high praise from Admiral R. R. Waesche, commandant of the U.S. Coast Guard, who had originally set in train A.O.F's commission.

After the *Campbell* episode, my father was often called upon to speak at various functions, though he always avoided doing so when possible. On those occasions when he did speak, it was generally most telling and successful. Two weeks after he got home he was asked to participate in the radio programme *Report to the Nation* in which he himself was to speak only briefly, and his role in the *Campbell* incident was to be played by an actor who, it was assured, was marvellous at taking off speech characteristics. All the time they were talking beforehand, this fellow was bobbing about beneath A.O.F's chin, but when he came to do his piece gave him a thick, guttural accent typical only of some caricature in a cartoon! A.O.F.

* The U.S. Coastguard had no lien on these canvases. They had merely requested that A.O.F. sign all his pictures 'Lt-Commndr. U.S.C.G.' for the duration.

60. The Fischer family at Woodstock, 1943.

did have an accent, but nothing like the exaggerated and comic one with which this man credited him.

He projected himself better as guest speaker at a dinner given by the Art Directors Club. When A.O.F. had an interesting story to tell, he told it simply and unaffectedly and with great success. It will be clear from the various excerpts from his letters that he was an extremely balanced man, seeing all sides of a question and seldom taking an untenable stance, and this balance helped him in his public speaking.

So the war dragged on, and finally came to an end. In October, 1945, A.O.F. received his discharge from the Coast Guard, with the rank of full Commander, in view of 'his outstanding contribution to the war effort'.

There had been changes on the *Saturday Evening Post* editorial Board, and the amount of work coming to A.O.F. had decreased noticeably. With the war's end, work slackened in general, and two paintings he had submitted to the Audobon Artists exhibition in October, 1945, were turned

down, prompting my father, always the pessimist, to write to my mother who was visiting in Washington:–

> 'I'm too much of a realist not to realise what's the matter with my things from the painter's point of view. My things, unless they are actually painted from nature, will always have the illustrator's touch and, even if I paint from nature, they are handicapped by too much good drawing. Today, that is a defect.'

How true!

A.O.F. had started with the *Saturday Evening Post* in 1910, and he had produced hundreds of illustrations for them, as well as many covers for the magazine. There had been a series of stories by F. Britten Austin: one of historical subjects and one of the sea and ships from Greek and Roman times to the present era. There had been a long series by that great sea-writer, Capt. A. E. Dingle*: by Kenneth Roberts; Nordhoff and Hall, and all the *Cappy Ricks* stories by Peter B. Kyne from 1915. His favourite character was Guy Gilpatric's drunken old reprobate of a ship's engineer, *Glencannon,* a series which started in 1930, followed in 1931 by Norman Reilly Raine's *Tug-Boat Annie* and *Mr. Gallup.* When Metro-Goldwyn-Mayer made their *Annie* film with Marie Dressler, they sent representatives to A.O.F's studio to be sure that they got the wardrobe right!

After he had been asked to do pictures for the Coast Guard, A.O.F. took the first four to the *Post,* which he always reckoned to have the first call on his work. He saw Larry Kritcher, the then art editor, but the *Post* was not interested. It published a short article on his visit and commission in the Coast Guard, saying that, to A.O.F's disappointment, that was why Fischer's glorious living seascapes would be out of the *Post* for the duration (of the war.)

Feeling despondent about the *Post,* he took the paintings to *Life,* who were enthusiastic and bought them immediately. Then, when he went to sea in the *Campbell, Life* had, of course, commissioned the pictures and they got the story.

A.O.F. was helpless. He was by then tied up with *Life* for the war pictures and he resented the *Post's* injured innuendo about lack of loyalty after his years of service to them and the fact that he had, indeed, given them the first option on the pictures. Of course, there had been sweeping editorial changes in Philadelphia (the *Post*), and it was there that the continuity was lacking. (In 1951, when they brought out their book of

* Son of a whaler turned itinerant preacher, Capt. Aylmer Dingle had a hard up-bringing. After being 2nd. and 1st. mate in full-riggers, he was master of a barque and of steamers in the Cape and Australian trades. Due to being blown up in the first war, his eyes had suffered and he came ashore. Living at Oxford, where he was born, with a small family to care for, he worked his passage to the U.S.A. as a waiter and was then washing automobiles and, indeed, spent several years doing similar jobs until he managed to get off the ground with his writing. Then he sent for his family and, living in Bermuda, spent most of his later life aboard his schooner-yacht *Gauntlet*.

61. *In Extremis.*
When A.O.F. showed this picture to Oswald Brett, he remarked: 'This painting was to show the tough nuts that, in the last extremity, they always get down to first principles'. (The 'tough nuts' were probably some of the people he had met on coast-guard service.)

Saturday Evening Post illustration, his name was omitted except in a derogatory comparison with the artist then illustrating the *Tug-Boat Annie* stories – a comparison which had not been borne out by letters from their readers, previously printed in their own columns!)

In March, 1946, writing to friends, he commented:–

'It is a sad world at present and we as a family are fortunate that we are able to detach ourselves, more or less. At least we enjoy harmony and affection within our family circle and we don't mix much with the intelligentsia of Woodstock. It is fashionable here to idolise everything Russian and Woodstock is a hot-bed of Communism. It is not so much from conviction. One could possibly conceive of communism as a Utopian base of the economic state if all humans were angels and completely selfless and only concerned with the other fellow's welfare. But this Woodstock type of Communism is largely social, and it does seem very funny to have them meet at cocktail parties and spout their stock phrases—and most of them living on unearned income or alimony! It is all the rage and it would do them all good if they could be transferred to Russia and know what the Communist state really means to the human soul.'

The matter of the *Saturday Evening Post* irked A.O.F. for most of the rest of his life. At the time of the *Campbell* episode he had been illustrating for them for more than thirty years and the magazine had been the mainstay of his professional life. Although he had done work for myriad other publications, this had all been on a more or less irregular basis. His relationship with editors, always very cordial, had been especially so with George Lorimer who had been editor-in-chief of the *Saturday Evening Post* for 37 years until his retirement in 1936. Various changes had occurred in the Art Department as well, all bringing about changes in the magazine. However, the fact was that *Life* had commissioned the *Campbell* convoy paintings which, on publication, created a sensation and constituted an editorial scoop.

The *Post* had never wanted an exclusive lien on A.O.F's output, nor protested in the past when his pictures appeared elsewhere, as they often had. Furthermore, all the work he had done for the *Saturday Evening Post*, save for the occasional covers, had been to illustrate an existing text (which was not the case with the convoy pictures). When this was pointed out to them, since they had let it be known that they felt aggrieved, they replied that 'this case was exceptional'. In view of their lack of foresight initially, it all savoured of sour grapes. Although A.O.F. did receive some further

62. *A.O.F.'s studio in the garden at Woodstock.*

commissions from the *Post,* as will be noted, their volume was never on the same scale again. Indeed, two other artists took over *Tug-Boat Annie,* one of them basing her on the Marie Dressler film version (which had been based on A.O.F's illustrations!) but many readers and even the author, Norman Reilly Raine, protested that *Annie* was never the same again. It was all foolish and unnecessary. One result, and perhaps it may be thought a good one, was that A.O.F. became more artist than illustrator.

Now he returned to the *Foc's'le Days* project. He had already done most of the eighteen planned pictures and, in 1946, he started writing down the stories he had told so often to eager children and friends. I typed the manuscript for him, making sure that he 'sounded like himself'—a filial editorial service he acknowledged gratefully. The contract arrived from Scribner's in March, 1947. In the meantime he had been busy for three months illustrating a so-called *'de luxe'* edition of *Moby Dick,* turning out a colour jacket, ten full-page colour pictures and some 56 tail pieces and 96

103

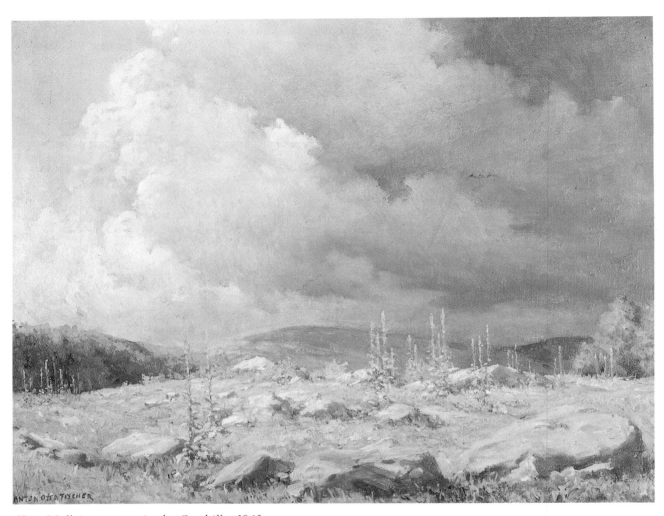

63. *Mullein pastures in the Catskills, 1943.*

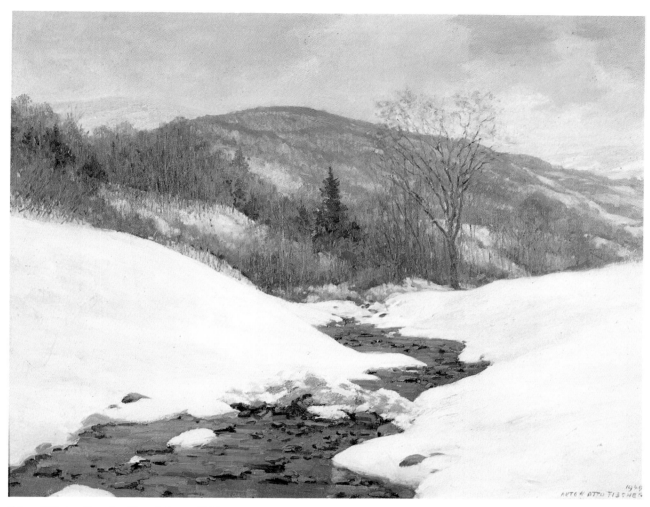

64. *Winter Brook, Shandaken, 1923.*

marginal drawings in pen-and-ink. All of this, however, was on a royalty basis with no immediate returns. He still worried unnecessarily at the loss of the regular *Saturday Evening Post* income and, although a *Mr. Gallup* story by Norman Reilly Raine came through from them this year, it was only the second *Post* job in five years—a far cry from the hustling work schedule of so many years.

Foc's'le Days came out in October of 1947. The pictures were reproduced in monochrome, to his disappointment, but the book was well-received, and Scribner's used a number of the original paintings in window displays at their New York store and elsewhere. The local book store asked A.O.F. to come and autograph some copies and, when he got there, not only was there a reporter and a photographer present, but a number of the more prominent local people to pay homage, as it were. A.O.F. was much amused that these included some of the very people who had written to the Government to report him as a 'suspicious character' early in the American hostilities!

In November he appeared on the popular Mary Margaret McBride radio programme (with Richard Lauterbach and André Maurois), but the fact was that the book, in terms of royalties, brought in only a couple of thousand dollars, which was nothing to what he would have realised from the eighteen paintings individually. At the same time, the returns in terms of personal success and satisfaction were enormous.

In 1948 my father and mother took a winter holiday for a couple of months on Merrit Island, Florida. It had been A.O.F's idea, but it was my mother who enjoyed herself the more until, towards the end, he became absorbed in painting the local landscape. When they arrived there was ice an inch thick, which was not what they had bargained for. Although the weather improved, it remained problematical, as did the fishing. My father wrote to me:– 'There is a pier over on the ocean side at a little hamlet called Canaveral and there is the best fishing.' (Little did he know what was to happen to that 'little hamlet')* On the whole, A.O.F. had to be restrained from returning home early. The overpowering kindness and inescapable sociality of friends in the next apartment depressed him and in one of his letters to me he wrote:–

'The higher the living standard gets, the more it whittles away man's capacity for happiness. And yet we are caught in the sticky mess like flies on fly-paper.'

* It became the site of the John F. Kennedy Space Centre from which all the American rockets and space missiles became launched.

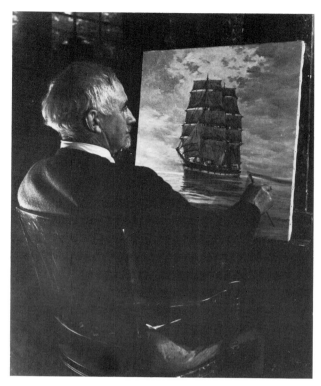

65. *A.O.F. at his easel.*

I reproduce this comment, since it is something which he—and we as a family—felt keenly.

On his return in March, A.O.F. found a story from the *Post,* making it now three in six years!

The following summer, in July, 1949, he suffered a heart attack. Fortunately it was not a major one, and perhaps it was a needed reminder that it was time for him to slow down a bit. He had been clearing scrub by the acre and 'relaxing' with eighteen holes of golf, and it came on after a dinner at a Chinese restaurant up a long flight of steps. However, six weeks in bed, during which he proved to be a surprisingly good patient, followed by a further three when he developed a 'strep' throat, effected a complete recovery. After a year of what he considered to be 'taking it easy', he was back in his usual round—perhaps a bit more circumspectly but not very much so! He had been an inveterate cigar smoker most of his life until, one day in 1947, he had stopped completely. Now he felt ill-

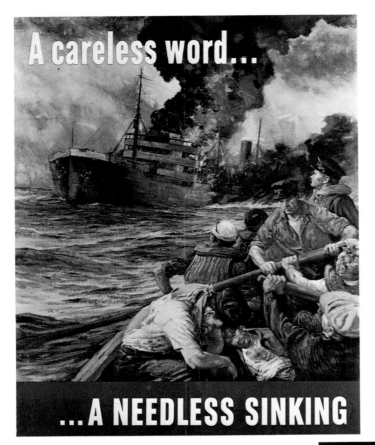

66.

Two of A.O.F.'s war-time propaganda posters.

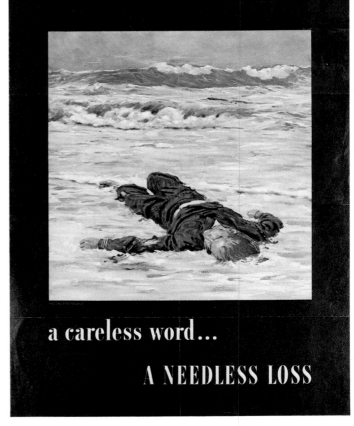

67.

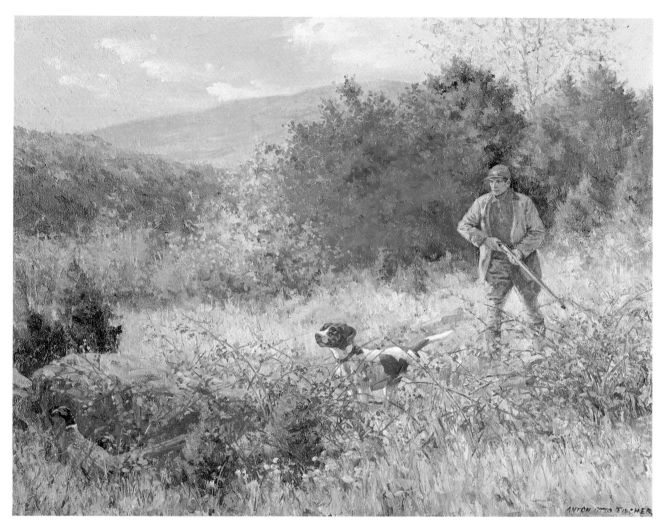

68. *Autumn with a pointer in the Catskills, 1940s.*

rewarded for two years of such virtue and he commenced again. (He did stop, finally, in 1957.)

The next year another story came from the *Post* and he was told to take his time over it. Kenneth Stuart, who had become Art editor in the mid-forties, was a great admirer of A.O.F's work and their relationship was very cordial. With this story, the price was raised to $850 for a two-page illustration and $500 for a one-page, and in 1952 was raised again to $1,000 for a double-spread. However, after forty years of working against a deadline, a pressure syndrome had built up and he could not escape it. His heart no longer protested against physical exertion, but it did against tension. But for this, I suspect that there might have been more of his work in the *Post* during the Fifties. He did a few more after the 1950 story, but then only one a year from 1955 to 1958 when *The Third Man in the Boat* (Plate 173) by Edmund Gilligan appeared in the December 6th issue. It was the last work he did for them.

During the Fifties A.O.F. began to receive a good many more commissions from individuals, and this type of work did not bother him. Most were for marine subjects to be hung as paintings—the sort of work A.O.F. liked best to do. Sometimes a particular ship was requested (often the warship in which someone had served), sometimes it was for something similar to a Marine seen in the *Saturday Evening Post* but, as often as not, it was just for a 'Fischer Marine'.

A.O.F. did not charge exorbitant prices. They were usually in the $300–$500 range, depending on what was wanted. He always preferred selling to the glamour of a high price, and could do this because his output was so prodigious. Quite often he adjusted his price to the purse of some eager but impecunious enthusiast, not infrequently allowing them to pay in driblets. He never asked for any payment before painting an order, and always stipulated that the purchaser must be pleased with the result. This made for many pleasant business contacts, and I never remember any order being rejected.

A good many people began coming to the studio, too, and when A.O.F. was not busy on a commission, he painted on speculation. There were business men (notably Henry Foss, of the Foss Tug and Launch Co.) who preferred to make business gifts of paintings rather than the customary cases of whiskey; wealthy people who thought of paintings as an investment, and just plain admirers of A.O.F's work who wanted to own a painting. I began writing my name on the back of things he was not

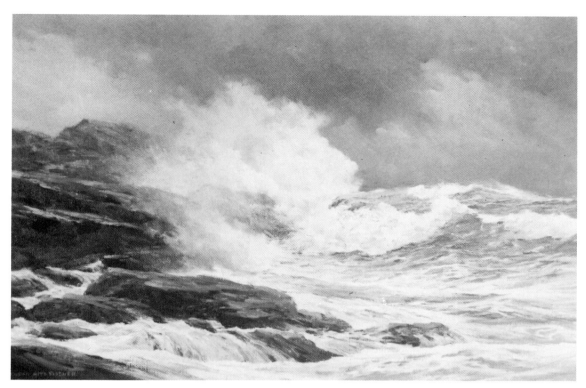

69. Ogunquit Seascape.

allowed to sell! Even so, some subjects moved out so fast, like *The Misty Ship with Terns* (Plate 112), that I never got my hands on one. It was always:– 'I'll paint you another that will be better'!

Much of the demand at the studio was for landscape. A.O.F. enjoyed painting these and he combed the countryside with his camera looking for subjects. The actual painting he almost invariably did in his studio. They were executed with the same, sensitive realism as his sea work and were very popular. As a matter of fact, there were many people in the area who thought of A.O.F. only as a landscape painter. He sold landscapes for considerably less than the Marines—(around $100–$300)—so they were within the range of many more people.

He also continued to keep his agent, Celia Mendelsohn, supplied with calendar subjects (the Hunting/Shooting and Fishing paintings were often pot-boilers in this category). Quite a few advertising commissions also came in through her American Artists Agency.

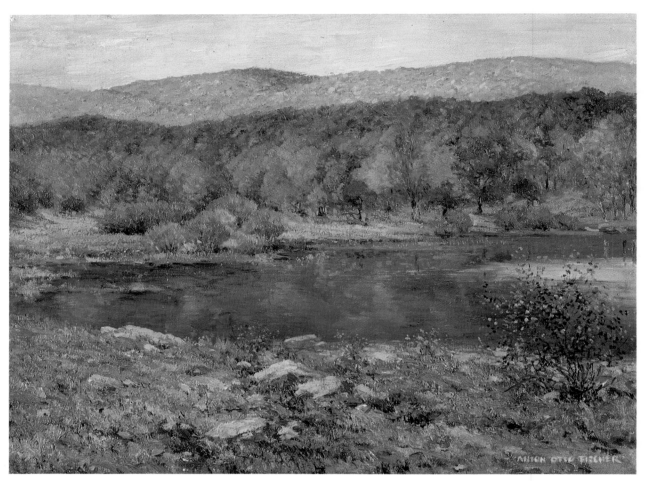

70. *Autumn colouring in evening light.*

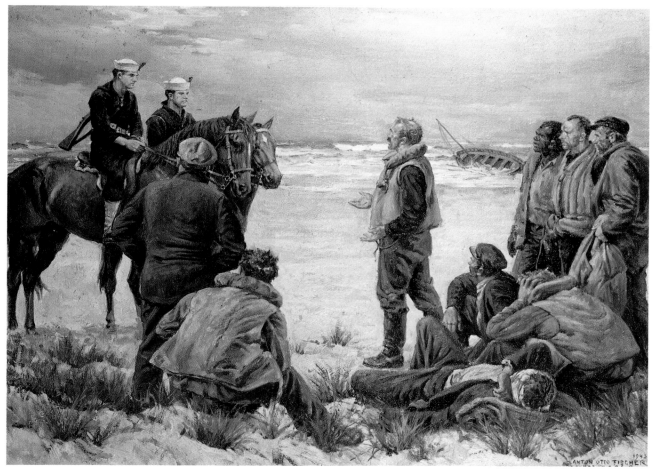

71. Explanation – at the end of the boat journey. (The picture speaks for itself. The survivors of a sunken ship have
finally sailed their boat, which now lies abandoned, to the shore. Their very expressions and attitudes tell of their
privations, while the two mounted coast guard hear their tale with apparently little sympathy! No doubt their
somewhat serious expressions are not actuated by wondering whether they are dealing with enemy agents, but on
how best to return them to civilisation quickly! The men's spokesman appears to be almost pleading with them.)

In the Fifties, Woodstock had simmered down considerably, though there were ever-recurring civic tussles and we always managed to be on the unpopular side of the fence, somehow. However, we had a number of very good (and congenial) friends, and there was much companionable sociability. A.O.F. was very popular on the golf course and was made a life-member of the Country Club, partly as a long-time senior member, and partly because he had made a painting of each of the nine holes which were a much appreciated addition to the walls of the club house.

During the latter half of the Fifties, little strokes began to nibble away at my mother who was now in her eighties. She made an astonishing recovery each time, but in October of 1960 she had a massive one and died three weeks later. She was, of course, older than my father and she had never been strong physically—a legacy of rheumatic fever as a young woman. Nevertheless she had been a staunch bulwark, always with well-formulated opinions and the knack of lifting A.O.F. out of his bouts of pessimism. As we were an exceptionally close family unit, her loss impinged so much the deeper.

A.O.F. was not at all well himself at the time of my mother's death. He had always had a notably good circulation, (no other artist had been able to work in the studio (Plate 62) at our home in the winter-time, for in cold weather it could be brought up to 60°F only with the greatest effort), but something was wrong now and he started having periodic and alarming black-outs. The doctor never made clear to me precisely what was wrong, but, whatever it was, it was affecting his heart by 1961. He was still working and painting, but there were long spells when he did not go near the studio at all.

Suddenly becoming an old man was a strange experience for my father. I remember one day when he had difficulty getting into the new car he had bought me—he no longer drove himself because of his black-outs. It was a station waggon and lower than our old sedan. After he had finally managed to get himself in, he turned to me and said:–

"You know, it is a Hell of a thing what can happen to a young and vigorous man"!

After my mother's death, A.O.F. was given a television set by solicitous friends and it was a godsend. It relieved the periods of enforced inactivity enormously, and being able to watch his ball games was a real source of

pleasure. (We had been without a television set previously because neither my mother nor I wanted one in the house, and my father had not wanted it sufficiently to be banished to the studio with it.) On the afternoons when there was a conflict of games to watch, he would manage both—one on television and one on radio!

He also became addicted to Westerns, explaining that the action was always good to watch! At any rate, television did not seem to bother his eyes in the same way that reading for any length of time now did.

Often the two of us played Cribbage and Scrabble together. His love of all games stood him in good stead at this time though, as time went on, I had to play a game within a game, since otherwise, failing as he was, he would never have won. There was a good deal of this sort of thing going on and it was no life for a man like A.O.F. to be leading. At least it can be said, however, that the end of his life contained a full measure of that family devotion that had been so lacking in his youth.

During the winter of 1961, after considerable correspondence over the years, A.O.F. finally met Mr. Henry Foss, of the Foss Tug and Launch Co.* Mr. Foss and his wife were travelling to the East Coast and they came to Woodstock to see us. We became very friendly and they did their best to entice us out to the Pacific North-West for a visit and a trip to Alaskan waters in their craft, the *Thea Foss*. Unfortunately, A.O.F. was no longer up to this sort of thing, and we never made the visit.

February 23rd, 1962, was A.O.F's eightieth birthday, and he was as pleased as a small boy with all the congratulations which poured in but, a month later, he was dead. He was not well for most of the month of March, but had received a letter from a doctor in Georgia who was anxious to have one of the historical battle subjects. For my part, I was unwilling for any of those on loan to the Navy Department to be sold and so, on March 26th, all bathed, shaved and spruce, he woke me at an early hour to say that he was going over to the studio to commence work on the picture.

After breakfast, he went to potter a little in the garden before getting to work and, a little later, I found him slumped across the wheel-barrow which he had been emptying of a load of leaves on to the compost heap. It had been very quick and, as I knew that his condition might easily have led to an incapacitating stroke, it was a merciful way for him to go.

Thus ended a very remarkable life, and the story of a remarkable man. It is easy, it may be thought, for a daughter to eulogise, and it may be that such a relationship does not make for an objective biography. In fact,

* See pages 110 and 212.

72. *Winter afternoon – Shandaken, 1940.*

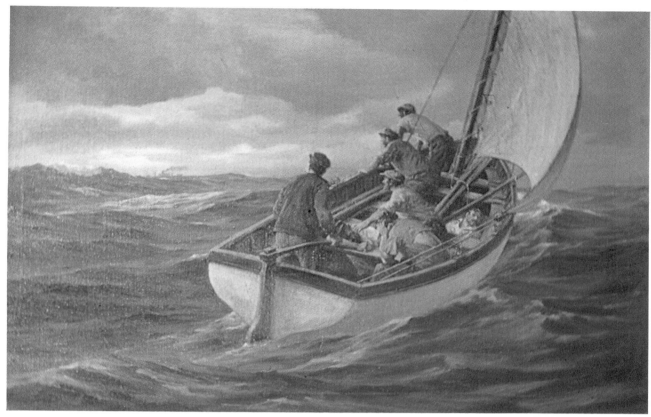

73. *Has she seen us?*

there is no-one else today with the knowledge and material which I possess and, it must be confessed, I not only could have written more, but did! However, at this point, I should express my appreciation for the help of the publishers and in particular to Alex. Hurst, who approached me in the first instance at the suggestion of Oswald Brett, and who has felt throughout that the title of this book should be *Anton Otto Fischer—His Life and Work*.

Clearly, the work cannot be appreciated to the full if the man himself is not understood, and thus there is much that is not concerned with the sea or with painting. That A.O.F. was a superb marine artist is without doubt. After his death, the number of known and quite unknown people who wrote to me about his work made one enormous epitaph of praise. Technical accuracy is not a subject on which I myself am qualified to judge, but all those letters bore ample testimony on that score. His life was remarkable, I think, when one considers its beginnings, coupled with the self-discipline which he so clearly exercised both at sea and in his early days in Paris and New York. Yet, despite his success, he was prone to those fits of pessimism, and he never really trusted Dame Fortune, who certainly smiled on him. Indeed, during the depression, playing a low stock market, he created sufficient income to ensure that, even when commissions were at a low ebb, the effect was rather on his morale than on his pocket.

I have touched on the difference between an illustrator and an artist on page 3. Of course, A.O.F. was primarily an illustrator by profession for most of his life, though latterly he turned to be rather the artist. Yet, if some of the originals of the 'illustrations' be examined, few viewers would regard them in any light but that of sheer artistry. Being an illustrator, he obviously 'pot-boiled' on occasions, and his output was unbelievably prolific. Nevertheless, it was seldom that his technical accuracy could be faulted, though sometimes, like all artists, he got too close to his canvases. At the instance of Alex. Hurst, who served in square-rigged ships himself, one of the paintings in colour from *Foc's'le Days* has been rejected for another on a similar theme. Both are splendid studies of men fisting canvas on a yard in storm, but in the one the yard is, as it were, suspended in the air. No doubt there are similar instances, yet it seems to be common ground that his wide spectrum of seascapes (apart from an array of other subjects) of which he himself did not have first-hand knowledge, is truly remarkable. It is generally accepted that in the expression of emotion in men's faces he was without peer. The compositions of his pictures will speak for themselves.

74. *A.O.F. before 'To the Rescue'.*

A.O.F. was also fortunate as, indeed, I was myself, in the fact that we were such a tightly-knit family unit. Many people who read *Foc's'le Days,* which includes his rather dramatic life up until that time, wanted to know what happened next. The answer lies in the preceding pages but—apart from the brief *Campbell* episode—it was not dramatic. Once married and with a family, he revelled in that very domesticity which he had been denied as a boy and as a young man.

He was a man of great integrity and saw hope for the future of mankind only in a truly religious revival. Politically, he had been inclined to the Democrat (Labour) side of the fence until Roosevelt became President. In 1946 he had written to his friend Louise Schofield:–

'During the Roosevelt administration Labour was put in the driver's seat and now we are under its thumb. It has come to a sorry pass when the Labour leaders are almost more powerful than the chief-executive of the nation, and all

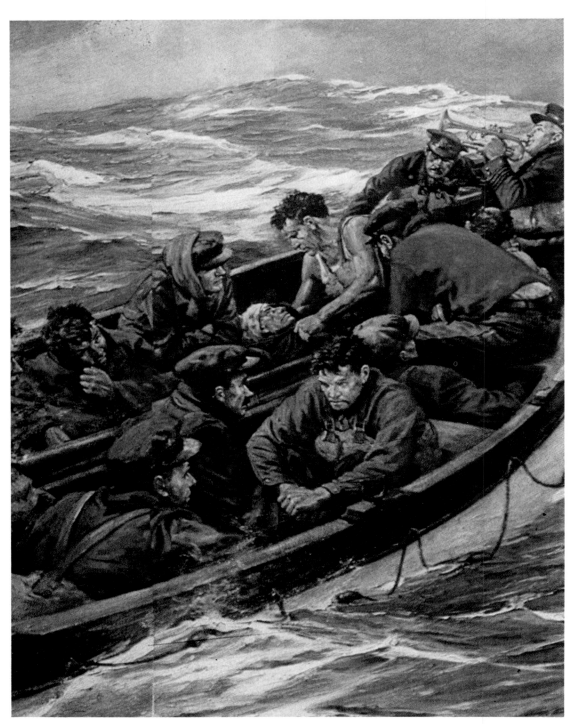

75. *Men and the Sea.*

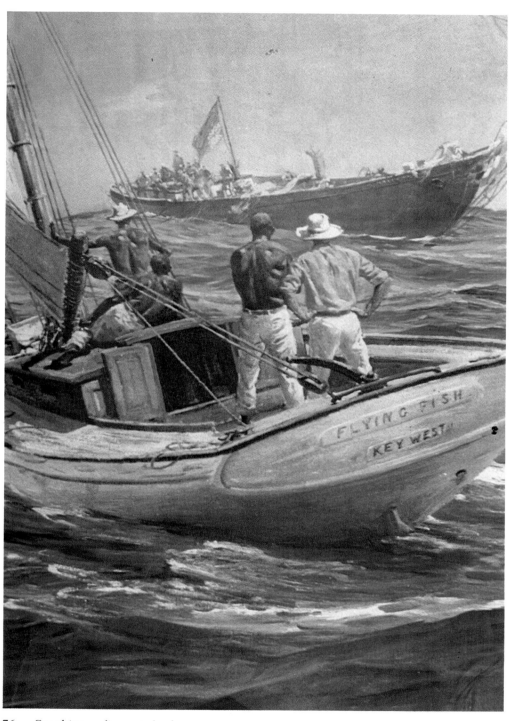

76. *Speaking a dismasted schooner.*

because everything has become subordinated to political expediency. It is not the courageous, statesmanlike thing to do, for the benefit of the most people. . . . it takes a wise man to know how to use power and the present labour leaders haven't that sort of wisdom. . . .Franklin Roosevelt may have had good intentions, but he left us with a sorry heritage. He split the country in two and made enemies of employers and employees. The virus has infected everybody. . . . I wouldn't employ a man around the place now, if I could get one—not with their present attitudes. It is, in truth, not a very pleasant time in our world's history that we are living in and yet, I feel, people are fundamentally decent. It is only that they set up false standards and are not satisfied with the simple realities of existence. Perhaps only a religious revival will bring this about. . . .'

Certainly he had switched to the Republican (Conservative) ticket, and it might be thought that his growing involvement with the stock market had something to do with that. I doubt it. He was a man of principles, and he found them at stake.

Like his contemporary marine painter on the other side of the Atlantic, Arthur Briscoe, and although their lives had sprung from such very different roots and run along very different lines, he was never immediately concerned with trying to charge maximum prices. Both men were masters of their craft and, again, overlapped in subject matter on occasions, but despite A.O.F's bouts of pessimism, and despite all the energy he expended in turning out pictures to schedule, his working life was really a vocation. Perhaps his early life and hardship had set his values in proper perspective but, however that was achieved, it made him a contented man.

The sea, rivers, running water—any water—fascinated him. He himself thought this odd, with his inland background, but it may be thought odder still that, once established as a marine artist, he spent no time at all either sailing or on the deep sea again, excepting the *Campbell* trip. It is true that he took some vacations by the sea but, spectacular as it can be, the sea inshore is seldom the same as that same sea away from the shelving coast and beaches. He was unquestionably an acutely observant man with an extraordinarily retentive mind and it was as though his years at sea had provided a bottomless fund of memory. That he was born in Bavaria and that he loved the Catskill mountains can only suggest that blood is thicker than salt water!

This book can contain only a representative collection of my father's vast output. Selection has been an impossible task. The following pictures are not necessarily the best, nor a complete cross-section. Rather have they

been confined to specific themes, and thus the vast mass of the iceberg of his paintings remains below the surface! The richest part of his heritage lies in the marine oils, which so many of his admirers never saw at all, but the total legacy of pictures is scattered on walls all over the world. Still, and often by chance, do I learn of the many people, famous and mere enthusiasts, in all walks and stations of life, who own and treasure them. He would have been pleased to know that.

77. *The PEQUOD, from Moby Dick.*

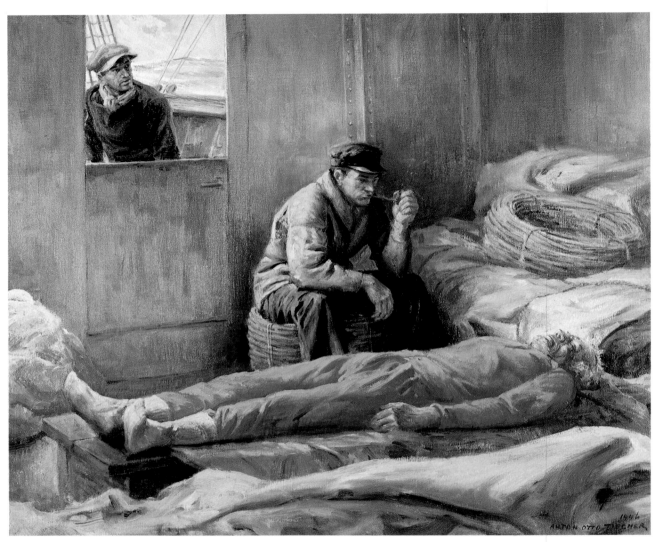

78. *The Death Watch.* (see p. 127)

79. *The whaler.*

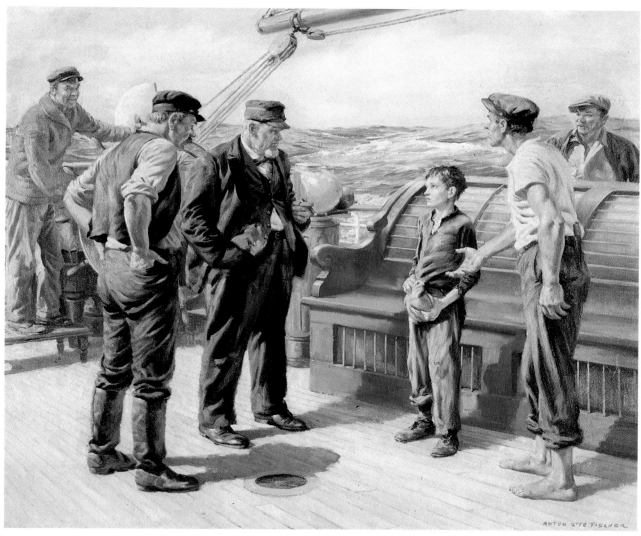

80. The stowaway.

81. Taking in Sail – from Moby Dick.

Something has been written of A.O.F's voyage in the *Gwydyr Castle* in the Biographical section. He himself wrote something of it in his book *Foc's'le Days* but, since this book was conceived, some research has been made into that voyage, and there are certain facts now known about a few of the personalities who appear in the pictures, and also of the circumstances surrounding some of the events portrayed which may provide added interest to the pictures themselves.

The ship's log is still extant. Like many of the Welsh ships, she was managed by R. Thomas & Co. of Liverpool, and in all probability her real owners were all sorts of people in Welsh villages, who held one or more of her sixty four shares. Her master was Capt. Evan Jones, of Nevin, aged 52, and her mate, named John Owen, was 48 and hailed from the same small seafaring port. Richard Evans, aged 28, from Barmouth, was second mate. There were four apprentices, two of whom completed their time in Tacoma, and it is odd that A.O.F. never mentioned them at all. A Swede, a Norwegian and an American who signed on in Hamburg deserted in Cardiff, together with a German named P. Grundol, who was 28. The cook, who was from Mozambique and appeared on the articles as both Antonio and Amroy, was a cause of grievance to the crew and the steward, who was equally disliked, was 46, and named Ellis Roberts (Plate 113). He, with the master and mate, had alone stood by the barque since her previous voyage.

The man lost overboard was T. O'Sullivan, a young Irishman from Cork, who was 27. The log book entry reads:–

'4/7/01. In Lat. 20°13′S, Long. 35°59′W, T. O'Sullivan, aged 27 years, while aloft with two other A.B.s sending main royal clewlines* down to the deck happened to fall unseen at 8.30 a.m. and struck the rail by the main rigging, dropping overboard. His blood was seen on the rail. Water quite smooth, and vessel going about four miles per hour. The boat was out in a few minutes† and went in search of him and came back after an hour without finding any trace.'

The matter of the loss of the sail-maker caused a good deal of trouble. He was a very fine man, named David Simpson; an American from Boston, Mass. who had given his age in the articles as 53, though the implications are that he was probably considerably older. He had come out of the fine 4-masted barque *Mashona* before joining the Welsh barque. The log book reads:–

* The royal was the highest sail on each mast. The clewlines were used to haul the clews (lower corners) of the sail to the yardarms.
† Plate 82.

'16/2/02. Lat. 41°3'N, Long. 133°W at 5.45 a.m. the sailmaker, David Simpson, was found lying on his face on deck and blood oozing out of his nostrils, part inside and part outside his berth. Apparently being turned out to make water, he keeping watch. The vessel at the time was under lower topsails and tossing about. Steering N.W. by N., Wind South. Carried him inside but found little hope of recovery. His body was quite warm. Tried all means for recovery but of no avail. He was on deck at 4.0 a.m. apparently well, coughing awhile, and buried him at 4.0 p.m. the same day.'

He was, in fact, found by a young Finn who was going to relieve the wheel and who stumbled over him in the dark. Clearly he had over-balanced and hit his head on a ring-bolt in the deck, but the ship had her sea-lawyer, who tried to whip up the men with tales of foul play, and whose idea it was that someone should sit by him in case he showed signs of life. Hence *The Death Watch* which made sufficient impression on A.O.F. that he painted the scene years later. (Plate 78).

A.O.F. did not ever mention a sort of sequel to this affair, which has come to light in the form of a report which was attached to the ship's log, viz:—

'Report of an investigation held on board the British ship *Gwydyr Castle* the 2nd of April, 1902, on the complaint of F. Tungmon*, Carpenter, No. 3, P. Bergholz No. 15‡ and F. Huntley** No. 19, each 'A.B.' seamen, as to food and treatment of D. Simpson, deceased, sailmaker. No. 4†, in the presence of Mr. Sachse, an attorney, to whom the complainants had appealed, and myself; the Master not being present, as the complainants allege that they were afraid to speak before the Master. For further particulars c.f. 'B.& D. 1 and 3, forwarded to the Board of Trade on the 5th. of April, 1902, through the Portland Consulate.

In the matter of provisions:—

I find that the vessel has been out almost a year, consequently the supply of provisions is considerably reduced; that fresh supplies were taken on at Panama, including 400 lbs. of flour; that this 'Panama' flour, although very nice to look at, is of poor quality and will not make good bread, but can be used, and was used, in other ways; that the 'Cardiff' flour, with the possible exception of one sack, was good: that the beef was of the usual quality supplied and used on board ship; that the pork was very inferior and apparently had been 'put up' at some time; that the rest of the provisions were of the usual quality and character; that the same provisions were used in the cabin and forecastle; that the cook made the best of the materials provided him by the steward, who seems to have distributed the allowance in a just and proper manner; that when any complaint was made to the Master in regard to the

* A Swede, aged 28.
‡ A German, aged 18, a year younger than A.O.F., who was clearly too level-headed to get involved in this trouble stirring.
** From Manchester. Probably 'Liverpool Jack' of A.O.F's narrative. He was 31. The numbers refer to their numbers on the ship's Agreement.
† The numbers refer to the spaces in which the men were entered on the ship's articles.

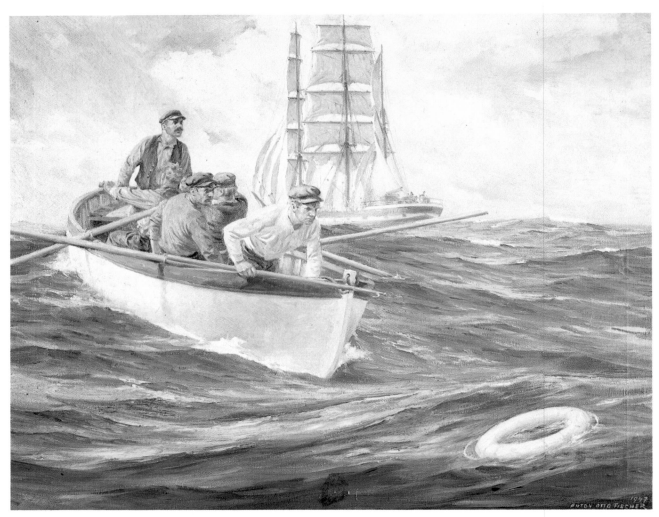

82. *'Man Overboard'. While the GWYDYR CASTLE lies hove to, her boat discovers the life-buoy thrown for Tim O'Sullivan, but that is all.*

83. *A sketch from Moby Dick.*

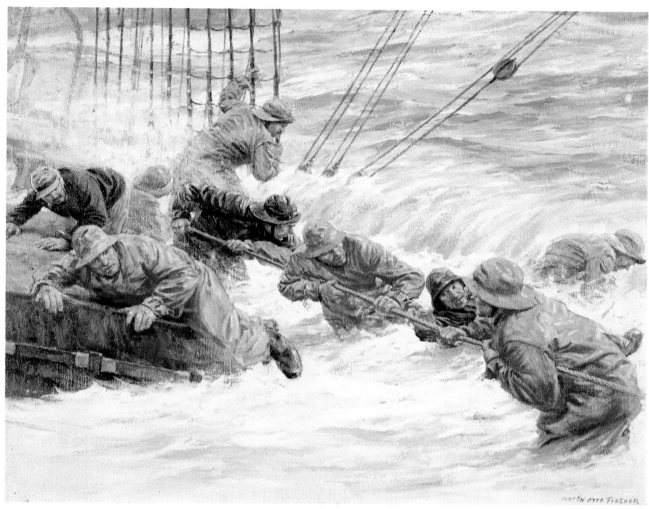

84. *Lifelines. The men have just hauled up the lee fore braces, seen in the centre of the picture. One man is still making fast at the rail on the right. This was the wettest part of the deck.*

85. *Hard weather!*

food, the matter, at once, was rectified to the best of the Master's ability.

In the matter of the treatment of Simpson, sailmaker, deceased, while on board:—

I have attentively listened to what Tungmon, Bergholz and Huntley have said to Mr. Sachse and I do not believe that Simpson was cruelly treated or abused by the Master or anyone else on board this vessel, or that he had had any serious quarrel of a serious character; on the contrary, I have every reason to believe that the Master did what he could for him, not only when he came to him for medicine, but on other occasions, and Andrews, No 18*, states that he and others were frequently 'told off' to help him in his work†; Huntley states that Simpson, on several occasions, said he was 'starving to death', but I can not find that Simpson ever made complaint to the Master about 'starving to death' or asking for food.

I find that considerable dissension exists between the members of the two watches and also, that there has been trouble between the apprentices and sailors, and I am of the opinion that the chief agitator and promoter of all the trouble and annoyance is Huntley, who has induced Bergholz and, to a certain extent, Tungman, to side with him, who, by this means, hope to obtain their 'Discharge' from the ship while in this port.

Dated at the British vice-consulate this fifth day of April, 1902

John B. Alexander.

(Consular stamp)

In fact, both Tungman and Huntley deserted in Tacoma, but Bergholz stood by the ship till she reached New York, and signed off with A.O.F. My father recorded that the sailmaker was most popular: that he was a man of great experience and had probably been at sea for more than fifty years. He did occasionally go aloft in times of stress (though, of course, as an 'idler', or day-worker, he was not normally in the watches.) He further records that Simpson probably knew more of seamanship and sea-lore than all the rest of the ship's company put together, and that he himself learnt a tremendous amount from him. The morning of the old man's death, the mate came forward and said that the Master wanted a man to sign the log-book as witness to the occurrence. Huntley at once said *he* would not, and hinted that it savoured of foul play (though it was common enough). In fact, A.O.F. who had been on consistently bad terms with Huntley, at once volunteered, according to his own account, but the fact remains that neither his signature, nor that of any other man forward appears in the official records. Only the Master and the mate signed the entry.

Plate 91 is a marvellous record of social history. The bowler hatted crimp's runner is giving the men 'rot-gut' alcohol with which to induce

* A Cornishman, aged 38, from Penzance.
† Though it was common practice for men to assist the sailmaker.

them to come up to his boss's boarding house, whence they would be shipped aboard some outward-bounder for 'blood'-money. Entering the door is the 'Lady from the Mission', whose motives are diametrically opposed to the crimp. However, while crimps were common enough in many ports, Ladies in Seaman's Missions were not, but it does so happen that we know all about these two, in this picture.

The crimp in Tacoma was a man named Dave Evans, but his runner, shown in the picture, was known as William Ryan. His real name was Engelhart, previously a prize-fighter, and he had been a big and powerful man, being about six feet six in his socks, who gave the impression of being able to knock out a dozen men. He had used the name Ryan as a prize-fighter, but by the time he had become a crimp's runner he was only a shell of a man and had little defence. He worked simply with the aid of his bottles of alcohol, which were always a great temptation to seamen fresh in from months at sea, and who needed little to make them more than tipsy. It is on the record that quite a number of seamen he had shanghaied made sure that they came back to Tacoma to settle accounts with him but, soon after the *Gwydyr Castle* visited the port, so much of the trade was in steamers that the whole business of boarding houses of this sort became a thing of the past. Dave Evans took up a more respectable calling and Ryan was killed, unlamented, in a car accident soon afterwards.

The 'Lady from the Mission' was Christine Funnemark, who was the toast of many a Cape Horner, both in the foc's'le and in the after-guard. Her Mother had been brought up in Christiania and given a rather exceptional education for those days. Her name was Birgette Svendson, and she was not only a gifted musician, but spoke French, German and English fluently, as did her three sisters. She married the son of a ship-master from Krageroe in Norway, (where A.O.F. had traded in the *Renskea*). Albert Funnemark had determined to be a surgeon, but in fact he followed the family seafaring tradition until he was lost at sea in a vessel in which he himself had shares—the *Axellius,* leaving his widow with a boy, Benjamin, and a girl, Christine.

At first they went to Grimsby to keep house for an uncle, but when he got married they returned to Norway and Birgette learnt the techniques of photography and opened a business which prospered. However, one of her married sisters persuaded her that America was the 'promised land', and the family took ship across the Atlantic. Birgette gave piano lessons in Minneapolis until Christine developed tuberculosis and she was advised by

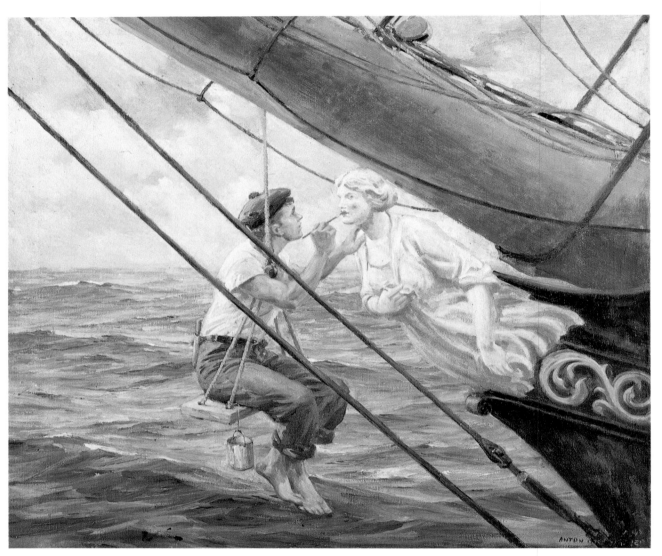

86. *A Labour of Love.* *(p. 135)*.

87. *A whale and a distant ship.*

88. *The GWYDYR CASTLE in the Doldrums, while sharks hang around her, awaiting the next offering of galley slops.*

89. *An actual photograph of the GWYDYR CASTLE be-calmed.*

her doctor to take her to a milder climate, and, after a short time in Portland, they moved to Tacoma in 1888. After keeping herself and the children alive by giving piano lessons, they opened the Seamen's Rest nine years later, by which time Christine, now eighteen (and very attractive) was able to assist.

The 'Rest' was kept in existence for five years, on a non-denominational basis. There was a room for reading: a service on Sunday and two other nights: a thoroughly Christian atmosphere and books and magazines in many languages to cater for all: there were coffee and cakes and often Christine, who had an excellent voice, would sing. Moreover, she boarded every ship which visited the port, which was no light matter for a young and pretty girl in those days.

Not only that but, appreciating that the two things seamen so lacked were letters and contacts, she would, after the mission was closed in the evenings, write long letters to the men, which were posted by faster (steam) ships to ensure that they would be awaiting them. They waged a constant battle against Dave Evans and his practices, and were often appalled at the tragedies at sea which befell so many of the men they had known. Christine supplemented the meagre income, which was normally derived from "whip-rounds" aboard the ships before they sailed, by working as a shorthand typist at the local undertakers during the day, but the venture was successful and, in 1899, they were able to purchase a larger building close by. Men from some 200 vessels visited their two establishments, both officers and men, and of all nationalities.

The mother and daughter did splendid work, long remembered by many a grateful seaman who appreciated a civilised environment in port. Christine had numerous proposals but, in view of all the tragedy at sea with which she had come in contact, would not marry any sailor. The Mission finally closed down in December 1903, due to the mother's failing health. She died finally in 1919.

A.O.F. often played the piano at the hymn singing sessions there, and was one who remembered the place with gratitude. He not only mentioned it in his book, *Foc's'le Days,* but also in some personal reminiscences he once wrote in the *Saturday Evening Post,* and was gratified to receive a letter from Christine Funnemark who had finally, at the age of 48, married a widower called Mitchell, who had a small daughter. He worked with the railway company. In the meantime, she had been doing a great deal of missionary work on her own, and she finally died, aged 81, in April 1960. One thing is certain, Christine and her mother were not only doing a great deal of good, but doing it in a most enlightened way. A.O.F. recorded the vast number of photographs

of ships and their crews which were kept in the Seamen's Rest, and which were always in use by men, examining past and known ships and ship-mates. In his own book, the *Lady from the Mission* preserves a certain anonymity which is odd, since he did correspond with her for some time after visiting Tacoma.

Plate 86 on the preceding page, may be deemed to be a self-portrait in retropect. A.O.F. did paint the figure-head outward bound, though he has painted a bit of sea for additional effect. It would need to have been a calm day, or he would have had to have bowsed his bos'n's chair in to avoid swinging about and losing his paint. Figureheads look best a traditional white, but he admitted that he allowed himself a certain licence with the job and gave her carmine lips and cheeks. He does not relate the mate's re-actions to this, though the practice was by no means unknown.

Perhaps Plate 80 has become one of the better-known of A.O.F.'s pictures. Superficially it might be thought to be a scene aboard the *Gwydyr Castle,* but it is actually based upon a story which he heard when serving in the vessel. One of his ship-mates, a Welshman with a big walrus moustache whom we may deduce from the articles to have been Richard Evans, had also had an unhappy childhood and, not knowing his parents, had stowed himself away in a ship's lifeboat at the age of thirteen.

When discovered, he was hailed before the "Old Man", who seems to have been a decent enough fellow and who recognised that he could not put him in the foc's'le, so he was made cabin boy. The man recalled that he had never had such a good time before or since!

This is A.O.F. at his best, for all the atmosphere of the ship is splendidly portrayed, whilst the expressions of each of the half dozen faces is so exactly right. The small boy is so obviously abashed before the master, whilst the man who found him is clearly explaining where he was, whilst the master himself regards him somewhat balefully, obviously wrestling with the problem of what best to do with him. On his right, the mate sees the boy as a potential problem, but both the hand on the other side of the skylight and the man at the wheel, neither of whom have any responsibility for such matters, are displaying their amusement at the youthful apparition. The more one regards the picture, the more touches become apparent.

In general terms, stowaways were a great nuisance. They were seldom good sailors (though the same might be said of many "shanghaied" men), but they were mouths to feed over and above the ship's complement and, in a five months voyage, a man will eat quite a lot of food and use quite a lot of

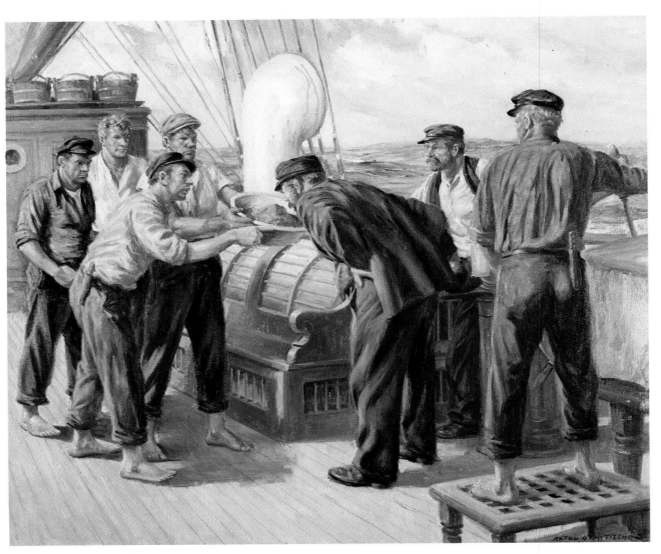

90. *The Grievance Committee.*

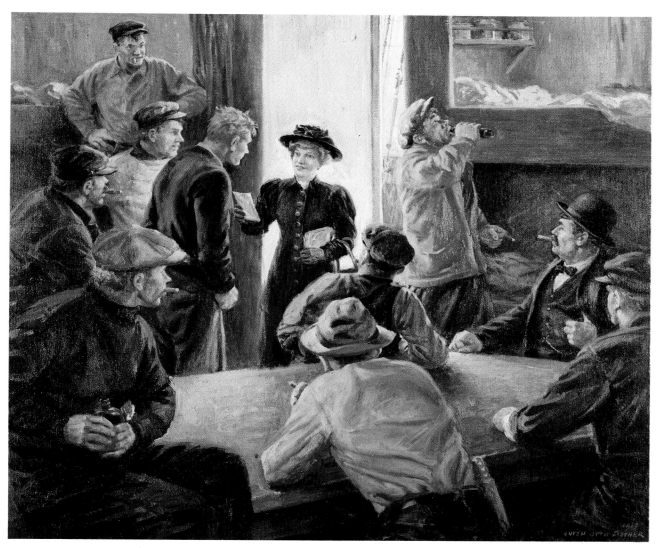

91. *The Lady from the Mission (p. 131)*.

water. In "hungry" Limejuice ships, this was a consideration!

In this case, the boy's tender age would have been in his favour. Had he been a little older, he would have found himself doing all the most unpleasant jobs aboard which are normally done by rota, without any break.

Tim O'Sullivan, an Irishman aged twenty seven from Cork, had run up a bill at his boarding house while the *Gwydyr Castle* was in Cardiff, and thus the boarding house master had shipped him aboard. The man's last ship had been the s.s. *Benedict* and as, indeed, his whole sea experience had been confined to the stokeholds of steamers, he was not a useful member of the crew of the barque, being incompetent even to steer and able only to keep look-out initially.

There were only about five British members of the foc's'le, the rest being from a variety of countries and it is easy to imagine that conversation was not by any means carried on in English all the time. Possibly in an effort to assert himself, Tim started making references to "Square-heads" in a derogatory manner and began to create a strained atmosphere early in the voyage.

Then, the first night that the ship picked up the North-East Trade, the mate's watch, which included A.O.F., slipped into the foc's'le to watch a poker game, with plug tobacco as "chips", knowing that they would not be wanted. (British ships did not usually keep "kalashi"* watch). The mate came in and ordered them out on deck, to the good-humoured jeers of the watch below. However, at the change of watch, Tim O'Sullivan kept the matter alive by making further sarcastic gybes which were apparently specifically aimed at A.O.F. who, being at a linguistic disadvantage, finally swung at him.

The two men were quickly separated and it was agreed that it was then too dark to fight but, by common consensus, that the dog watch the next evening would be the time to "have it out". A.O.F.'s rage had quickly evaporated but, when the time came, the hands crowded round and, with "Liverpool Jack" (Huntley) as referee and some sort of makeshift Queensbury Rules, the fight started, with Tim catching A.O.F. twice full on the nose, and making it bleed. The (impartial!) referee was yelling to Tim to "Go in and knock his block off!" while A.O.F., who had throughout regarded the whole business of boxing as a peculiarly British foible, was now maddened and went in with arms flailing. He knocked Tim down and had to be dragged off him. Tim rose, to be knocked down again, but, by then, the crowd had changed their loyalties! Then the mate appeared and the fight was stopped. My father offered to shake hands, which was accepted and the affray did clear the air in the foc's'le, as such things do, and no doubt it increased A.O.F's stature with his shipmates at the same time! It was O'Sullivan who was lost overboard in the Pacific.

* In many ships men had to spend their night watches actually on deck, even when there was nothing to be done. When keeping "Kalashi" watch, those not at the wheel, on look-out or "stand-by" might be in the foc's'le or elsewhere, providing they were available to come out instantly on call.

138

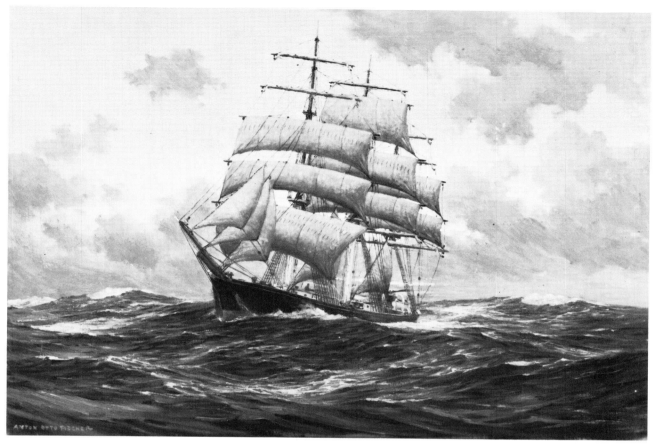

92. Reeling off the knots.

There is a tremendous liveliness about this full-rigged ship as she makes the most of the hard wind in clearing weather. She is setting a full main topgallantsail and, with the wind slightly on her quarter, living up to the title of the picture. She is one of the earlier specimens of the intermediate generation of full-rigged ships, still with some affinity to the earlier clippers. Appearing to be flush-decked forward, her bowsprit and jibboom still have a certain steeve which tends to date her, while, with her white lower-masts, she has all the appearance of a smartly-kept vessel. She is, of course, a much better looking vessel than the *Gwydyr Castle,* which was built in that last era of sailing ship construction when capacity had taken precedence over all other considerations.

Plate 88 is of the *Gwydyr Castle,* however, and shows her in the Doldrums— that belt of calms usually encountered just north or south of the Equator and between the Trade Wind belts, when a ship made little progress, often heading all round the compass and at the mercy of every catspaw and every squall.

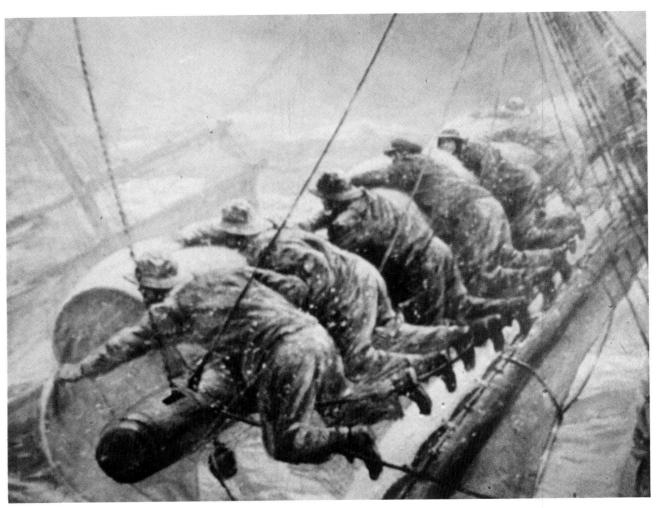

93. *Furling the main upper topsail. Snow and storm near Cape Horn.*

94. *Going aloft.*

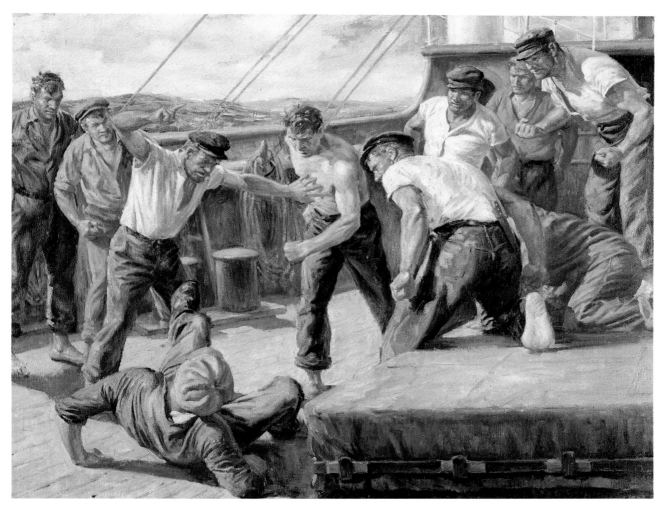

95. *A Difference of opinion.* (p. 138).

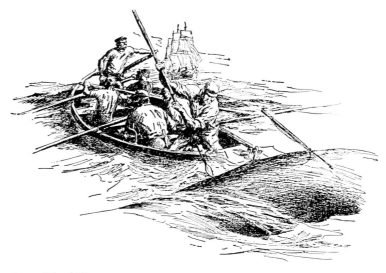

96. *The kill.*

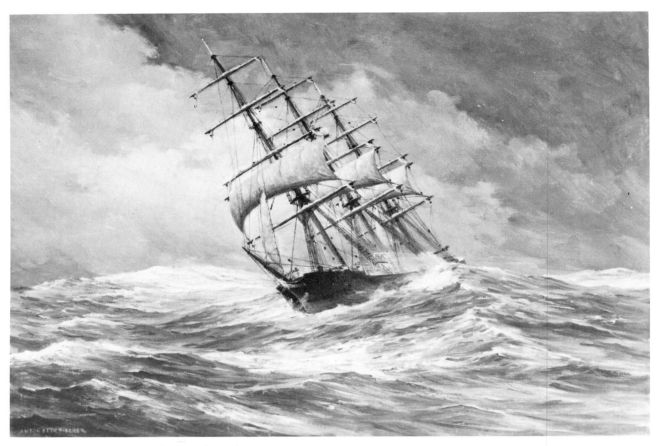

97. Running before the gale.

The loss of O'Sullivan (Pl 82) took place between the South-East Trades and the Westerlies, and somewhat affected my father who not only had his first experience of death at sea but also remembered his recent fight with the man. He spent a week making a painted and lettered memorial card which the carpenter framed and which was hung in the foc's'le. I record this, not so much apropos the matter of the memorial idea, but because he had had to ask the mate for a piece of stiff card for the purpose, which demonstrates that he was not equipped himself with materials for drawing and painting. It leads us to suppose that the paintings to which the mate referred, when speaking to Hester in Tacoma,* were executed on odd scraps of canvas, which was not an uncommon sailor's practice.

It was winter-time when the *Gwydyr Castle* came to beat to the westward round the Horn, which was the worst trail known to the merchant sailing ships. Plate 97 shows a full-rigger coming the other way and flying right before the wrath of the weather. She cannot really reduce her canvas any more without heaving to, and even has her foresail fast—that sail which provided so much drive

*See page 27.

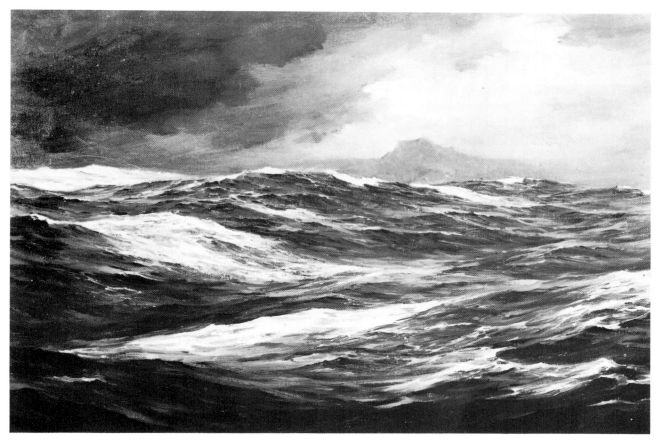

98. Cape Horn.

and, at the same time, so much lift, both keeping her before the seas and making her decks dryer. It was a great temptation for any master to make the most of so favouring a gale, but the time could come when he *must* heave to and, if he had run too long, he was faced with the possibility of broaching to and falling across the sea. This ship is almost in that position. It may be thought that the lower topsails look too deep. Men who have been in a ship in such conditions are accustomed to see them as thin, arched and narrow strips when seen from on board but, of course, when seen from outside, they do not have this appearance to the same degree.

Plate 98 is a splendid view of Cape Horn and its seas, which A.O.F. actually based on a photograph which Jack London, who took it from the 4-masted barque *Dirigo,* had sent him'. He himself knew all about that area and needed no reminders—witness *The Wanderer* (Pl 103) and the ensuing pictures. In Plate 115 the *Gwydyr Castle* is hove to, battling her way against the foul gales which are fair for the ship in Plate 97. There was little daylight at that time of year and incessant wet and cold with perpetual violent motion.

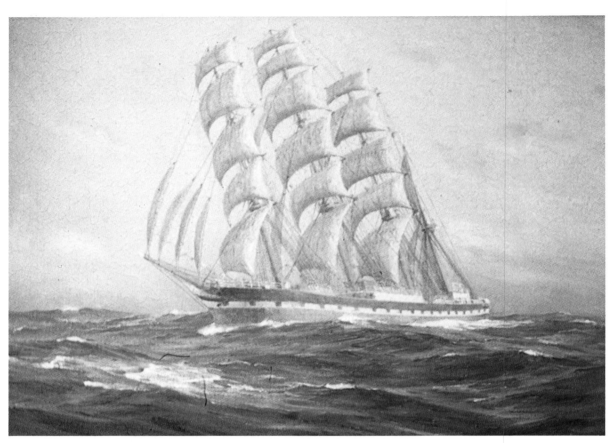

99. *The four-masted barque WANDERER. (In fact she normally had 16 or 17 painted ports.)*

100. *On the yard.*

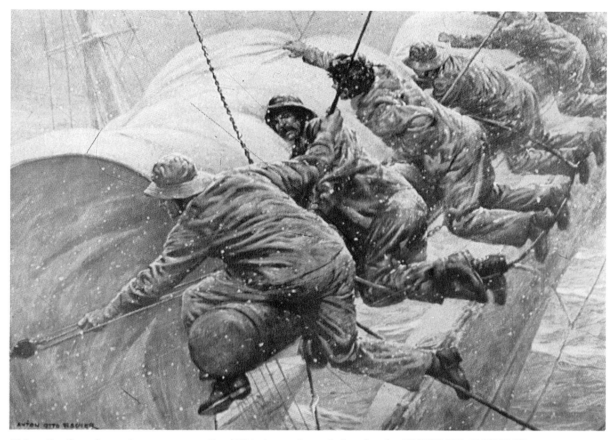

101. *Reefing the main upper topsail.* *(This is not intended to be the GWYDYR CASTLE).*

102. *Another view of the PEQUOD.*

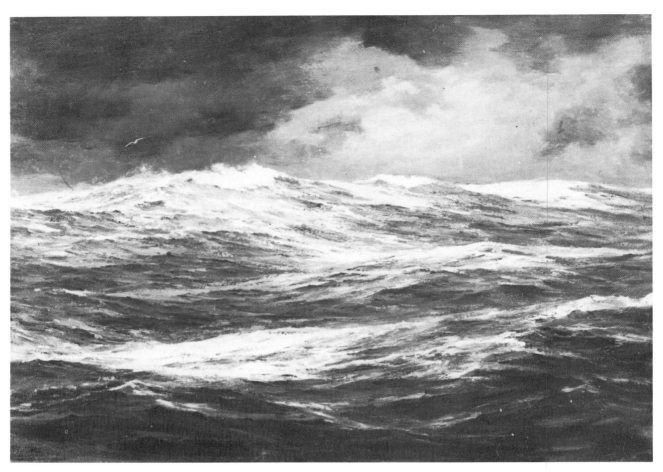

103. The Wandering Albatross.

A.O.F. made a number of oils of the seas of the Southern Ocean and, no doubt, one might look like another to those who had no feel for the sea or who had never witnessed them. This one, measuring 22 × 32″, a study in grey, green and white, is obviously in worse weather than in Pl. 98, as the spume from the crests spills down into the hollows. One solitary albatross—and the Wandering Albatross is the biggest of all birds on the wing in terms of wing-span—wheels against the storm-clouds. The scene is north of the Horn, for the albatross are seldom found quite so far south as that. Here, in its element, it sweeps above those long, angry seas with a fantastically long fetch, never seen in the Northern Hemisphere.

Those with an interest in rigging may supppose that A.O.F. was in error when he gave the *Gwydyr Castle* a double spanker on her mizzen in the pictures he made of her. Certainly it was very much a German foible, though one or two Norwegian vessels were rigged in the same manner, but it was extremely rare in British ships. This was the second barque built named *Newfield,** the

*See p.25. The second *Newfield* became the *Gwydyr Castle.*

104. Running her Easting down – a pen-and-ink sketch.

first one, built in 1889, also having been owned by Brownells, but she had been wrecked on the Australian coast in 1892. This feature made the two barques very distinctive, for both had double spankers.*

The term "Running the Easting Down" was used of sailing down the long degrees of longitude before the prevailing Westerly winds, either from Australasia to the Horn or from West of the Cape to Australasia. The weather was often bad, but the wind was generally fair and gave the ship a fine shove along her way, day after day. An outward bound ship, beating against the Westerlies, would be under very much more reduced sail and have her decks full of water most of the time. Lifelines (Plate 84) were essential. Boarding seas, which carried immense and unbelievable punch, could carry all before them. A man must hang on and, if his legs were carried away and he was spun round on the life-line like a top, at least he was secure from being swept up the deck and jammed under, perhaps, a ladder, with broken legs. The men all have the oilskin trousers *outside* their sea-boots and lashed at the bottom. It was the only—vain—hope of keeping one's feet at all dry.

*The spanker is a leg-of-mutton shaped sail on the aftermost mast, set on a boom and gaff. In the case of a double spanker, the sail is split, and there are two gaffs, the upper sail setting between them.

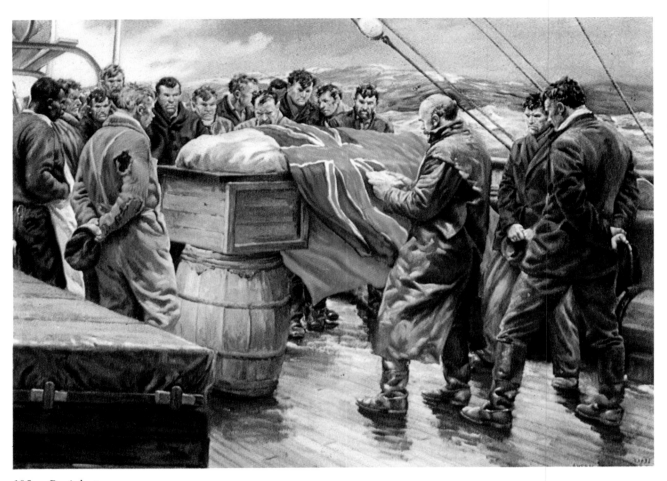

105. *Burial at sea.*

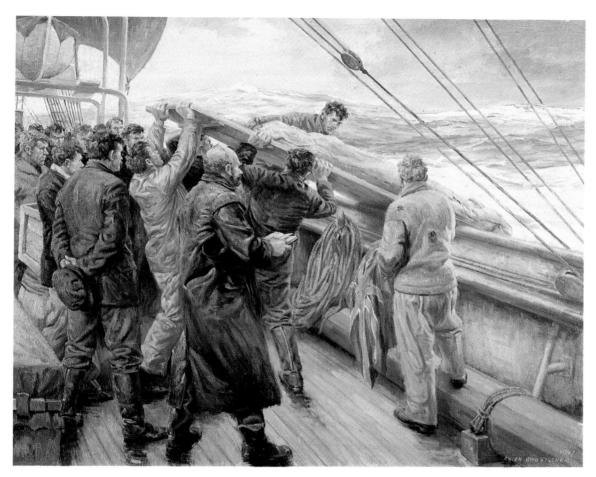

106. *Burial at sea.*

Few pictures give any idea of the conditions of a ship beating westward round the Horn. A.O.F.'s are so close to life that they remain in the memory. Many British square-riggers, with those of other nationalities, could spend weeks down there, losing as much as they ever gained until finally, after thirty, forty, sixty, eighty days or more, they would get a fair slant and "get round the corner". Whether this was necessary is not really within the terms of this book. Certain German companies did not seem to encounter this trouble; this monumental waste of time and this misery for their crews. Great strength was built into the vessels both on deck and aloft: their masters did *not* reduce sail to the same degree and kept them going, whilst making longer boards to the south'ard. It is small comfort to tell men who spent weeks of such unmitigated suffering that it was all unnecessary and that, had their ships been differently built and handled, it would never have occurred. Yet that would probably be true. A.O.F. wrote, years later:—

> "Thinking back on those two nightmarish months it took the *Gwydyr Castle* to get round Cape Horn, I often wonder how we survived at all. It was a succession of Westerly gales: the ship hove to half the time under two lower topsails, making two feet south or north for every foot west; blizzards when we couldn't see thirty yards beyond the ship and huge, grey seas would loom to windward like nebulous monsters; sleet storms when rigging and footropes became coated with ice, when coiled and belayed ropes were solid blocks of ice to be pounded apart and when sails were stiff as boards and as unmanageable ..."

The barque may have been hungry, but at least she had a bogey-stove in her foc's'le, which could provide some minimal comfort not found by any means in all vessels of her type, for without such a stove there is no hope at all of ever getting clothes dry once they are wet, until away round the Horn. Clothes get wet quickly enough. Oilskins are but a palliative down there. One day the ship had taken a particularly heavy lurch to leeward, seeming to take half the Southern Ocean aboard and then, immediately, repeated the process to windward while, at that instant, the foc's'le door flew open and the sea poured in. In all this, a sea-chest broke adrift from its lashing and, plunging against the stove, carried away its guys so that it, too, broke adrift. Its doors came open, spilling out its red-hot coals, filling the room with smoke and steam and decanting some of the contents into the lower bunks, in which the "donkeys' breakfasts"—the straw mattresses—immediately caught fire. In a foc's'le well awash, there was no difficulty in extinguishing the fires (though it was lucky that all hands were not on deck or aloft when this occurred), but it was the end of the bogey-stove. Misery was absolute!

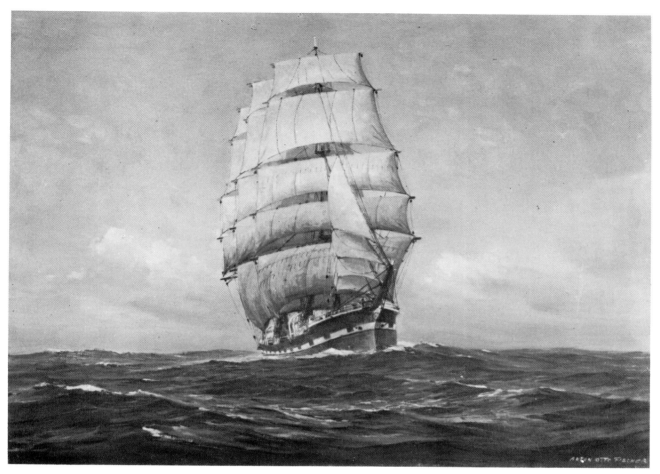

107. The weather we signed for.

It must have been a relief to come up into the Trades after so long off the Horn, and to encounter the conditions being enjoyed by this full-rigger. The picture won the prize at an exhibition in Maine, and was so successful that A.O.F. repeated several canvases on the same theme. One, on the cover of *The Country Gentleman* in March 1932, was almost identical. The cross jack was set (which made little enough odds with this angle of view): the peak of the outer jib was slightly higher: there was a little more cloud and list to the ship, but one had to look for these details to perceive the differences. Most artists developed a few favourite themes and this was one of A.O.F.'s. (And see the *Home Again* series.) Some might say that it was a little "calendar-like" and, in some sense, it is, but a sailing ship under full sail in the clean wind and sea of the Trades *was* an ideal subject. Many calendar artists romanticised their ships, but this one, with her spike bowsprit and masts of equal height, is no great beauty and wholly true to life.

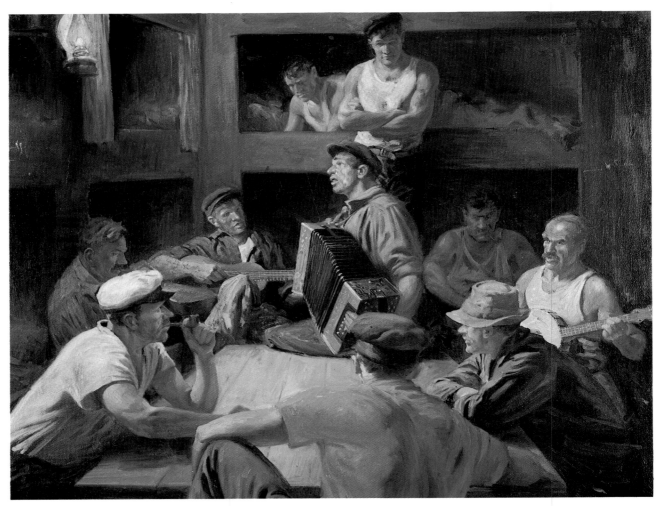

108. Songs of Home. (p. 154).

109. A Moby Dick sketch.

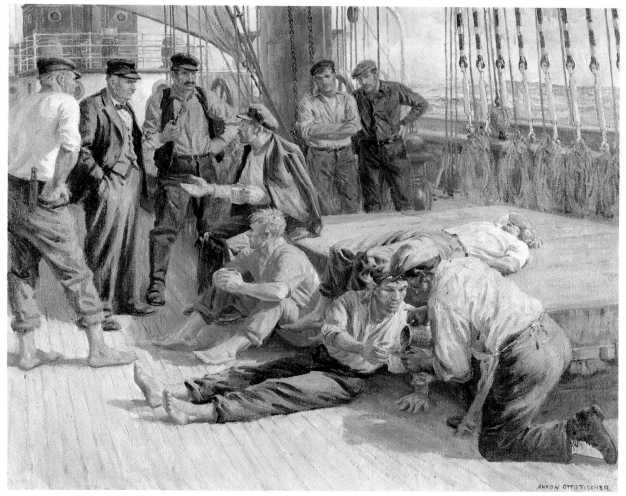

110. *The Survivor's tale.*

111. *The PEQUOD becalmed.*

When we look at *Songs of Home* (Pl. 108), we must surely regret that so few marine artists have had the strength of mind to transport themselves from the deck, the rigging or the sea itself to record the very life of the sailor. Here A.O.F. is at his best, for the characterisation of the ten men, so perfectly balanced in their composition, bears constant inspection.

The occasion was in the dog-watch of Christmas Eve, 1901, while the *Gwydyr Castle* was bound from Panama towards Esquimault for orders. Mixed nationalities never helped a sing-song, and it will be observed that the man with the accordion, and the mandolin and guitar players, are the only ones actually singing. Welshmen, with their natural propensity for singing, would have helped in this ship, much as we can be sure that the Finns on board would have been able to turn their hands to any musical instrument very quickly. In a ship's foc's'le an accordion, that most versatile of instruments, was a great boon.

Many of the Dutch masters, whom A.O.F. admired, and the earlier Spanish artists, would probably have thrown their figures against a dark, rather indefinable background, but it will be appreciated that Velasquez, whose possible influence has already been noted, was famous for his back-cloths—so often recognisable as the Guadarrama foothills. So, in this picture, are the men sat against *their* appropriate background—the bare and austere furnishing of the barque's foc's'le. The men at the sides of the scrubbed table would have been seated on benches, the rest on their sea-chests. Indeed, this foc's'le is even more spartan than most, for only one bunk had been equipped by its owner with curtains, which represented the one resort for personal privacy.

As a matter of history, one suspects that there was no sing-song on the Christmas Day which followed. The ship was by then in a state of seething unrest since, to understate the case, the Christmas dinner had been an utter failure and thrown back, literally, into the face of the negro cook, who, drawing his knife, advanced from the galley. One man struck his arm with a belaying pin from the rail and made him drop it, whereupon he retreated aft. The mate became involved and was equally abused, incipient mutiny being only quelled on the appearance of the Master.

There was still a good deal of grumbling, particularly since the steward (see Plate 113), who was held to be really responsible, kept well out of sight! There was no spirit of good-will by the time the dog-watch came round that Christmas Day! She was not a particularly happy ship that voyage.

The Survivors was another theme on which A.O.F. worked a number of variations and, although he included this one (Pl. 110) in *Foc's'le Days*, it does not seem to accord with any particular incident in the barque's voyage.*

*A.O.F. said it related to a tale told aboard by one of his shipmates, Jack Williams. There was an A.B., William M. Williams, aged 21 in the crew. Maybe he was called "Jack"!

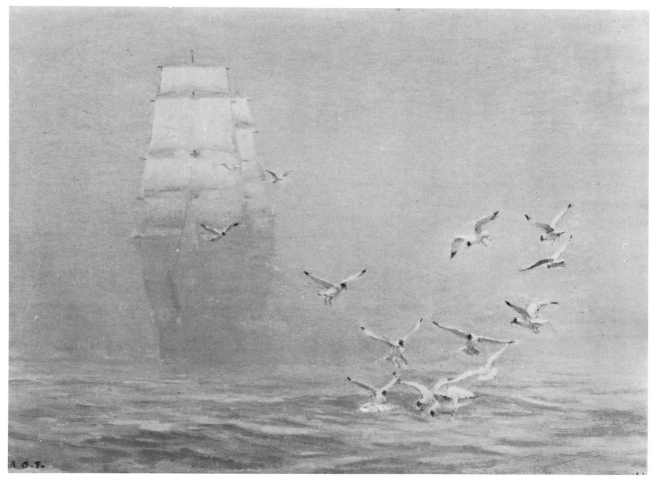

112. Morning Mist.

In this case, the men have clearly just been brought aboard, since the Master is on the main deck listening to their story. Nautical purists may say that the picture is painted back to front, since the roping of the staysail is to starboard but—it was by no means unknown for staysails to be set upside down!

Morning Mist catches all the glory of one of the most entrancing sights the sea can offer. There is a light mist on the face of the sea, being quickly dispersed as the sun rises and first catches the upper sails of a big sailing ship making towards the land to gradually—yet all too quickly as one watches—light up sail after sail until, almost before one is aware of it, dawn is transformed into day. The terns, wheeling and crying in the foreground, give all the promise of land that cannot be far away. It is a splendid study—one of many of the same ilk—devoid of dramatics, by a keen observer whose storehouse of memory caught the scene just as it should be.

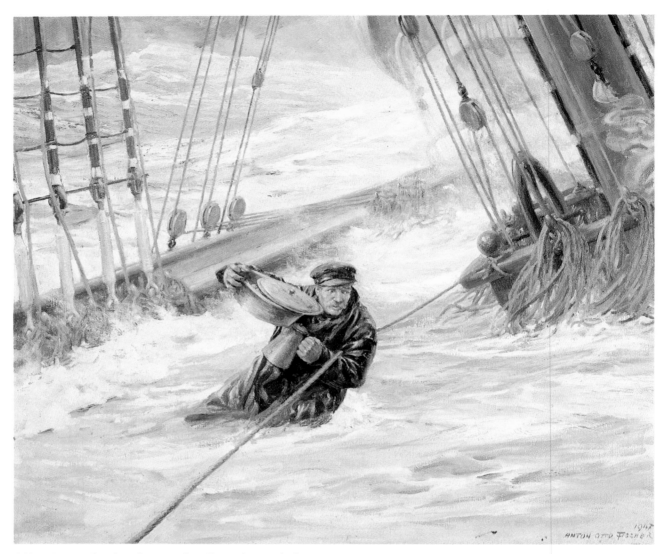

113. *Dinner for the afterguard. Ellis Roberts, the barque's steward, struggles along the swirling decks. He had scant sympathy from the crew. It was an occupational risk of stewards to be disliked, but in a hungry ship he was disliked the more, and the crew would lose no sleep if the dinner for the saloon was lost.*

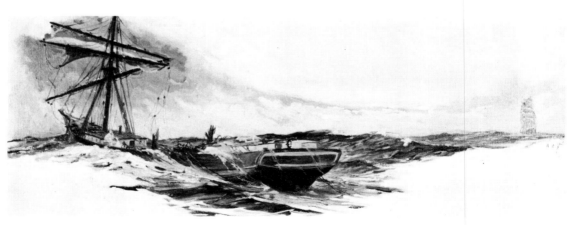

114. *In trouble.*

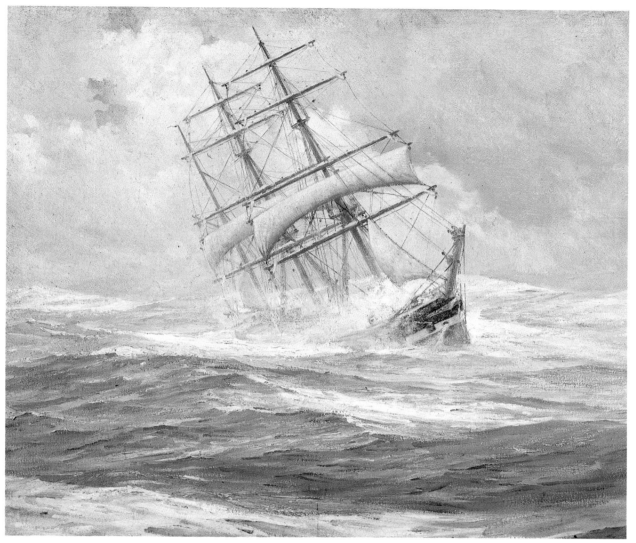

115. The GWYDYR CASTLE hove to off the Horn.

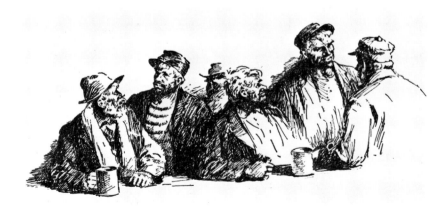

116. New Bedford whaling types.

Whatever the consul at Tacoma may have recorded about the food in the *Gwydyr Castle** there was much substance in the complaints. A.O.F. had not heeded the advice given him in Hamburg to avoid the ship. He admitted that her gear and maintenance was excellent but registered in print his astonishment that Britain, the biggest maritime nation (as it then was) should treat its sailing ship crews so stingily. Of course, there were *some* good ships, whose crews stood by them voyage after voyage, but these were the exceptions. In Callao, he had been aboard a German ship for a meal which was a revelation to him on grounds of quality, quantity and variety.

The salt pork was pure fat and cooked down to nothing, while the beef was of a curious magenta colour and, whatever it was, it was held not to be beef. When cooked, it was so hard that it could not be cut with a knife and my father used a piece to whittle out a ship's hull! That was the measure of it.

Thus, as depicted in Plate 90, a deputation went aft to the Master who, according to his custom, was sitting on a skylight with his lame leg stretched out before him. He got up: asked what was wrong and smelt the offending dish. He said it smelt all right, so A.O.F. produced the model ship. On this, the Old Man called the steward, who alleged that he had bought bona fide provisions but the sight of him—the cause of all the trouble—so inflamed the deputation that they turned on him, reciting all his scurvy tricks and calling him every name in their book. This led the Master to order them forward, and they had to live with the foul provisions, which seemed to embrace every item of diet. Deputations to the Master did act as some sort of safety valve, but seldom achieved any lasting effect.

When bound towards Esquimault, the provisions were so low and so bad that the crew developed boils, together with some unpleasant scalp disease which led to loss of hair. A.O.F. lost the hair on the crown of his head at this time and, long after he was married, caused his family much hilarity by his efforts to restore the hair on the bald spot. Finally, he gave up this vanity in despair, his minor baldness never getting any better or worse!

No doubt the consul was right in his findings that one or two men had gone out of their way to stir up trouble aboard, but there is equally no doubt that his assessment of the food was somewhat wide of the truth. It is a true, if unpalatable, fact that examination of British ships' articles provides irrefutable evidence that, in cases of dispute, the Consular reports almost invariably came down heavily on the side of the Master, and were equally weighted against the crew. Men who had never seen the *Gwydyr Castle* would have known what to expect, from the reputation of her kind!

*Page 127.

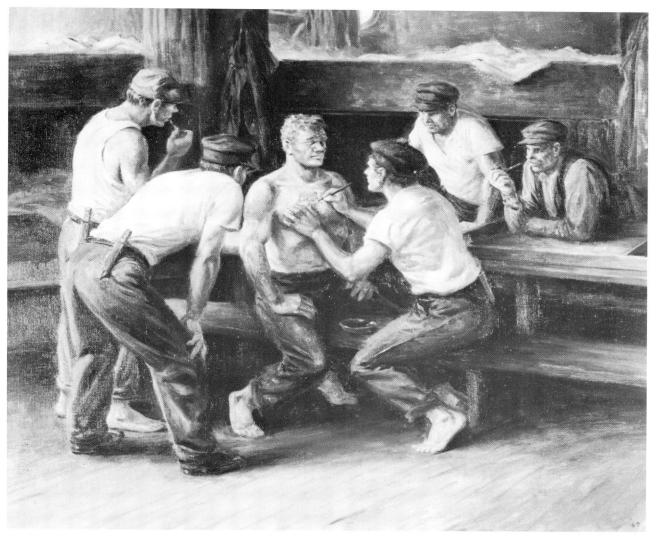

117. The artist.

By the time the *Gwydyr Castle* had left Tacoma, there was no doubt that A.O.F. had a reputation on board as an artist and, when a rather shifty-eyed Swede who had joined the ship there was found to have a solid cake of dried Indian ink in his chest, he was impressed into tattooing his shipmates. Here he is pricking out a full-rigged ship on the chest of J.Eklund, (a twenty-year old Swede from Lulea who was known as "Fatty"), with a steel pen, which was all that was available. It must have been rather painful, but everyone was pleased with the result. After that he went from height to height, his *pièce de résistance* being a naked girl on a man's biceps, which seemed to do a rather questionable dance whenever he flexed his muscles!

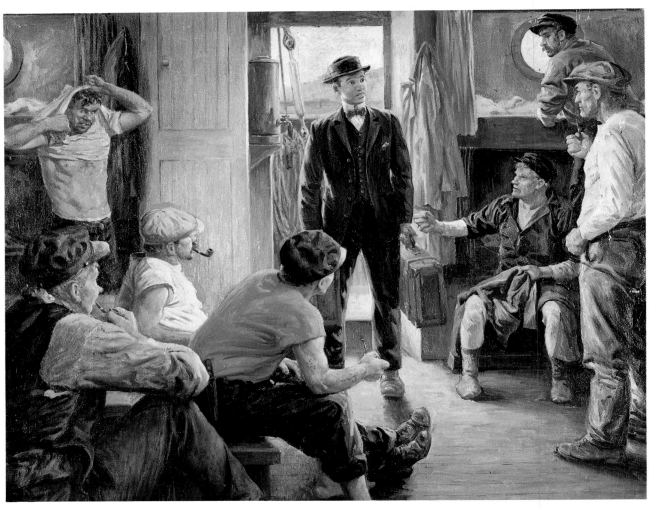

118. *The New Hand.*

This young man, fired by the exploits of the U.S. Navy during the short war with Spain, came from Spokane, in the State of Washington, to try to join it, but being ignorant of what to do or even how to look after himself, he had met Dave Evans and landed up in the *Gwydyr Castle* after she had towed out to anchorage to await replacements for the men who had deserted. Even he thought that the barque did not accord with his ideas, but he was told that he "could not expect to be put aboard a battleship right away"!

Signed on as A.B. (!) he was sea-sick most of the trip to Callao, incapable of going aloft despite all coercion, and was consigned to being permanent "peggy"—washing dishes, cleaning lavatories and the like, all the voyage. He was shipped back home from Callao, after his parents had been contacted! This, at least, was to the credit of the barque's Master, though one may be sure that the parents had to foot the bill!

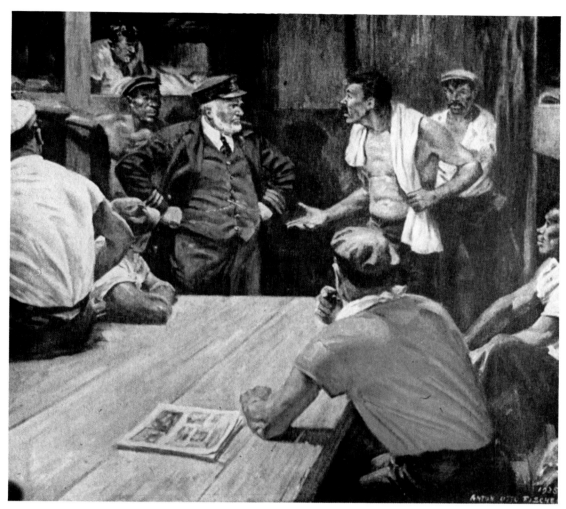

119. Illustration of a first mate confronting Puerto Rican stokers.

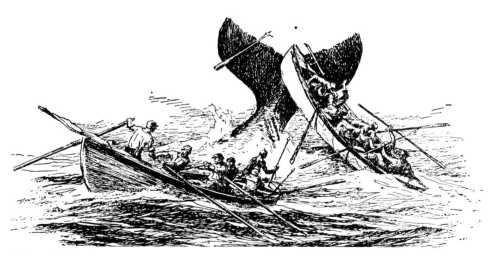

120. Flask's boat is overturned (from Moby Dick).

We do not all like the same pictures best. There are those who regard them as a means of visual enjoyment, but also those, especially amongst sailors when finding themselves confronted by a Marine subject, who must always first attempt to find some slip or error by the artist! Thus, in Plate 117, there will doubtless be critics who would say that the deck-planking is running the wrong way (i.e. Athwartships), since foc's'le tables generally ran fore-and-aft. This might be fair comment but for the fact that, unusually, the *Gwydyr Castle's* foc's'le was broader than it was long, and the table ran athwartships! Abaft it, running across the deck-house, was the galley, just forward of the idler's* cabin to port and the half deck† to starboard: this latter arrangement being also unusual, while A.O.F. never made any mention of the apprentices who berthed in it. The after end of the deck-house was the sail-locker. Her arrangements were not entirely orthodox.

Regrettably, the atmosphere aboard the ship did not improve even after she had left Tacoma and some of the trouble-makers had deserted. There was the rather shifty-eyed Swede who joined the ship: a huge Norwegian who attempted to play the bully until Fatty Eklund called his bluff, and a foul-mouthed German, who, with the Swede, had venereal disease and seemed to be proud of it although, as may be imagined, such men were not popular in the close and confined living of a ship's foc's'le.

All artists make mistakes sometimes. They are no more infallible than those who presume to criticize them. Sometimes, no doubt, they became too absorbed with their canvases to see them as others will: sometimes the mistakes are simply because all the facts and data are not available to them, and sometimes because they have so concentrated on some aspect, which is their subject, that a technical omission occurs elsewhere. Marine artists who have never had the opportunity of emptying salt water from their sea-boots must—and do—fall into many errors, and paint what they believe the eye would see, but they do not really *know* how a scene looked. A.O.F. suffered from none of that disadvantage, and many highly critical and practical seamen have inspected many hundreds of examples of his work without succeeding in unhorsing him on a single point.

However, it would be absurd to pretend that he never did make a mistake (the Historical Battle scenes are considered on page 197) and one of the most remarkable is one of his *Foc's'le Days* paintings of the *Gwydyr Castle* in which he has given her a fishing schooner's wheel (though it is always correct elsewhere)‡ and in Plate 121 the mainyard is actually suspended only by its lifts, with no parrel or sling, while the main top is somewhat odd.

*The carpenter, sailmaker and bos'n (the petty officers), who did not normally keep watches. (They often did in bad weather.)

†The apprentices' accommodation.

‡Plate 218.

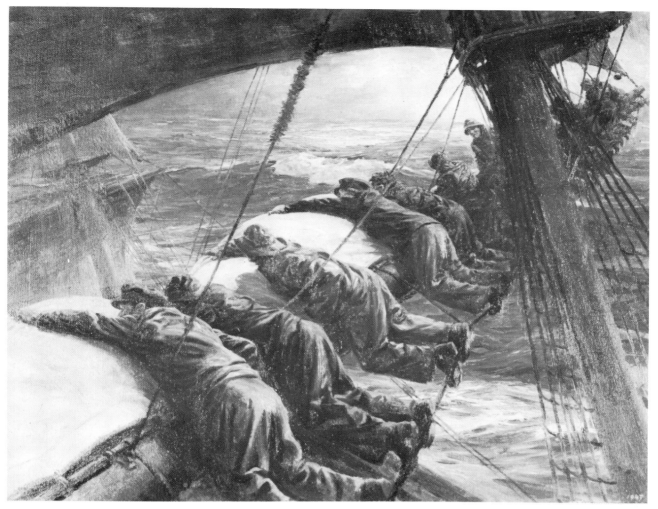

121. Furling the mainsail.

The striking illustration, on page 149 was used in *Foc's'le Days*. By the time that the burial of the old sail-maker took place, the wind had piped up and she was staggering under lower topsails. Thus she was not hove to. Spray was whipping over the weather rail and there was plenty of water in the scuppers. It was a dramatic, rather than a solemn scene, with all hands present save the man at the wheel and the coloured cook, the latter watching from his galley door and puffing his pipe. This subsequently led "Liverpool" Jack to make further hints of foul play and like all trouble-makers, shop-stewards and the like, he was assured of a certain following.

So the old sail-maker, sewn up in a shroud of his own canvas and weighted by a few links of spare cable, is being slid over the side into the storm-wracked sea after the "Old Man" had read the burial service—the ensign which covered the shroud being retrieved prior to its final plunge.

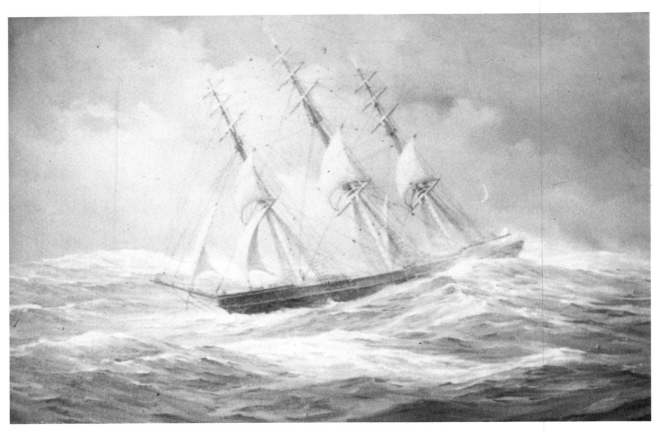

122. A favouring gale.

All the atmosphere of a favouring gale is caught in Plate 122. Perhaps the clipper is making the most of a fair slant homewards round the Horn but, with the force of the weather and the height of the seas, she is running with a reef in her big single topsails. The vessel is probably the *Flying Fish*, or one of her contemporaries, which ranked as the fastest ever built. One feels the drabness of the whole hate of the Southern Ocean in this picture but, equally, one is aware of the great difference between the behaviour of these wooden vessels with such fine ends and their steel, full-bodied successors, like the *Gwydyr Castle* which, under the conditions portrayed, would be scooping several hundred tons of water aboard with each sea that passed, whilst they would be steering abominably. No doubt it is cold enough aboard this ship, and the very air would be filled with flying spume, but it is clear enough that there is no necessity for the life-lines which were so essential in her steel descendants. (Plate 84).

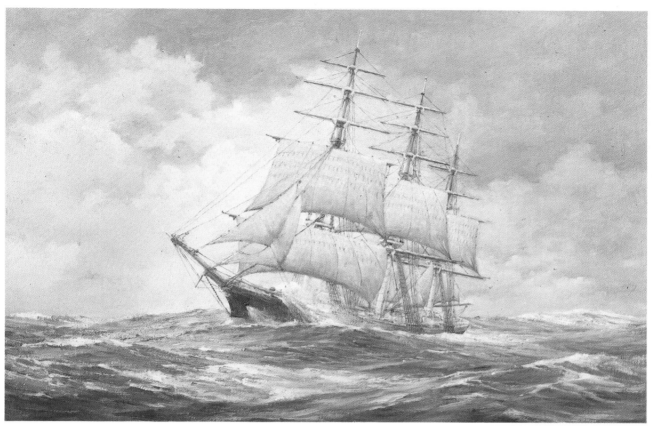

123. Topsail weather.

It is impossible to identify this vessel with certainty, though there is little doubt that A.O.F. had a specific one in mind. She is typical of that great spate of American clipper-ship building after the Californian and Australian gold rushes and is one of that lean, thoroughbred class of ship built mainly between 1851 and 1854. She still has the deep, single topsails and flaunts three skysail yards. There is nothing romantic about this picture: the vessel is in a hard wind with all her upper sails fast but full topsails (i.e. no reefs yet) and a foresail set. Everything is just as it should be: a wooden ship with fine ends, she is not as wet on deck as her bigger steel successors a generation or so later. Few people realise the number of clipper ships built in these years—years when speed was the first criterion: when high freights compensated for a more limited cargo capacity, and when ships were really driven along their ways.

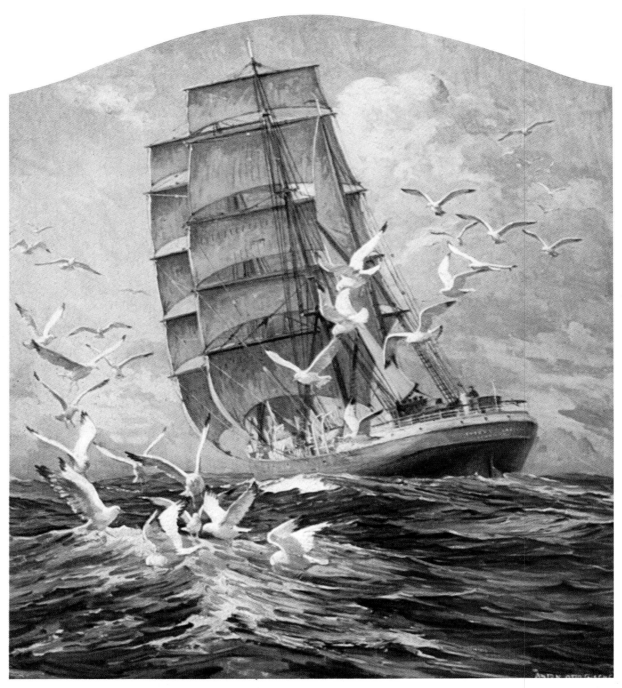

124. *A barque making her departure. (This is not the GWYDYR CASTLE—witness the single spanker. That the vessel bears that name on her counter is scarcely an artist's mistake—rather a nostalgic act of vanity on so fine a study! In fact, this vessel does not have a standing spanker at all, but a lowering gaff, which was most rare in British ships, though common in American ones.)*

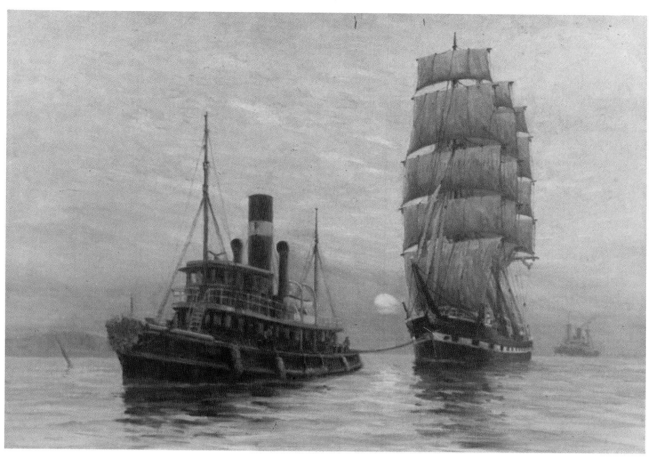

125. *Home again.*

126. *The Fischers' Christmas card, 1947.*

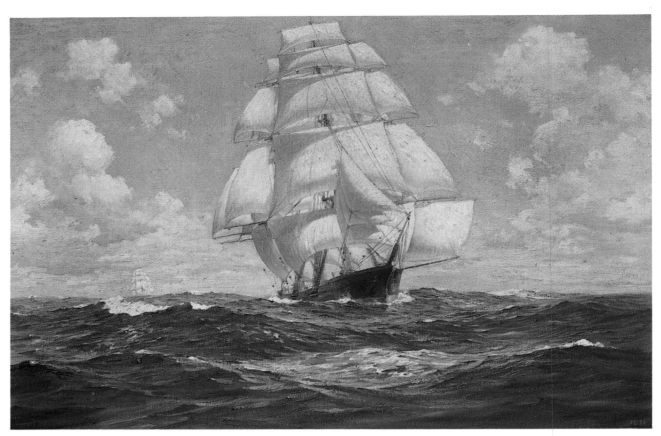

127. Clipper ships racing.

This is undoubtedly the famous packet ship *Dreadnought,* known as "The Wild Boat of the Atlantic" under her redoubtable commander, Capt. Samuels. The ship and her performances became a legend, and she was the only one of the St. George's Cross Line (the insignia being on her fore topsail), since the others were quickly lost before the *Dreadnought* came into service. Certainly Samuels was a man to crack on sail, but it is doubtful whether lee stun'sails would have done any good with the wind slightly on the port quarter. In fact, they would probably have come aback and acted as a brake, but there was never a marine artist who could resist such a picture! Maybe the hull is reduced a little to give an extra impression of height, but it is an effective canvas, showing the clean line and simplicity of the American clipper ship. Finally put in the Cape Horn Trade, the *Dreadnought* went ashore in calm in the Straits of Le Maire long after Samuels had left her.

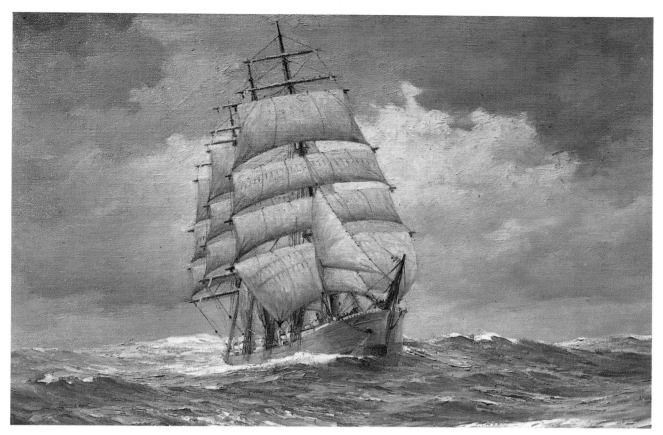

128. The SHENANDOAH.

This picture is titled *Shenandoah* with reasonable certitude. A three-skysail yard, four-masted barque built of wood (witness her stem) and with a spike bowsprit and outside channels leaves little doubt. Her near sisters, the *Roanoke* and *Susquehanna,* were built in the same manner, and were the largest wooden ships of their rig ever constructed. The *Shenandoah* was the pride of the American Merchant Marine and figured, as an engraving, in many official shipping documents. Her master, scarcely less famous than Capt. Samuels in his generation, was Capt. Jim Murphy and, built in 1890, she had a great career, famous the world over, until she was converted to a barge in 1910. Her trucks were said to be 217 feet above her deck, making her a very lofty vessel indeed. In this picture, she is not far off the land, since her cables are shackled on to her anchors.

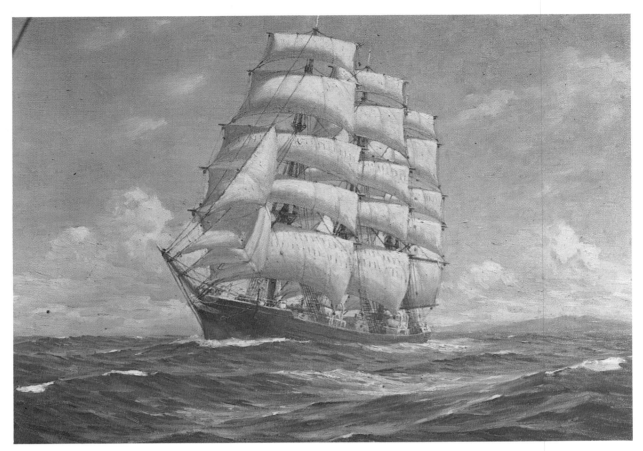

129. *Making a fine departure. A full-rigged ship, in ideal sailing conditions, clears the land.*

130. *Safe Harbour.*

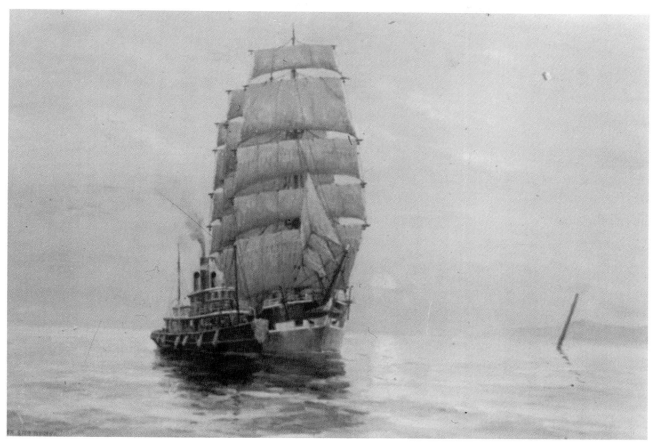

131. Towing in. Another of the 'Home Again' series, painted in 1955.

132. Coming alongside.

133. *Fair wind in the moonlight with a rising gale.*

134. To the Rescue.

British readers may not identify the term "coast-guard" as used in England with the wide applications of the U.S. Coastguard service. In Great Britain, a coast-guard is shore-based. Originally formed against smugglers, he often takes part in rescues from wrecks around the coasts, and keeps a look-out. In the United States, on the other hand, the service is the British Trinity House; Board of Trade Marine Department (as it was) rolled into one, together with such duties as maintaining the standards of safety even of yachts, maintaining the ice patrol, and hydrographic work, to name but a few. It is a vast, efficient and, mainly, safety service in peace-time.

In this canvas, one of the Banks fishing schooners is in real trouble. Her dories are all swept away—not that that matters to her survival:— her mainmast is broken off at the deck; she is well down by the head and her foresail and headsails are in tatters. One concludes that her decks have been truly swept, and all her men are gathered aft awaiting their rescue.

135. *A steamer in peace-time paint.*

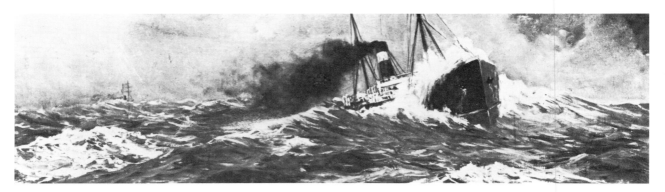

136. *Butting into it.*

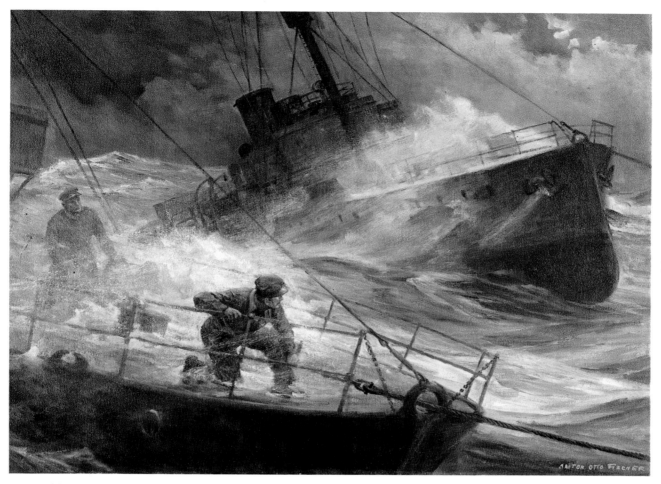

137. Wartime encounter.

Plate 137 tells its own story, the very weather militating against fast manoeuvreability.

In the foreground of Plate 138 is a swathe of broken water through which a ship has just passed. Beyond lie a couple of the old four-stacker destroyers which had been lying in moth balls off San Diego since the first war, and some of which were exchanged with Great Britain for useful bases in the Caribbean when she had her back to the wall—a hard bargain. Beyond the destroyers and alongside them is a big tanker—big, that is, by the standards of the times, when an 18,000-tonner was a "monster". Astern is a merchant ship under way in the channel.

Head-quarters and recreation rooms alike were in rough buildings ashore, joined by snow-rutted roads covered in frozen mud over the stoney surfaces under the treeless hills. It was a poor place to relax between convoy duties.

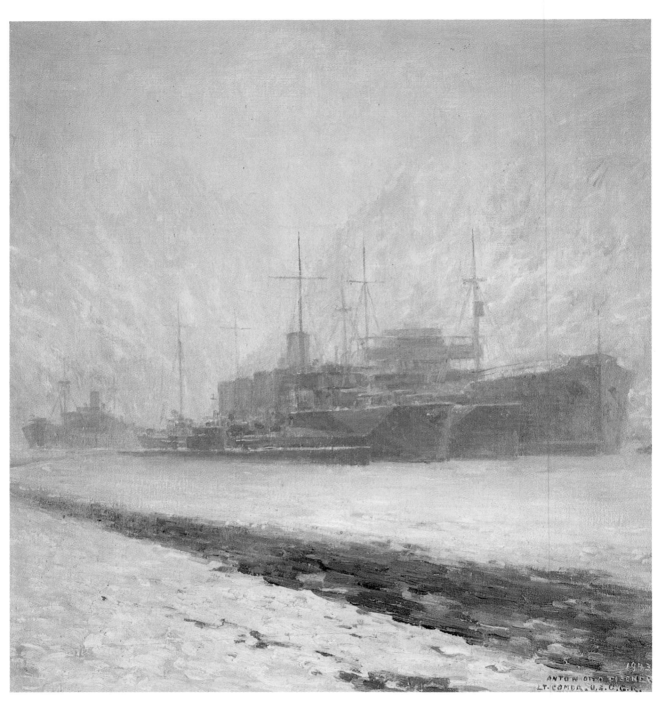

138. *Ice-bound in Argentia.* *(see p. 88).*

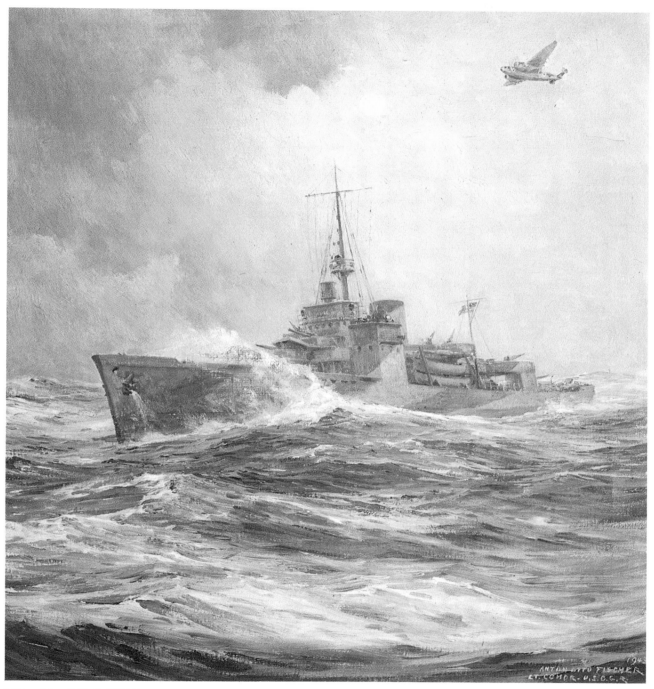

139. The *CAMPBELL puts to sea (p. 88)*. *At full speed, in worsening seas, the cutter steams at full speed to meet her convoy which has already left Halifax, while a camouflaged Vega Ventura flies overhead on anti-submarine patrol.*

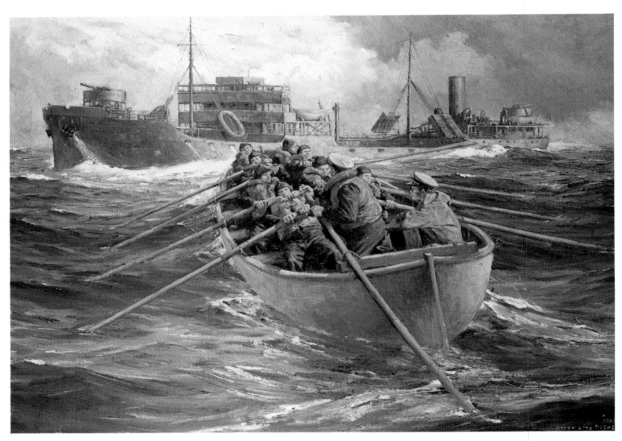

140. A U.S.P.H.S. doctor being pulled to a tanker.*

The boat is pulling towards the tanker to fulfil some urgent medical need. She is clearly American since she carries a defensive gun forward and has a turret around both 4″ guns; two features which were not normal in other nationalities. An officer is seated aft with the Chief Boatswain at the steering oar. This is very typical of the appearance of war-time vessels, with her paint a sombre grey and her rafts in the shrouds ready to let go on the instant.

*United States Public Health Service.

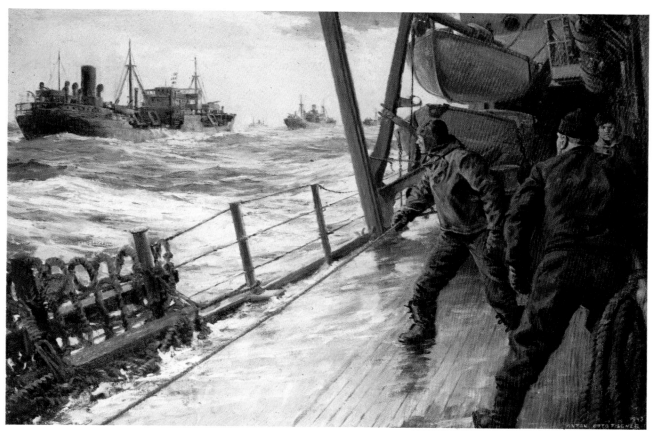

141. *Tallying the convoy.*

On January 29th. 1943 the *Campbell* cruised up and down the lines of such of the convoy as had been re-assembled after the bad weather to check the names and numbers of sixteen of them. This gave A.O.F. superb material for both sketch-book and palette.

People do not realise the extent of a convoy on the face of the sea, even in fine weather. There were seldom more than five ships in any column, two cables between each, and the columns were spaced four or five cables apart. In practice, most diesel vessels had a critical speed, dependant on the pitch* of their propellers, which created excessive vibration and at which they could not steam. All too often, this was the convoy speed, which meant that each diesel ship would be dropping back and then catching up her position all the time, with a consequent enlargement of the whole area of the convoy.

*The "pitch" of a propeller is the distance that it would advance in one revolution through a solid substance—i.e. something unyielding, unlike water. It depended, in large measure, on the angles of the blades.

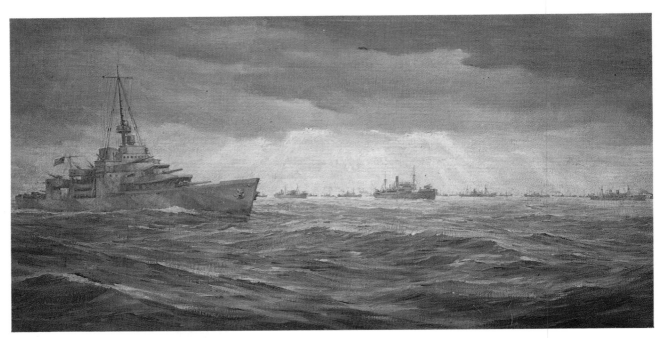

142. After the storm.

In the foreground the *Campbell* is on station, with the serried ranks of the ships left in the convoy spread across the sea "touched", as A.O.F. remarked, "with a benediction of light that fell in shafts through the overcast and washed the rows of dirty freighters with bands of gold." Such scenes were immensely impressive, and all the more lasting when one considers the shortness of the day in those latitudes at that time of year. The canvas succeeds admirably in giving an idea of the area of sea covered by only a part of the depleted convoy.

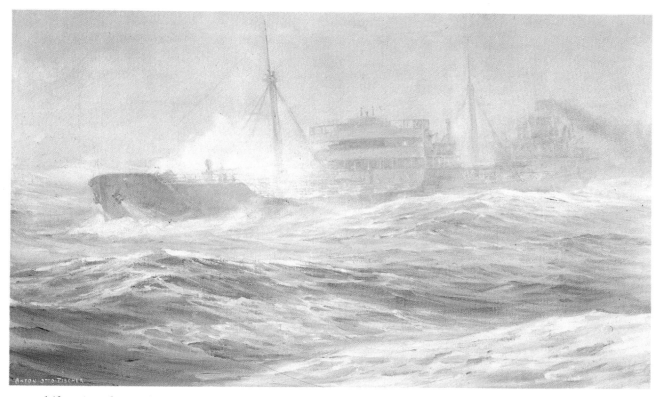

143. A tanker in heavy seas.

Often enough a tanker's decks would be like a half-tide rock, since she seldom had bulwarks along her well-decks, but rails, whilst the tank-tops and pipes, with their valves, broke up the invading seas in spectacular fashion. Having no vulnerable hatches to protect, a tanker, all else being equal, was enabled to steam into appalling weather much longer than a conventional cargo ship which, in worse conditions than those portrayed here, might have to heave to.

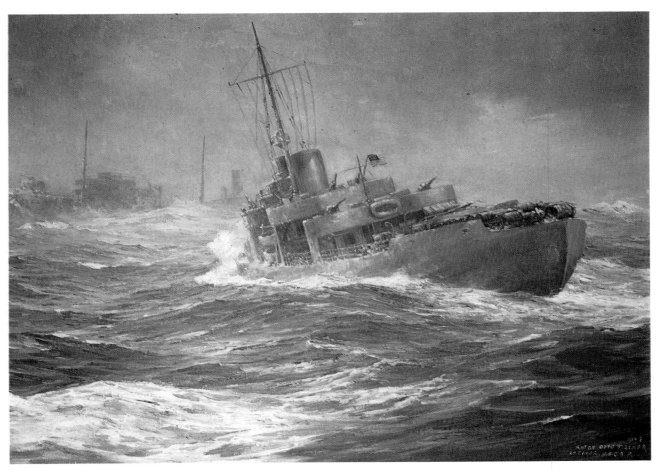

144. *The errant tanker. An escort vessel rounds on a 'straggler', to bring her back into the convoy.*

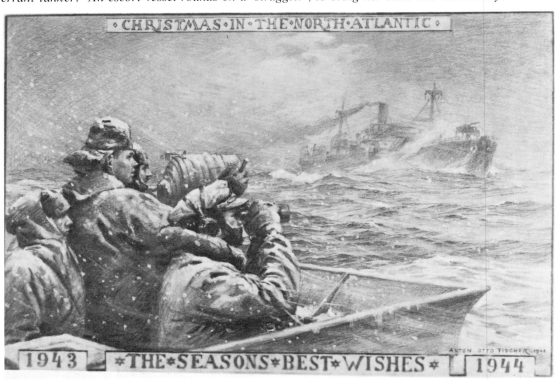

145. *The Fischers' Christmas card, 1944.*

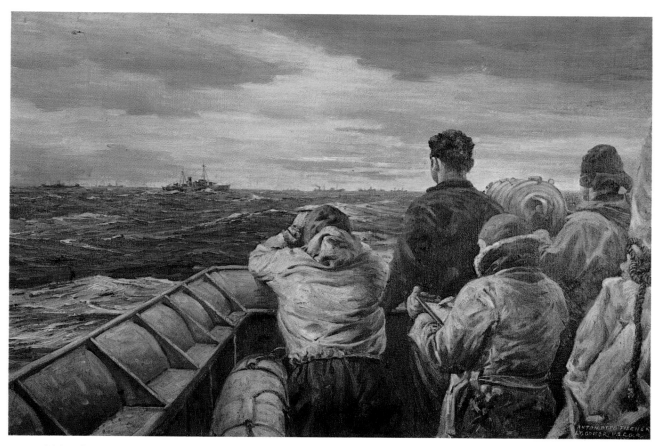

146. Signalling a corvette.

With the convoy strung out across the horizon against the sunset, the *Campbell* signals by Aldis lamp to a Canadian corvette to check on the units of merchantmen which are still scattered. Much of the voyage she had been iced up and the official photographs show men breaking thick ice from deck and guns. This evening is not quite so bad, but the sunset sky belies the frigid temperature, and the signalman, noting the message down on his pad, must have been doing so with much difficulty.

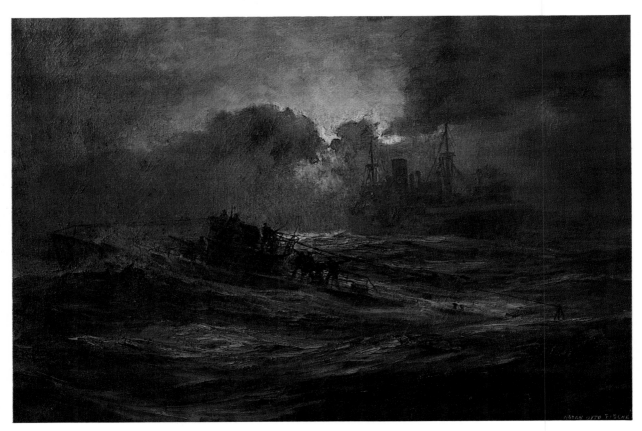

147. The fate of a straggler.

The freighter, separated from her convoy, is now on her own as the wolf-pack closes in. So, as the real wolf-packs, from which the packs of U-boats took their name, will always fall on the deer which falls behind the herd, one of the submarines comes to the surface in the gathering dusk to claim her first victim—a vessel now unescorted and defenceless. She knows that she is relatively safe on the surface, where she has greater speed and manoeuvreability, and that the odds are that she will not be spotted at all while, even if she is, her victim's gun crew are not at the ready and will take time to be assembled. This situation was the dream of every U-boat commander.

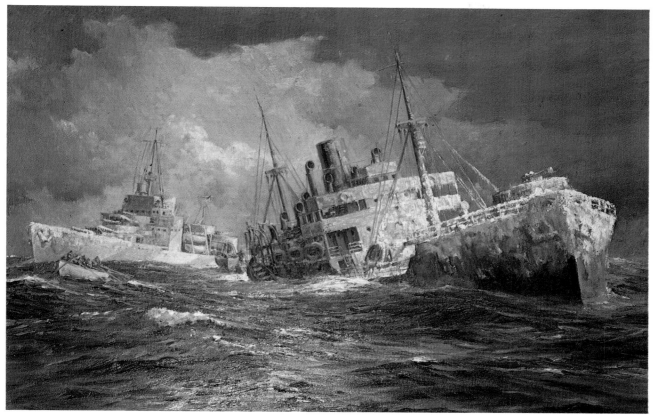

148. *Abandoning ship.*

The rest of the convoy has passed ahead to leave a stricken ship, with all way off her, as she lies wallowing and sinking deeper in the water after being torpedoed. The cutter stand by to pick up survivors.

The merchantman is listing well over to starboard and it would now be impossible to launch the port boats. Perhaps one has already got away. The forward fall of the midship starboard boat has apparently been let go, and the boat lies bow down in the sea, still attached to the after fall. Men can be seen launching the after starboard boat. In addition to her list, she is well down by the stern. Note, too, the ice formed all about her bow; her foc's'le head rails and her gun turret forward. It is no weather to be abandoning ship and it is well that an escort is available to pick them up, since there are strict limits to the time of survival in boats in those sort of temperatures at sea—let alone for any who may have been decanted into the water when the boat was up-ended.

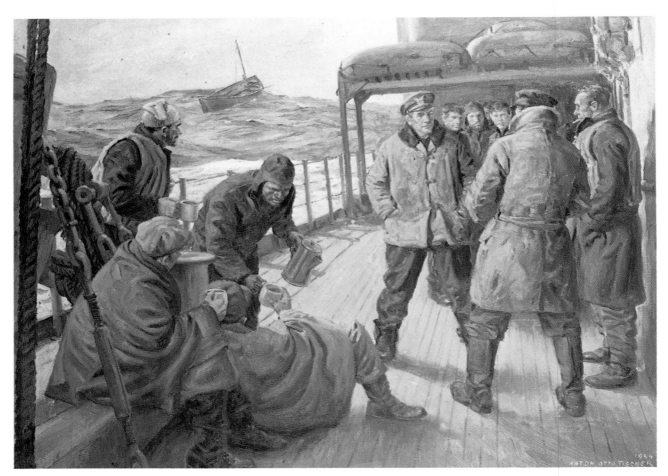

149. Survivors on deck.

A.O.F. painted innumerable pictures of the convoy war in the North Atlantic as a result of his trip in the *Campbell,* only a selection of which can be reproduced in this book. There was a close-up of the night-action with the U-boat (p. 157), showing the cutter opening up with all her armament at point-blank range while Germans jump into the sea or stagger back wounded or killed. There was *The Wake of the Convoy* showing a drear Atlantic sea with, floating upon it, the flotsam of the sunken ships. There was a dramatic picture of the *Spencer,* pretty well iced up, cutting through the sea astern of the *Campbell* while, in the foreground, men haul in a line with a casket of confidential papers. Others showed the transfer to the *Burza* and there were plenty more though, unlike Van der Velde, A.O.F. did not paint himself into the pictures!

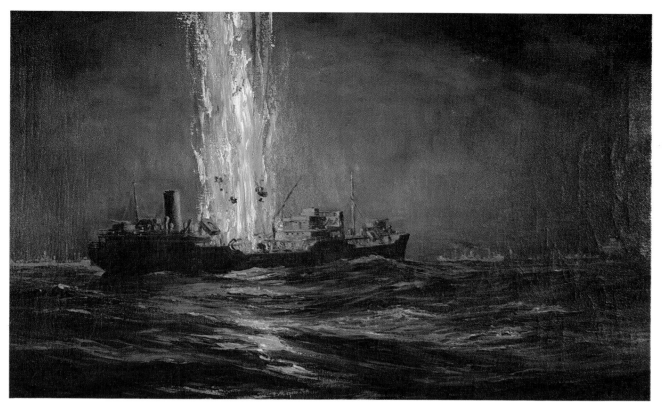

150. A torpedoed tanker.

To those who have never seen it, the whole lurid scene of Plate 150 may seem over-dramatised. In fact, quite the reverse is the case since the tanker is shown after the moment of impact. The scene was as awe-inspiring as it was fearful to behold. As the fire spread in a tanker carrying high-octane spirit, it reflected down off the cloud and up off the sea until the whole world seemed to be in the grip of the awful reckoning of Ragnarok. The ships in the further columns are already illuminated and, in a few seconds, the ship will be a blazing inferno. Alex. Hurst writes:—

"I recall a tanker immediately ahead of us being torpedoed one night when I was on watch. I had the helm put hard a starboard and only straightened up when almost in the next column but, as we passed her, the heat was too great to stand on her side of our bridge and, in the morning, all the paint on our port side was blistered. It was a terrible fate for her men. On another occasion, when in such a vessel myself, she did not catch fire until after we had abandoned her and she was in two halves, a mile or so apart. (We had been able to inject steam into the tanks and avert immediate explosion.) Yet everything seemed red even when the ship which rescued us was over the horizon and out of sight of the burning wrecks. There is no over-emphasis in Plate 150: the scene was as dramatic as a man could see—dramatic as it was terrible."

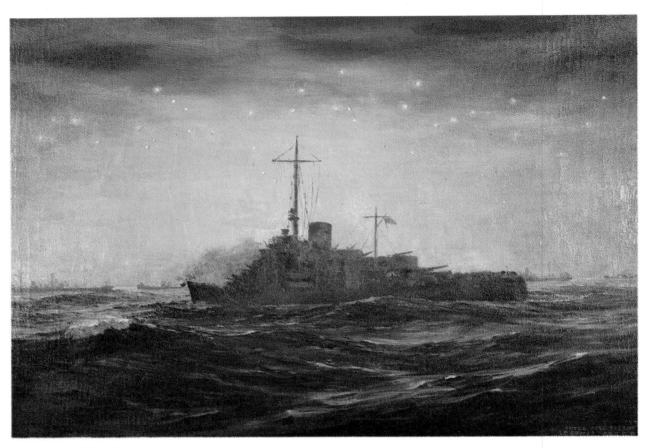

151. Star shells.

The convoy is under wolf-pack attack and a ship is hit beyond and ahead of the cutter's bows. The star shells have been fired above the ships and, although a fine pyro-technic display which people ashore would pay money to watch, the object is to illuminate any submarine which may be running on the surface. That the merchant ships are also illuminated makes little odds at that stage of the game. They were already under major attack and the elimination of the U-boats was more important than pretending a concealment by night, which no longer existed.

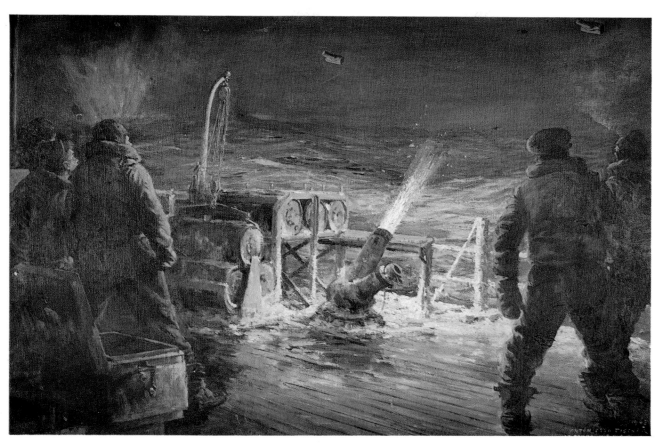

152. Firing depth charges.

This may not be a familiar scene to many merchant seamen who were in ships supplied with depth charges, since they did not normally fire them, but simply rolled them down a chute over the stern, set to explode at a pre-determined depth. Since their speed was relatively slow, and since they could not have progressed far from the point where they were dropped, it was dangerous to have too shallow a setting, lest they damage themselves more than the submarine!

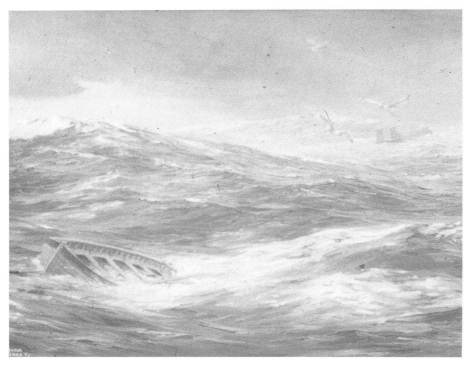

153. *The wake of the convoy. The boat, a case of aeroplane parts still floating, etc. testify to the weather experienced.*

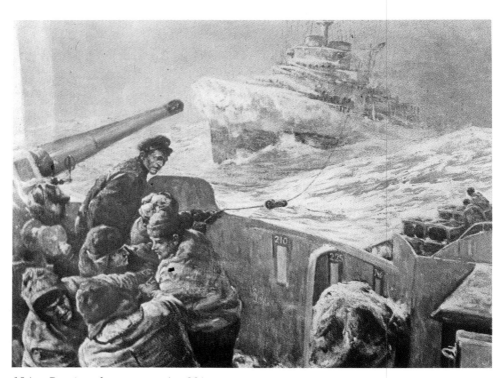

154. *Passing the papers. (p. 88).*

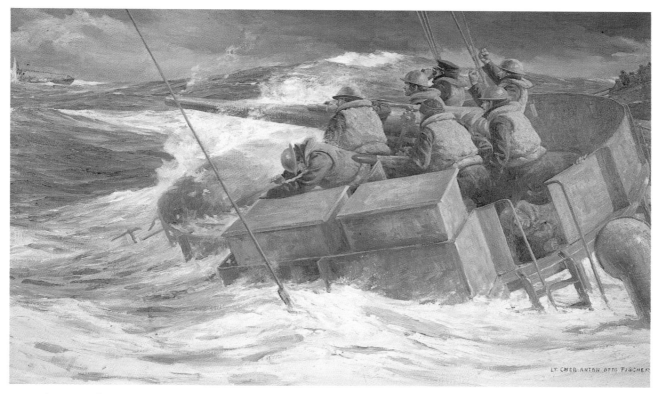

155. *Fight to the last.*

Their ship virtually sunk beneath them with only their gun turret still above water, and with one of their number slumped forward too badly injured to continue with them, the gun's crew fight the U-boat which has already sunk their vessel till the last moment, while some of their shipmates pull away on the other side of the picture.

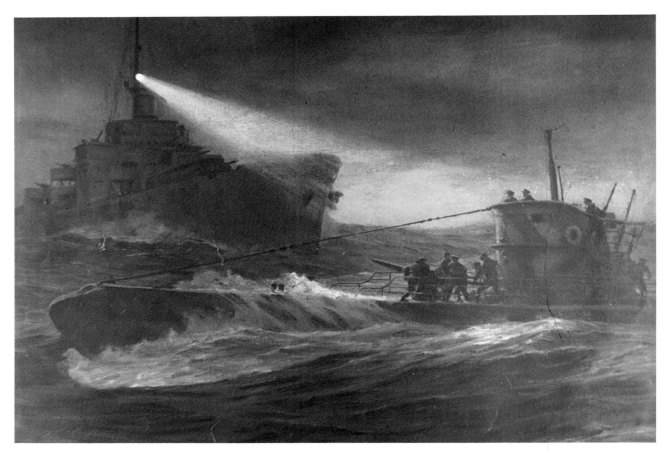

156. The CAMPBELL sights a submarine close on the surface.

157. The CAMPBELL pours a murderous fire into the U-boat.

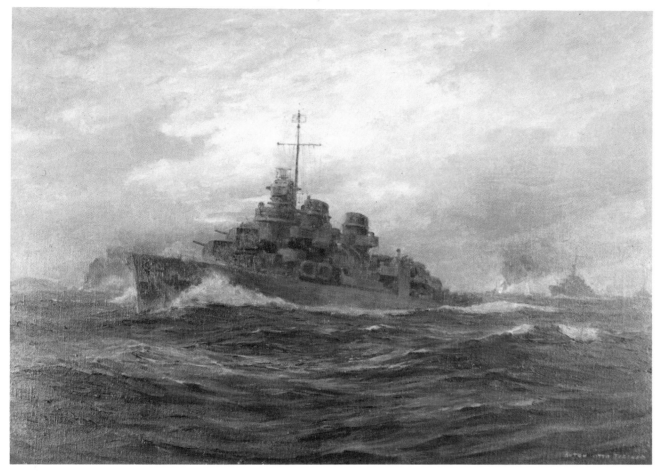

158. *The Little Beaver squadron. This painting was presented to Admiral Arleigh A. Burke who, as captain Burke, was commodore of the famous 'Little Beavers', as destroyer squadron Number 23 was known in Admiral Halsey's third fleet in the Pacific. After a famous raid on the Japanese warships in Augusta Bay in the Bourgainville campaign, their commander became known as '31-knot Burke'. Later the squadron were operating in the Guadalcanal area.*

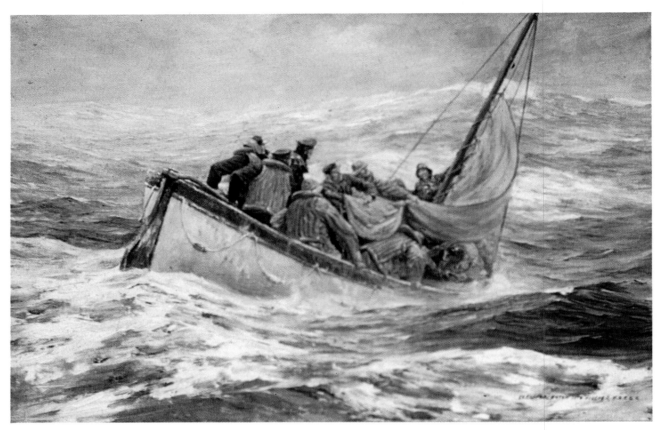

159. Worsening weather.

Steam-ship men were generally out of their element in lifeboats with, in bad weather, a motion to which they were utterly unaccustomed. Nor did many understand the run of the sea and the principles of sailing a boat when it came to the point. Lifeboat drills in a sheltered dock were a far cry from this scene. The weather is worsening, and they know they have no chance of being sighted until it moderates. They are hauling down the sail and probably about to lie to a sea-anchor. The life-jackets, making a man seem larger than life, created awkwardness in the cramped conditions of a lifeboat. A.O.F caught it all—even the two men forward on the lee side who are doing their best to keep out of the way and not to hamper the operation.

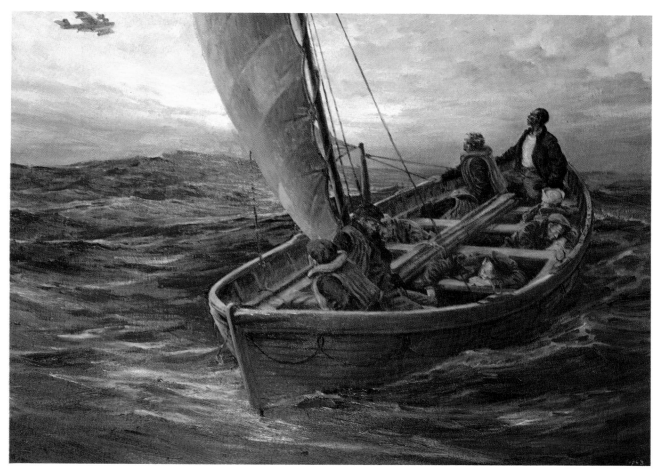

160. *Sighted at last.*

A.O.F. repeated a number of *motifs* on this theme. The men are almost in a state of exhaustion. Exposure is the great enemy in an open boat in high latitudes, for the temperature is always lower just near the surface of the water than, for example, on the deck of a ship, and a man is almost breathing in salt when in such close proximity with the sea.*

Few of the survivors are in any condition to take any notice, but the negro at the tiller, who seems to be the most alert, with the man next to him, have seen the reconnaissance 'plane, as has the man, one feels with more effort, who is up in the bow. They know that the 'plane can do nothing for them immediately, but that at least she will report their position and predicament.

*It is not commonly realised by landsmen just how close is the sea-horizon from a ship's boat. It is seldom more than two miles, though the upper works of a steamer will be seen further than that. Where 'h' represents the height of the eye above the sea in feet, the formula for determining the distance of the sea-horizon in miles is $1.15 \times \sqrt{h}$.

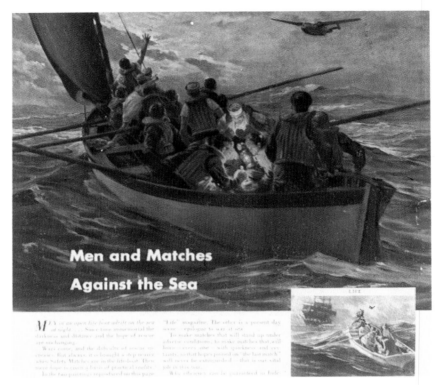

161. The 'Sighted at last' theme as an advertisement.

A.O.F. produced a multiplicity of Marine pictures for advertising purposes which were equal to any of his other canvases. In their original form, of course, they had no lettering on them. This one is for a safety match firm, but, although the men are in better case than in Plate 160, the theme is much the same.

Despite A.O.F's pictures of boats at sea after ships had been abandoned, it was a sorry truth that there was a great deal of gross incompetence manifested in their launching and handling in a large number of cases during the second World War. Few of the men had ever been either in sail or in coastal craft with low freeboard or in fishing craft, and thus they had had no real experience of the run of the sea nor of practical seamanship. It was not their fault. They were, for the most part, "seamen"—not "sailors".

A.O.F.'s career at sea had not been long, but it had been concentrated and, for the most part, in vessels where these attributes were learnt and never forgotten. That his understanding of the whole movement and run of the sea was profound is clear from his canvases. Indeed, he would have been a good man to have had in charge of a boat in North Atlantic weather!

There was nothing new about war at sea. Like most marine artists, A.O.F. occasionally produced canvases of historical battles and sea-fights. In the light of the wealth of research that has taken place during the past half century, it may be thought that, in one sense, they were amongst his least successful works, though this aspect would only strike anyone who was expert in the period and in the subject.

An artist should, of course, produce an aesthetically pleasing picture and, even if he is a representational worker (as A.O.F. was) it is no sin to omit certain details which would detract from the subject matter, but it inevitably excites criticism when he inserts technical details inaccurately. Yet all artists are human, and make mistakes sometimes. When Montague Dawson painted perhaps his greatest work, of the Battle of Trafalgar, after very great research, the finished result was to imply that the sun was in the *North* which, to say the least, taxed the credulity of all who saw it!

Many marine artists, it must be said, have made no effort to research their subjects and relied on the ignorance of the public at large—usually with some success. Others probably spend more time researching their subjects than actually painting. In these days there is a good deal of material available to this end and such artists as Derek Gardner in England produce pictures in which one may be sure that they can support and justify every detail. In A.O.F.'s time, such sources of information were simply not available, and I have no reason to think that he ever had access to William James' six volumes of *The History of the British Navy,* or that he had even heard of them. Granted that it was published in the 1820s, but it was never a popular book in the United States, against which it contained a certain bias.

The fact was that A.O.F. painted the ships concerned as he believed them to be and, where his knowledge was inadequate, he painted the details as *he* had known them—almost a century later! Much had happened in the intervening years and the rigging of ships had changed out of all recognition. He must have painted almost every conceivable type of craft, from outrigger canoes, through junks and dhows, to all sorts of local rigs which were outside his own personal experience, and in these he could seldom be faulted. It is thus abundantly apparent that he *did* research his subjects so far as he was able, but that the information on fighting ships of the Napoleonic age was simply not available to him and, fine as his pictures of the subjects are pictorially, to the *élite* band of purists, they are technical disasters.

The *Bon Homme Richard* had originally been built for the French East India Company as the *Duc de Deras,* but was placed at the disposal of John Paul Jones

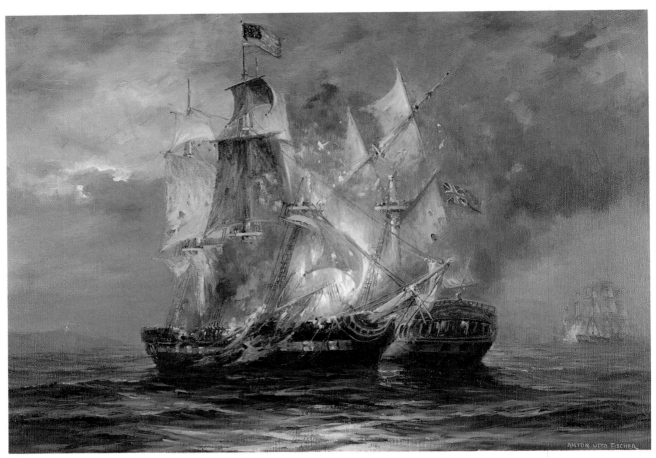

162. *The BON HOMME RICHARD engaged with the SERAPIS, north of Flamborough Head, September 23rd, 1779.*

in June 1779 by King Louis XVI and re-named in honour of Benjamin Franklin. She set out on a cruise with the American *Alliance* and three French ships, Jones being accepted as nominal leader of the expedition.* Off Bridlington the British fleet was sighted in the bay, and it soon emerged. The *Bon Homme Richard* engaged the frigate *Serapis* about 7.0 p.m. and, receiving the worst of the battle, Jones determined to board. He had lost the use of a number of his guns, and was subject to superior fire-power. His ship was making water and could not stand further continuous broadsides. In a break, the *Alliance* appeared, to the joy of his crew, but she, mistakenly, gave *them* a broadside! Finally Jones did manage to secure his bowsprit to the *Serapis'* mizzen, but, as the ships were in the final position in A.O.F.'s painting, the *Serapis* raked her sides again. Both ships were on fire: explosions were imminent, and the *Bon Homme Richard* finally sank but, just previously after a powder explosion, the *Serapis* struck her colours. It was a Pyrrhic victory.

*The command was not clear cut, since the French had supplied most of the ships.

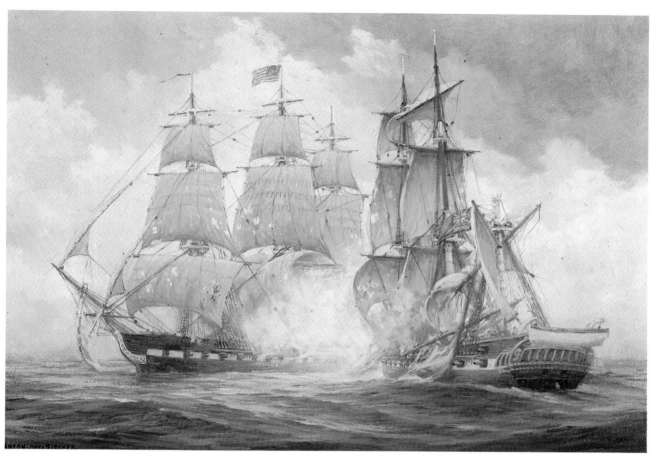

163. The CONSTITUTION engaged with the JAVA off the Brazilian coast, December 29th, 1812.

This action started at 2.45 p.m. and, within seven minutes, the *Constitution* shot away the *Java's* jibboom. At 3.08 her foremast came down and, seven minutes later, the *Constitution* raked the *Java* from ahead, shooting away her main topmast. Soon afterwards she passed down her starboard side and then, luffing up, raked her on the starboard quarter.

One would assume this picture to represent an early stage in the action, since the *Java's* foremast is still standing, though her mizzen topmast is shown as being shot away. This did not, in fact, occur until just after 4.0 p.m. when the whole of the mizzen mast went by the board.

Both ships are shown with crossjacks, though this sail was not used for another thirty years. The *Java* would have worn a Blue Ensign, as shown, but perhaps A.O.F. did not realise that the St. Patrick's Cross was incorporated into the Union in 1801. Even the American flag is wrong since, in 1812, there were fifteen stripes, of which eight were red and seven white, with fifteen

stars arranged in five rows of three. When the *Constitution* went into action, Commodore Bainbridge wore his broad pendant at the main, and the ship had ensigns at the mizzen peak and the main topgallant masthead.

There are more technicalities wrong with these pictures than can be described here. Certainly the *Bon Homme Richard* would not have had such a bow and, at the time when the ships were alongside, shortly before the *Serapis* struck, Paul Jones' vessel had two or three feet of water in her: was pretty low in the water and unable to manoeuvre properly, and her hull was afire near the magazines. At about this point, making water fast, and with most of his armament out of action and most of his starboard side shot away, John Paul Jones made his historic retort to Capt. Pearson of the *Serapis* who asked him if he wanted quarter. He replied:— "I have not yet begun to fight!"

In the *Constitution* and *Java* action, it now appears that the ships would have had black hulls with bright yellow streaks down the gun-port strakes, for white was not adopted by the British Navy until about 1818, and it seems that other nations followed suit. The *Constitution* carried four rows of reef-bands in her topsails in 1812—not three, but A.O.F. is correct in showing her with some sort of billet, since she lost her figurehead of Hercules with upraised club in a collision with a sister ship off Tripoli in 1803. The ship was re-built in 1833, and it was then that her head was boarded, as portrayed by A.O.F. In 1812 it was open, as in the ships of other navies.

In the *Guerrière* painting, many of the foregoing comments apply, while the ensign at the *Constitution's* main is incorrect. She wore one at the peak: one lashed to the starboard mizzen rigging and a third at the fore topgallant masthead. When three miles from the *Guerrière,* at 4.30 p.m. the American vessel reduced sail to double-reefed topsails, but later, about 5.40 p.m., when the action had been in progress almost an hour, she set her main topgallant-sail, though it would seem that the topsails remained reefed.

The painting appears to show the moment of the *Guerrière's* surrender, with her ensign being hauled down yet, at the time, she had no masts left standing at all, and her only battle flag was an ensign set on the stump of the mizzen. The *Guerrière* seems to be too long altogether, and in both her case and in that of the *Java* the stern davits achieve undue prominence since they are the wrong shape. They were actually much flatter and followed the line of the bulwarks when they were carried. In Pl. 163 the *Constitution* has royal yards crossed, but not in Pl. 164. In fact, all those American frigates carried skysails, but neither picture shows the skysail mast. (The yards would not necessarily be crossed.)

Many American vessels of that period did have white lower masts, but the British *never* had. Thus the *Guerrière's* lower masts should be brownish-yellow, and her doublings and yards were indubitably black, which was the invariable custom in the British navy. Then again, A.O.F. has painted the ships' tops almost as though they were those of the *Gwydyr Castle,* whereas their width was roughly one third of the beam of the ship at that period. In the same way there are innumerable points of rigging incorrect, and many omissions in the *Constitution* in Pl. 146.

In this plate, the records show that there was absolutely glass-like calm, which is not borne out either by A.O.F.'s water or by the look of the sails. It would certainly have been an occasion when the skysail yards would have been crossed, in the hope of a breath, though there does not seem to be any record of whether or not they actually were sent aloft. It may be a little harsh to suggest that the British ships only appear to be about a quarter of a mile astern since, had they been delineated at their correct distance, the picture would have lost its whole effect. This aspect, together with the implication that, in consequence, the shot only seems to be carrying about 200 yards, must surely be deemed to be fair artistic licence!

Nevertheless, these comments,* with others which might have been made on the same lines, do demonstrate two things. First, that an artist is on very dangerous ground when he attempts paintings of subjects which require an extremely specialised knowledge and in which he may create errors which would never occur to him to be errors at all and, second—and perhaps the more important one in this case—it can be assumed safely that he did the best he could with the material and sources available to him. Perhaps he had not succeeded in discovering all that was available, but it is certain that, with the research that has been done since these paintings were executed, it is very easy to point accusing fingers at this or that inaccuracy, and much of the information now available to the critics was not discovered in A.O.F.'s day.

Many experts make mistakes. Only seldom were expert artists present at battles. Van der Velde was the one great exception. Once an acknowledged expert makes a mistake, it is apt to become self-perpetuating, since those who come after assume him to have been right. Indeed, Viking "long"-ships have been portrayed so often with shields in their shield-racks at sea, that they are believed to have sailed thus. They *never* did!

*There is no implication that they are not extremely striking and stirring pictures, which have been accorded much acclaim. Indeed, one hung for a long time in the offices of the Secretary of the Navy and the Chief of Naval Operations. All now hang in the U.S. Navy Memorial Museum at Washington. The criticisms in the text are purely on technical counts and—to many—are purely pedantic!

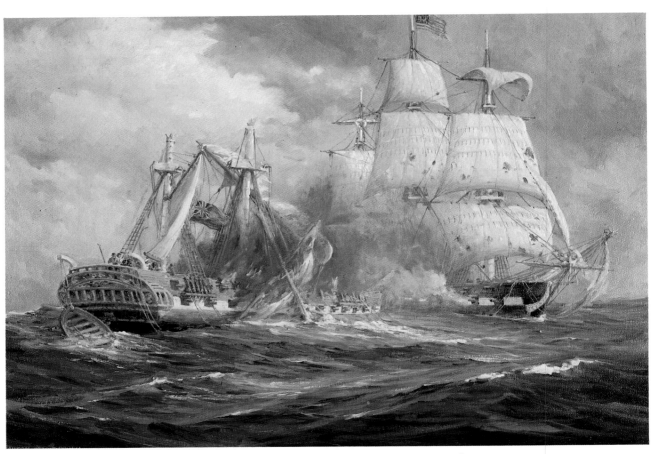

164. The engagement of the CONSTITUTION and the GUERRIÈRE in 40° 20′ N, 55° W on August 19th, 1812.

With a fresh nor'westerly wind, the action began at about ten to five in the afternoon and, a quarter of an hour later, the *Guerrière's* mizzen mast went by the board and knocked a large hole in her counter. After another hour and a quarter of close action, the British ship's bowsprit fouled the *Constitution's* mizzen rigging and then struck her taffrail. Since most of her shrouds and backstays had already been shot through, the shock of striking slackened up her forestay and thus brought down the damaged foremast and, rather on the principle of a ship in a bottle, this brought down the mainmast with it, so that the vessel was left as a dismasted and virtually defenceless wreck, "rolling her main deck guns in the water" as a contemporary account had it.

Once again, it is clear that A.O.F. was not appraised of the precise details of the action.

The *Constitution*, under Capt. Isaac Hull, and bound out from the Chesapeake towards New York was sighted by a British squadron at 3.0 p.m. on August

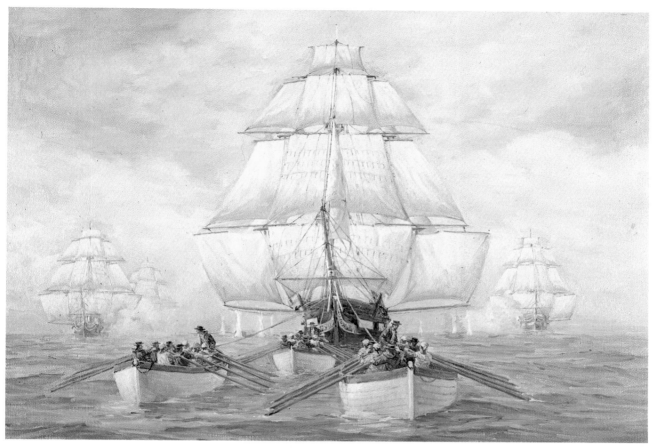

165. *The flight of the CONSTITUTION off the American coast, August 16–18th, 1812.*

16th, the ships involved in the subsequent chase being the *Africa,* 64, which was soon left far astern, and the frigates *AEolus, Shannon, Belvidera* and *Guerrière.* At dawn the next morning it was quite calm, with the *Constitution* 4 miles ahead of the *Belvidera.* The *Guerrière* was some distance astern of the *Belvidera;* The *Shannon* some two miles on that vessel's quarter and the *AEolus* fairly close to her. At 5.30 the *Constitution* sent boats ahead to tow, and the British ships did likewise fifteen minutes later. At 6.0 a.m. the *Constitution* set topgallant stun'sails and staysails and, an hour later, the depth of water being 26 fathoms, she got out a kedge and started warping.

The *Belvidera,* also warping, got near enough to open fire which was returned from 24-pounder stern-chasers, but the range, of about 1½ miles, was too great. Light breezes followed, to the *Constitution's* advantage. By next dawn she was 4 miles ahead, by 4.0 p.m. 7 miles, and was some 14 miles ahead of the *Belvidera* when the British ships broke off the chase at 8.30 a.m. on the 19th of August.

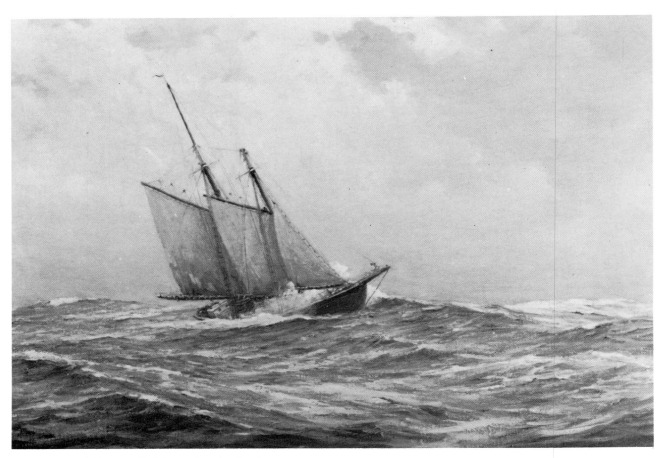

166. Reefed down for the Banks.

It needs little imagination to conjure up much of the horror of the war in North Atlantic convoys although, of course, there were those which made fair weather passages and arrived unscathed by enemy action. It was not unknown for outward and homeward bound convoys to meet, head on, at night, sometimes in snowstorms or in fog on the Grand Banks. Convoys were sometimes in trouble with icebergs. On the other side of the coin, they left memories of splendid and breath-taking sights when a huge armada might be reduced to so many cockle-shells, often with a scending bow; a rearing stern or the odd mast behind gigantic seas the only indication that there were, perhaps, five dozen ships within the immediate horizon—were there an horizon at all! A convoy forming up in brilliant sunset, or silhouetted against a flaming sunrise was not to be forgotten, and it was perhaps as well that such sights and sensations occurred to mitigate the ruthlessness of war at sea, and better still that such things were recorded for posterity on canvas.

Undoubtedly the sight of a squadron of the old "wooden wall" fighting

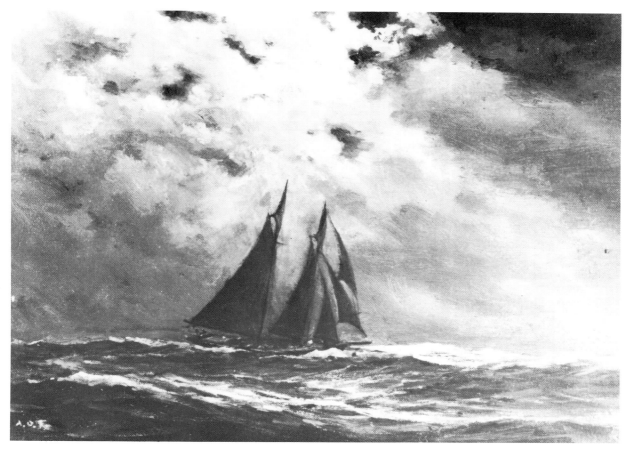

167. A passing Grand-banker.

ships presented a spectacle of breath-taking splendour, though whether it compensated for the scenes of horror and carnage in their cock-pits when in action is another matter. We have seen, earlier, many of the hardships suffered by the *Gwydyr Castle,* and thus of all square-rigged merchantmen yet ... they, too, could provide sensations of pure glory never matched by anything ashore. The sea was ever a hard mistress, yet ever exercising a fatal fascination over the men who came under her spell.

This is no less true of the Banks Schooners. In Plate 166, well-reefed down and with little enough of comfort in her decks, she may well be bound in from George's which, in terms of weather, could often offer even worse than the Grand Banks of Newfoundland, if they did not hold the hazards of fog and ice to the same degree. The yacht-like quality of these craft, with their inherent strength and vast sail plans, in conjunction with their very performances, made them perhaps the most admired craft of all amongst seamen. A.O.F. often painted them, and seemed to catch their very souls on canvas.

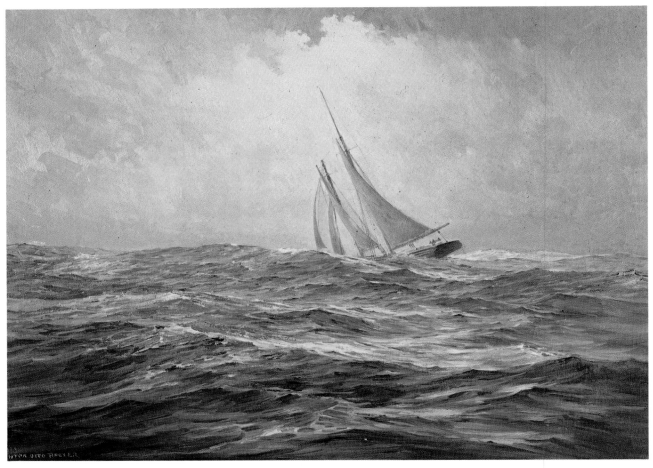

168. The 'Christmas' marine.

Close-hauled and pitching heavily into a short sea, the fishing schooner makes her passage through the golden light of a late afternoon. It is easy for artists to fall into the trap which has enmeshed so many of bringing the subject forward to fill the canvas with the ship. Seldom did one see a vessel so close—a fact which has often been apparent to people who tried to photo-graph ships which *seemed* to be close at sea, but in reality hardly appeared as more than a fraction of their film. This is how it was at sea and, with her stern rising as the little vessel pitches into the head sea, she is just a part of the seascape. A.O.F. was not one to fall into that trap!

It is an interesting sidelight on my father's speed of touch that my mother once remarked:— "Here we are with a marine artist in the family, and no marine paintings on the walls!" He then painted this picture, just before Christmas, in just under a day. Hence it was always known in the household as *"The Christmas Marine"*!

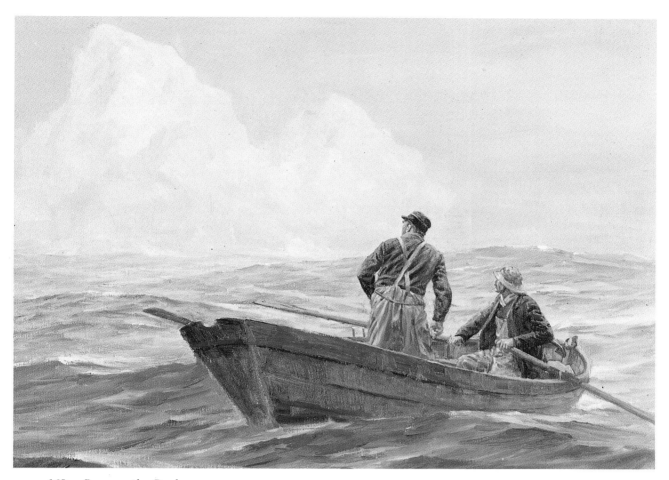

169. Berg on the Banks.

Once on the Banks, the schooners set their dories in the sea with (in American and Canadian vessels) two men in each, while they lay to. It was a hazardous undertaking, for the dories spread over a wide expanse of sea which was often fog-bound: usually extremely cold due to the Labrador Current, and with the ever-present risk of being run down by passing steamers—the fate of many a dory and many a schooner.

These two dorymen look back at a berg. There is all the feeling of the immensity of the sea and of their loneliness in their cockle-like craft. Maybe, before the fog cleared, they had been closer to the berg than they realised! This picture was produced as an illustration, and demonstrates the quality of the originals. Kipling, in *Captains Courageous,* and James B. Connolly in *Gloucester Fishermen,* left fine written records of these craft and their men.

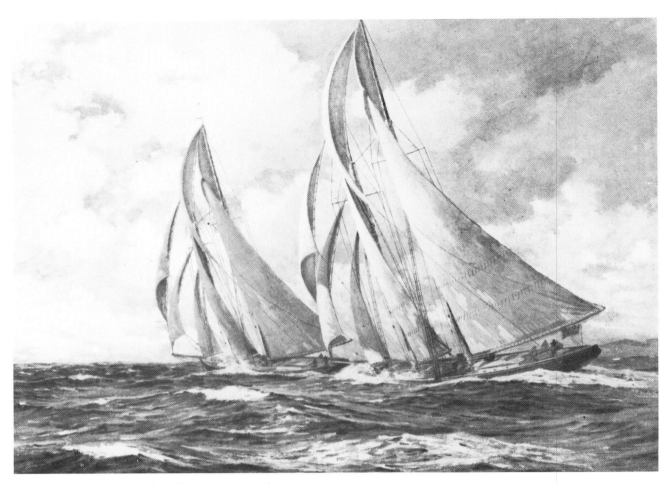

170. Grand Bankers racing in close company.

In half a gale, with everything set to their square-knocked fishermen's topsails, there is no exaggeration here. Built to take the weather, speed was essential to bring the cod back quickly and the schooners were tremendously sparred and canvassed whilst, in the early days of America Cup racing, the designers of the racing yachts also designed Grand Bank schooners, and they had much in common although, of necessity, the fishermen were far more strongly constructed. Some of their sailing feats were extraordinary and, when their annual sailing race took place in 1892, the wind was blowing at 60 knots, yet the fleet went out with all sail set! Some lost canvas, it is true, but none was handed for stress of weather and, when the *Harry Belden* came streaking over the line, heeling unbelievably, she had been carrying both full lowers and both topsails throughout that race sailed in a gale!

Granted that that was a race, but Alex. Hurst remembers a night of blizzard off Cape Hatteras when it was gusting with hurricane force. 'At dusk one of these schooners, probably running back from George's Bank, drove ahead of our bow, frozen right up. There were icicles hanging from her running gear and from everything else. They could not have started a sail had they wished and, heeling right over, she was going like a train as though the water made no resistance at all, to disappear into the murk. That night it blew a full hurricane. That was the measure of the Banks schooners!'

When a picture was commissioned by a private individual or, perhaps, from an advertising firm, it was generally agreed that A.O.F. should first submit a sketch. These sketches were a great source of joy and are almost as sought after as the finished works. Indeed, on receiving them, some people thought that they *were* the final pictures! Plate 172 is just a "sketch" and a lively picture in its own right. The Banks fisherman is beating back against the fading afternoon light and showing the very lift of her hull. "Only a sketch", A.O.F. said of it, yet it catches the very soul of the schooner. Many people have commented that it was remarkable how he was able to do this with craft which he had never known.

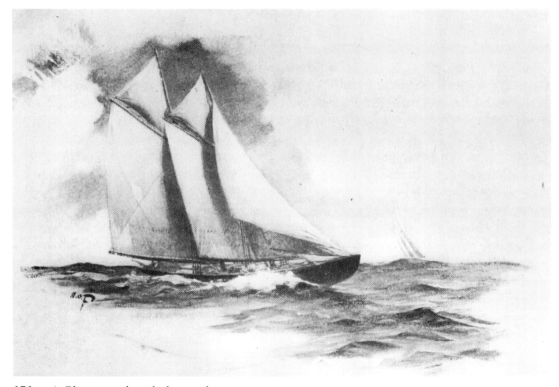

171. *A Gloucester knockabout schooner.*

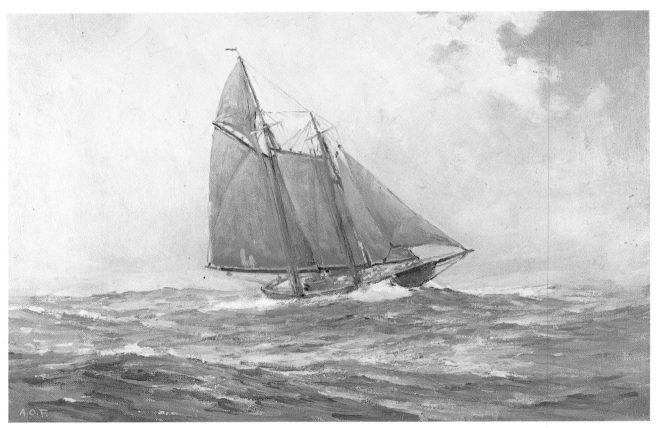

172. *Beating home from the Banks.*

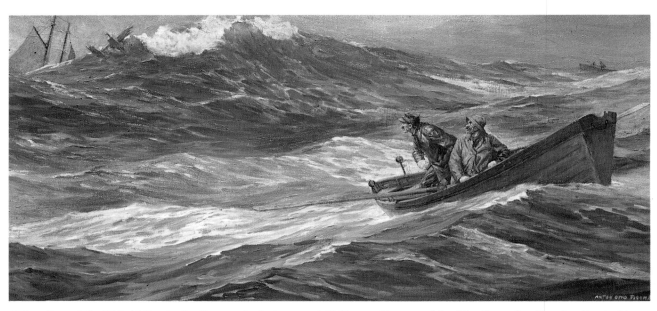

173. *From The Third Man in the Boat—the last story A.O.F. ever illustrated for The Saturday Evening Post. It was by Edmund Gilligan, a Woodstock man and a near neighbour, though the Post art editor did not know this!*

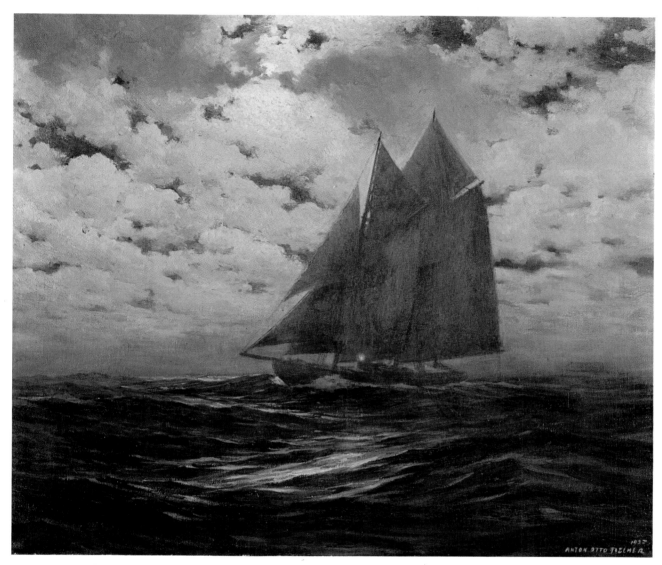

174. *Moonlight Magic. A Gloucester fisherman waltzes through the night.*

Very many of A.O.F's illustrations make splendid pictures although, if the viewer does not know the story of the point illustrated, they do leave some questions unanswered. Clearly this book cannot begin to deal with such explanations but, since so much of his fame, rightly or wrongly, did rest on his illustration, a number of examples are included in the book.

One of his most famous characters was *Tug Boat Annie,* of which the tale, so far as it concerned A.O.F., has been related on page 102. He did numerous pictures of her to illustrate the stories by Norman Reilly Raine who had been inspired to write the first story on learning that Mrs. Foss, the mother of Weddell and Henry Foss, of the Puget Sound Tug & Launch Co. had inherited the business on the death of her husband.

The idea of a woman running a tug company fired Raine and *Annie* became a most remarkable character who bore not the least resemblance to Mrs. Foss. Plate 176 is owned by Henry Foss, who was a great admirer of A.O.F's work and who visited him near the end of his life (p. 115). Moreover, all the tug companies fell heavily for all the stories and illustrations, giving an enormous amount of encouragement and co-operation when the series developed into cinema and Television productions. (Raine had only intended to write the one, first story, but it was so popular that he was persuaded to continue by Weddell Foss.)

Tugs were lent for these enterprises, the Foss tug *Wallona* became *Annie's* tug, the *Narcissus,* and, when the ferry *Washington* was rammed it was all done so realistically that she nearly sank in the middle of Elliott Bay! The tug *Sea King* took the part of Annie's competitor, the *Firefly,* and every facility was made available, for the towage companies saw some fine tugboat publicity in the public consciousness!

Another of Norman Reilly Raine's popular characters was *Mr. Gallup.* In Plate 180 he is holding the foc's'le fare out before him for the master on the poop to view, while he says (apologetically):— "Why, its this here defunct bit of animal life what cookie's dredged up for breakfast, sir." It will be noted that A.O.F. had instructions as to the position of the illustration and the manner in which it was to be masked out for the text of the story.

The fact that so many of these illustrations were reproduced in mono-chrome was obviously unavoidable, but equally rather a pity, since much was lost from the original colour and, no doubt, many readers never guessed that they had been in colour at all.

In plate 177, the picture caption read:— A feller the name of Bullwinkle's* swore out a warrant claiming damages against this here tug". Much can be guessed. These various stories were not high literature in any sense of the

*Bullwinkle was Annie's arch-rival and skipper of the *Firefly,* mentioned above.

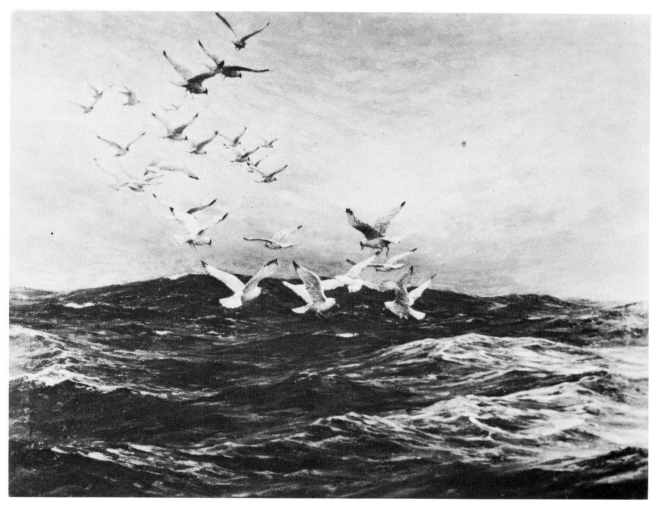

175. *Terns and the sea. (Also titled 'Ocean Scavengers'!)*

word, but the tales had an enormous following who awaited each new instalment with impatience, for the pictures no less than the text. The vast volume of fan mail received by A.O.F. told its own story.

Plate 181 might be held to be a good study of a typical freighter of the period. That is precisely what she was, but she was named the *Inchcliffe Castle* in which Mr. Colin Glencannon was the chief engineer. He was another of those characters whom A.O.F. made as familiar as their own neighbours to millions of readers, and was a somewhat engaging old reprobate. The picture with the paint tells its own story. Sometimes, of course, the pictures *were* reproduced in colour, which was much to their advantage.

It has already been remarked that he was punctilious about detail for his illustrations, often hiring costumes from New York for posing purposes.

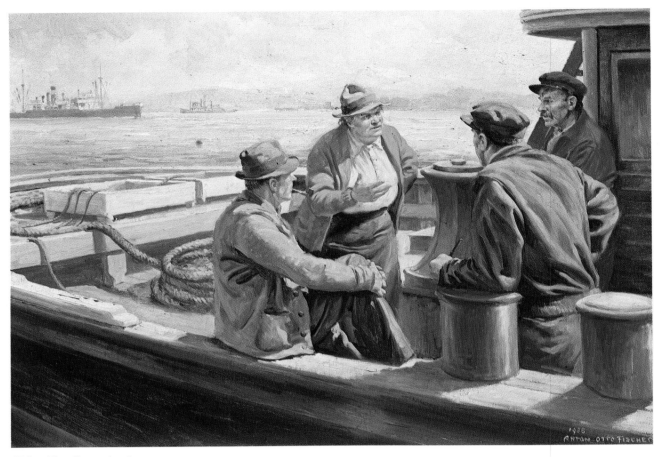

176. *Tug-Boat Annie.*

177. *Tug-Boat Annie.*

178. *Illustration for a Mr. Glencannon story.*

179. *The fight.*

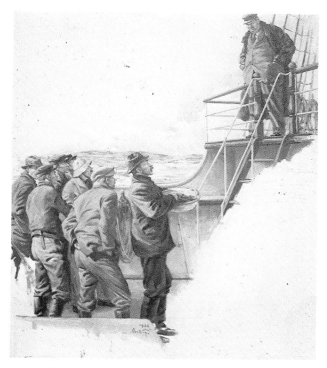

180. *Mr. Gallup.*

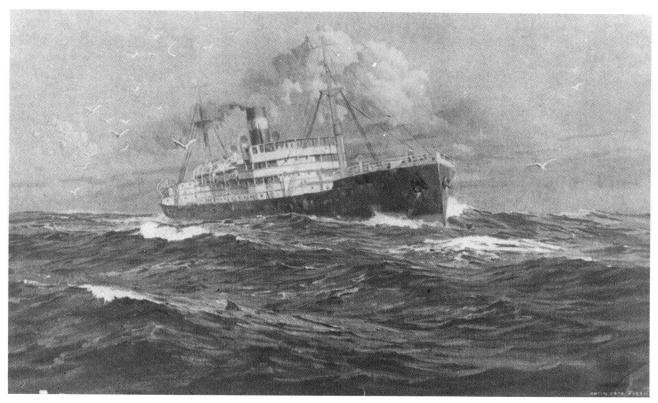

181. *The s.s. INCHCLIFFE CASTLE.*

The pictures on the previous pages are, of course, in a nautical setting but, when writing about a Marine Artist, it is clearly of greater benefit to show his pictures which do speak for themselves. Whilst it may be held that the aspect of illustrating militates against the reproduction of many of the pictures unless long explanations of the scene are also inflicted on the reader, it must be remembered that many of the most world-famous artists have pictures hanging in the great galleries which, although splendid as to their execution, character delineation and so forth, have very little meaning to the average viewer without the explanation which is normally attached to the frame or contained within a catalogue. Many paintings of scenes created by famous dramatists fall into this category, and it is safe to say that a large number of people, who both see and admire such pictures, are not really very much wiser about what is really going on in the picture even when informed of the source! In fact, only a minority of people are familiar with the settings of mythological scenes, but an artist, working entirely to his own conceptions, can generally create grandiose pictures which will, to some degree, tell their own story.

Most of the illustrations which A.O.F. executed for such works as *Treasure Island* or *Moby Dick* will strike a chord with very many people, whether they have seen those particular pictures before or not, since the books are very well read on both sides of the Atlantic. Conrad stands as a great author, but it is doubtful if many people would identify A.O.F's (or anybody else's) illustrations to—say—*The Shadow Line* or *The Partners,* whilst Jack London's novels, once so popular, are not seen to the same extent by the present generaation. The various series which he illustrated in *The Saturday Evening Post* and *Harper's,* for example, were probably read *at the time* by far more people than the rather more select band who read the classics, but they were hardly read on the Eastern side of the Atlantic at all and thus, when he chose to illustrate some point of dialogue, one must admire the various character studies in the picture, but must equally be left wondering about the implications of whatever may be going on. When I myself sorted through the vast pile of proofs and drawings left in his studio, I found myself in this position although, it might be supposed, I should have had a flying start on most readers.

It may thus be apposite to reproduce some of the paintings which he made for a book called *Lower Class,** by George Youell. The pictures are not by any means all Marines, but on the whole they do speak for themselves, although they are, naturally, related to the text. Youell was a man of humble origins who was brought up in a Suffolk village adjacent to the Waveney and, after a

*A fascinating autobiographical work.

216

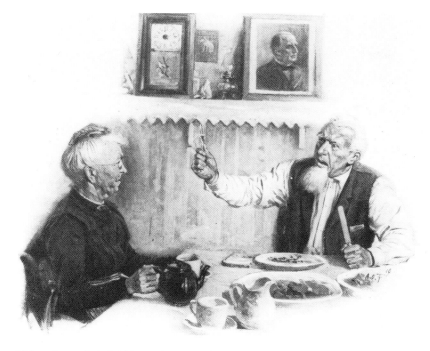

182. One of A.O.F.'s earlier—and typical—illustrations.

period of farm-work, spent some time in Lowestoft drifters and trawlers. Later he went to the United States and back, working his passage but, subsequently, he emigrated over there and, after various vicissitudes, made good in all the best traditions and became the President of a large West Coast fruit-packing company—though this latter and most successful part of his life is not included in the book.

Plate 183 does not relate to Youell's personal experiences but to a retired sea-captain who appears in the book. A.O.F. has shown a very different ship from the fine-lined clippers (Pls. 123 and 127), but a vessel of the same period with a long steeved jibboom outside her bowsprit: the single topsails and, generally, a more bluff-bowed craft altogether. There were hundreds of these vessels in their day but, because they did not hit the head-lines of sailing ship history, they have tended to be forgotten.

In Plate 184 the standing figure is Billy Bott, the local sweep who was aided by his daughter Lucy and a half-witted brother who mounted the chimneys. Billy was something of a pugilist and also prone to drink other men's beer. Protests were met with fisticuffs or handfulls of soot culled from his and Lucy's pockets. Naturally, he was not really welcome in the Red Lion, and even the publican found that he had to stretch his rule and wash the glasses after Billy had used them! There was no evidence that he *ever* washed!

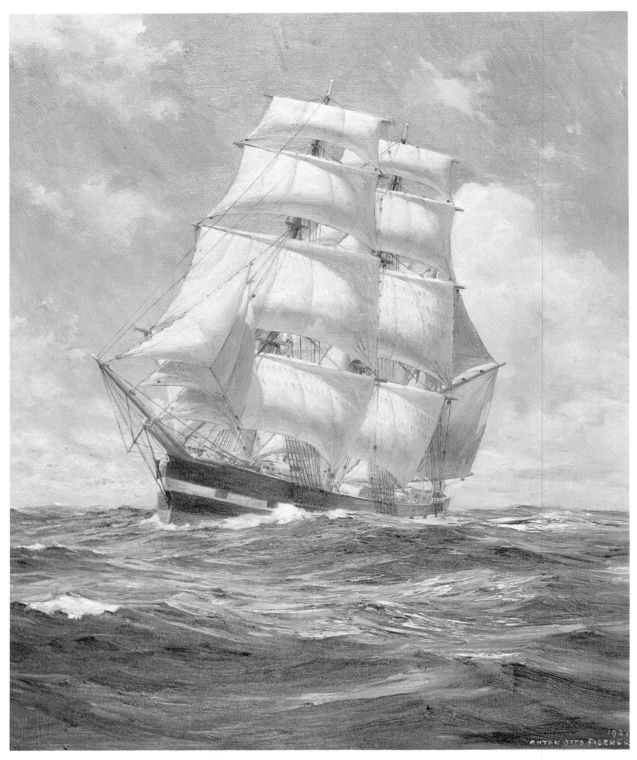

183. *An old barque—from Lower Class.*

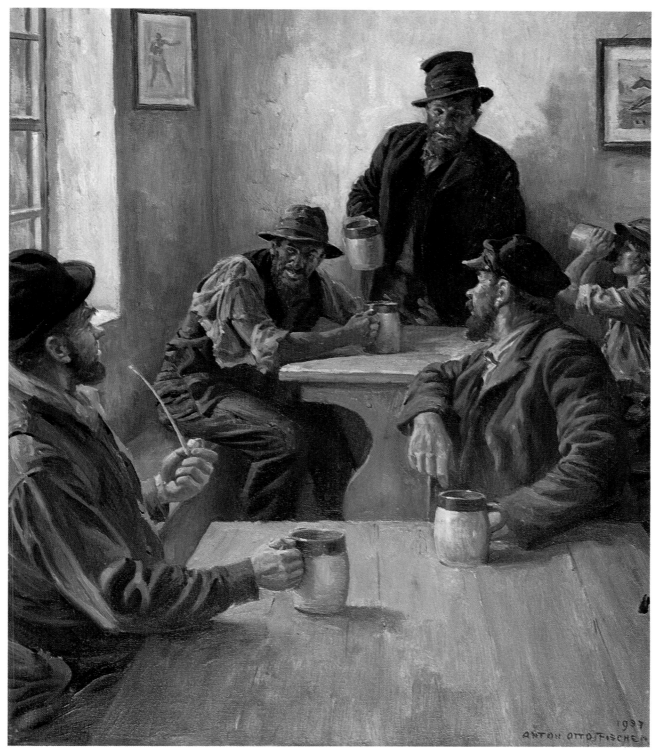

184. *In the Red Lion, from Lower Class. In fact, Youell altered the names of people and places in his book, and the*
 Suffolk pub. illustrated was then The White Lion—now called the Toft Lion, at Toft Monks.

Youell made his first trip in a 28-ton drifter named the *Eclipse,* which was ketch-rigged with a lug sail on the mizzen. Youell was the boy and, thus, the cook, though his presence was required on deck for hauling the nets.

In the event, the little vessel encountered just about as bad a gale as the North Sea has to offer, and the heavy-weather lug, which could be reefed down, was used in preference to the other, lighter sail. After putting a fourth reef in the mainsail, the remaining canvas split, and the craft is now hove to, in Plate 185, in conditions which might well have proved to be her undoing.* As she is shown, all the nets have been sent below, both for their safety and also to improve the stability of the craft.

Youell had not the experience to appreciate the implications of their situation, and found the whole scene utterly magnificent! The hard-bitten crew had long since ceased to eat and remained on deck and, as he records, even stopped "swearing"—a fact which was sufficiently unusual that it did give him pause to think! Certainly A.O.F. has caught all the implications of the weather in the West-Nor'Westerly gale in the North Sea in October. Pedants may argue that he has omitted the fishing numbers on the hull in this and in other pictures. Certainly the numbers were usual, but not invariable and, so far as these pictures where the numbers (or lack of them) on the sails are concerned, it should be recorded that it was not unusual for these fishing craft to sail their first season with untanned sails, and without the numbers.

After the weather had moderated, the first vessel to pass them—and she passed very close indeed†—was the very craft in which Youell's brother was mate, and she came flying past, after bearing down to speak them, flying all sail, including her big spinnaker (used in the local fishermen's terminology). These craft did carry a very big spread of sail for their size in an endeavour to bring the herring in fresh to the market, when they got a much better price for it than if it had to be salted down.

Whilst on the subject of the Lowestoft fishing fleet and of George Youell, I must express my thanks to his son, John Youell, who has allowed me to relate the following story in his father's book, since it is one with an irresistible appeal to almost everyone, and particularly to those who know anything about ships and their movements. Certainly it appealed to my father.

The Lowestoft harbour-master at that time was a burly man with grey whiskers and a very red face, and with an inordinate sense of his own self-importance, who was held in considerable awe by his underlings. There was, at the same time, a vagrant boy about the harbour, who used to sleep in fish-barrels

*Many craft and men were lost that night.

†Plate 186.

and beg meals from the various galleys, but who was able to imitate the bellowing voice of the harbour-master so well that his orders were generally obeyed!

One day a fairly large sailing ship arrived—perhaps the biggest ever to berth in the port, and the occasion was deemed to be an important one since it was thought that, if her visit should prove to be successful, it might lead to more trade with bigger, deep-water ships. In order to reach the inner harbour, she had to pass through a swing bridge (which is still there). This bridge had some old, disused water-pipes running along it, as they had never been removed. A break in a pipe at one end of the dock enabled anyone shouting down it to make it appear that their voice was coming from the dock above the point where the bridge crossed it.

The harbour-master, bustling with self-importance, had had the bridge opened long before it was necessary to do so, thus causing a great jam of road traffic on each side but, finally, her sails clewed up to their yards, the ship moved into the cut with bow and quarter ropes out. Now, attired in his best uniform and obviously feeling himself to be the key figure in this important occasion, while being flanked by his assistants, the puffed-up harbour-master started yelling his orders:— "Slack the starboard bow line!"—"Take in on the port quarter rope!" and so on. Then there was a quick succession of totally unexpected orders:— "Port your helm!"—"Starboard your helm!", etc. This engendered a state of bewildered excitement, particularly aboard the ship. Her anchors were ready at each bow and, as the confusion became absolute, the order came:— "Let go the starboard anchor!"—an order which was obeyed instantly!!

The incoming tide at once carried the vessel over her anchor, and anyone who knows anything about square-rigger anchor work will know the time it takes to heave one up again. In the event, it took nearly three hours, by which time it seemed that every horse and cart and every inhabitant in the district was waiting to get from one side to the other.

That the vagrant boy was not seen again for weeks was hardly surprising, though the harbour-master, being a singularly autocratic and often unreasonable individual, could hardly have escaped his share of the blame for the débâcle of the ship's arrival. He was, without any shadow of doubt, the man responsible for the berthing of the inward-bound ship and, until the terrible moment when the anchor had been dropped in the cut, he had not allowed anyone to be unaware of that fact by his very demeanour!

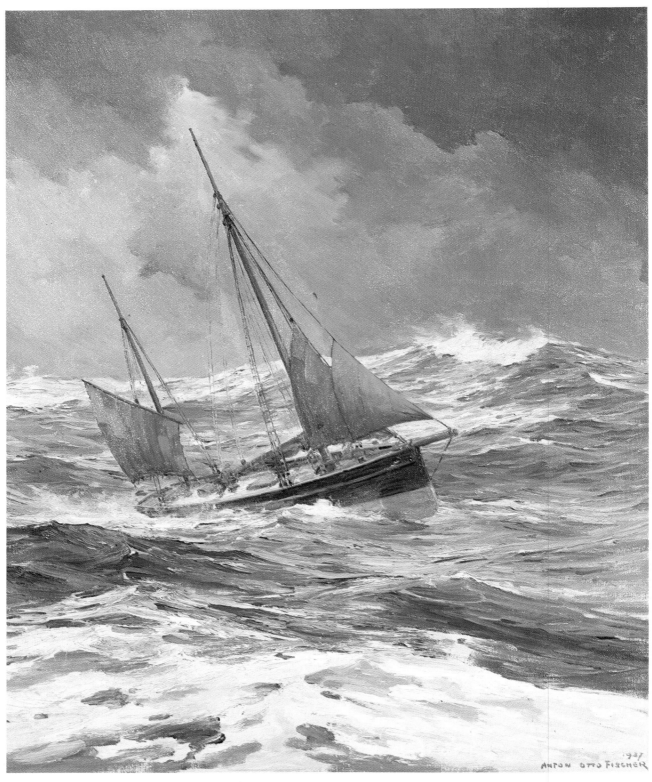

185. *The ECLIPSE hove to in the North Sea.*

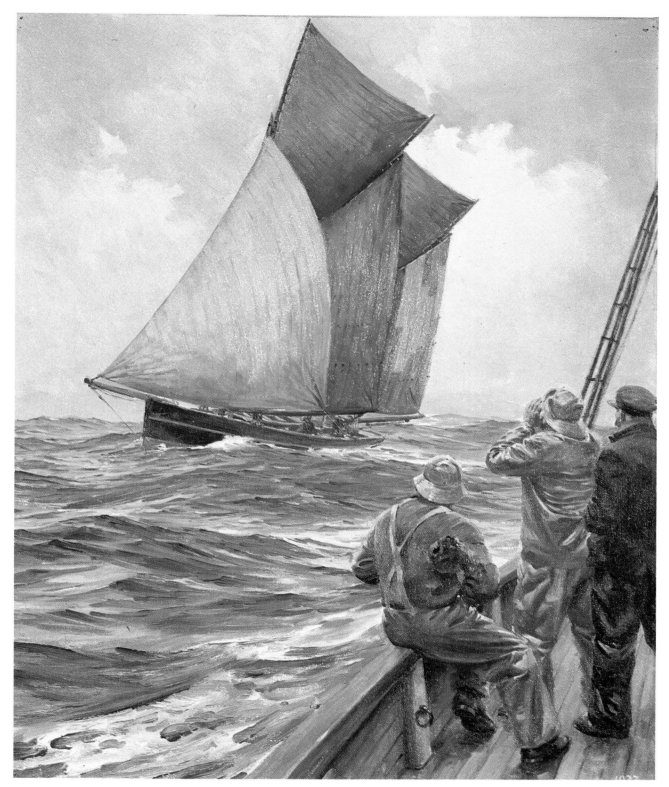

186. *Report us 'All Well'.*

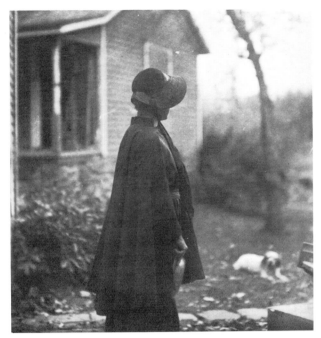
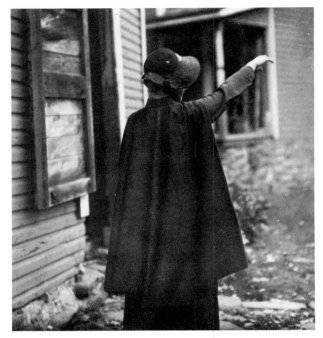

187. 188.

Louise Schofield posing in Salvation Army costume at Shandaken in the Catskill Mountains
for figures in Pl.190—a scene on Lowestoft pierhead in East Anglia!

In Plate 190 one of the lug-sailed fishing trawlers leaves Lowestoft. This picture is presently on loan from Mr. John Youell to the Lowestoft Public Library, and no-one familiar with the port will fail to recognise it when looking between the two masts of the trawler at the other end of the entrance. A.O.F. had done his homework!

This particular trawler was manned by a Salvation Army crew and, when she sailed, their colleagues gathered on the pierhead to wave them farewell and to sing hymns. I was also called upon to do a number of poses for this picture, for which my father had hired the costumes from a firm in New York, which he used a good deal.

On returning from his initial trip to the United States, Youell was persuaded, perhaps against his better judgement, to take passage in a cattle ship. His experiences make interesting reading, to say the least, but the vessel, of some 2100 tons, had originally been of about half that size when employed as a Western Ocean passenger ship. After coming out of that service, she had been lengthened. That, in itself, should not have affected her transverse stability but, whatever the reason, she was most unconscionably tender and started long, slow rolls from the moment that she left her berth. It seemed to be a moot point to those aboard her, until they had got used to her idiosyncracies, whether she would roll over altogether!

In Plate 191 A.O,F. had portrayed this vessel as she was making her departure

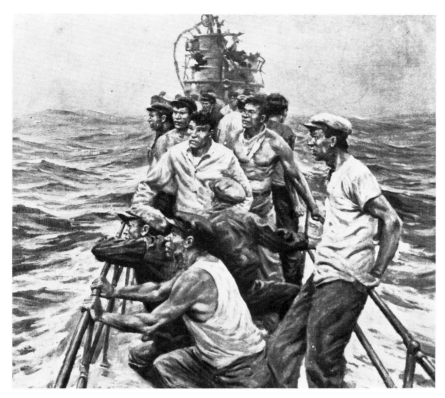

189. Crew of a damaged submarine, unable to dive, in enemy waters.

from Boston. Fortunately, the twelve day passage to the Mersey was a fine weather one with calm seas. One trembles to consider how the cattle would have fared had this not been the case.

According to Youell, there was an odd crew on board, both on deck and tending the cattle, one couple of men having only one pair of trousers between them! The result of this was that one had to go below before the other could come up on deck! How they got aboard in the first place defies imagination, unless it was due to the machinations of some less reputable boarding house master!

The Negro in Plate 202 sold a cup of coffee, baked beans and slices of bread for 5 cents. Youell recorded that although the negro probably did not know it, he was "right in the van of American progressiveness"!*

*Because he collected payment *before* supplying the fare!

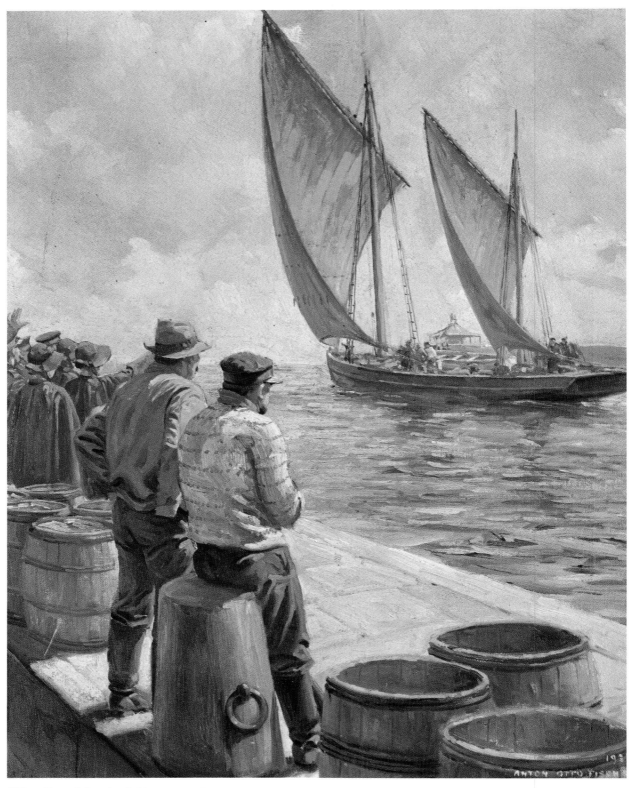

190. *Bound for the fishing grounds.*

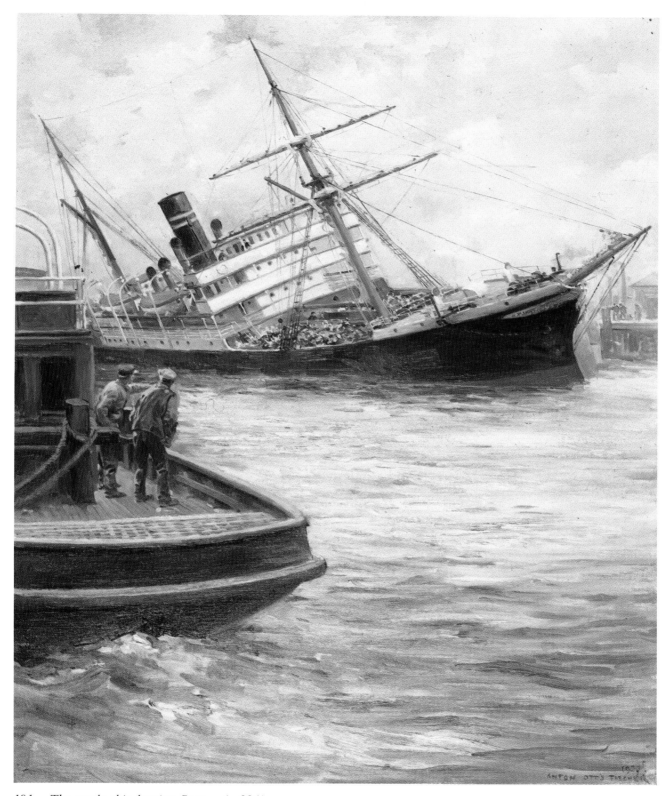

191. The cattle ship leaving Boston (p.224).

192. Louise Schofield posing for Pl. 197 . . .

193. . . . and with A.O.F. for Pl. 198.

194.

195.

Two scenes from R. L. Stevenson's Treasure Island.

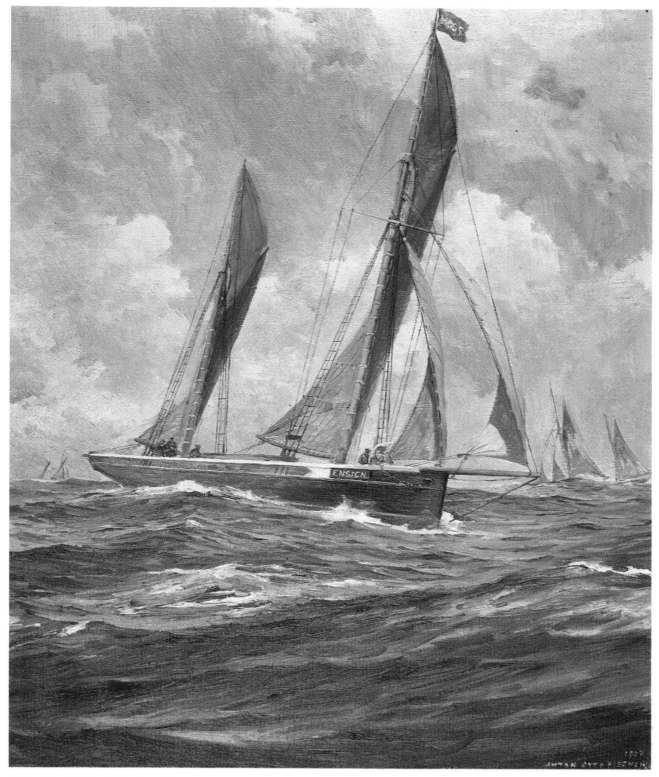

196. *Dr. Wilfred T. Grenfell's Mission trawler.*

Shortly before Youell left for America on his first trip across the Atlantic, Dr. Wilfred Grenfell had begun his famous Mission work in the North Sea. He had previously been out in one or another of the steam cutters to see the conditions under which the men in the fishing fleet lived and worked, and these had appalled him. Initially, he re-conditioned some of the older trawlers to carry out his work, and the *Ensign* was amongst the first of them. There is no question that his efforts were not only much appreciated by the fishermen, but had many beneficial effects. A curious one, recorded by Youell, was that, when he obtained Government permission to sell duty-free tobacco on the grounds, it virtually put an end to the Dutch and French "copers" which were converted fishing craft which used to come out to trade tobacco, rum, perfumes, dirty post-cards and so on with the fishermen. Since tobacco had been their main item of trade, they virtually disappeared from the North Sea!

Later, of course, Dr. Wilfred Grenfell became well-known in and off Labrador, where he also initiated similar work. He remained a life-long friend of John Youell and, indeed, wrote the forward to *Lower Class*.

A.O.F. was always at his best when engaged in character studies with a nautical scenario and, as Youell's text is very much a piece of social history, with a leavening of humour for good measure, so the illustrations are no less. The scene of the emigrants boarding the s.s. *Alaska,* in which Youell finally left England as a steerage passenger, is splendidly recorded in Plate 197, and shows all that difference between passengers boarding in 1891 and at the present time.

They are, in fact, boarding from a tender in the Mersey, and most of those shown are probably from the Ukraine. The father, who is leading the way up the gang-plank, is carrying much of the family's possessions in a piece of canvas measuring $12' \times 12'$, and tied at the corners. Imagine travelling half way across Europe with that! And bear in mind the disaster should a single corner become undone! Consider the matter of getting it in and out of lodging houses *en route!* These people had no help from anyone, either overland or aboard ship, and they had their children and all the bedding rolls and other impedimenta, without the facility of the modern suit-case and even their steamer ticket was a vast document nearly four feet long!

Each member of the tribe needed to be well rehearsed in his own part and to be relied upon to fulfill it at every stage of the journey. A.O.F. has included the small boy, noted by Youell, whose burden was the lightest but very essential item of family use. It was not of porcelain, but iron and,

although the book states that the inside of it had originally been white, the outside was enamelled in an irregular pattern of a particularly bright blue and white, which made it extremely conspicuous. Such considerations had no effect on its bearer, who would have borne a mace with no less aplomb, one suspects!

The conditions aboard the *Alaska* were beyond the belief of modern travellers, and the overcrowding: the mode of feeding them and all else was almost unbelievable to modern ears and ideas. Equally, the fare across the Atlantic was £4—say $19—and even that was 25% more than the usual steerage fare, since the ship was alleged to be a fast one, and did not, on her homeward trip, carry cattle.

The vessel was not sea-kindly, and encountered her mead of bad weather. Obviously, the crowded steerage quarters had no air-conditioning in those days, and the toilet arrangements were of the crudest. Each day, in the forenoon watch, all the passengers were herded up on deck, those too sick to walk being carried up. The "cabin" was then well washed down with the fire hoses— (and, with many of its inmates being perpetually sick, its condition after twenty-four hours almost defies imagination)—and then, after the decks had been scrubbed down, barrels of chloride of lime were scattered all around it. The effect of this was that the passengers simply could not return below until the fumes had cleared and since none had any sea-sense; few spoke English (very many being Jews from Central Europe) and since none had the wit to differentiate between the lee and weather sides and, for some perverse reason, persisted in herding on the latter and disgorging their last meal (invariably of hash), the session on deck was little better, particularly in the weather conditions which obtained most of the time.

Plate 198 gives a vivid impression of the daily "exercise" period. The vessel had no bulwarks along her fore-deck, but rails. Youell surmised that the bulwarks may have been replaced by rails to enable the decks to clear of the water that she was so prone to ship the more easily. This may or may not have been the case, but it was not a feature which added to the lot of the miserable passengers, who spent rather over a week on the passage.

It is not the intention of this work to plagiarise *Lower Class*. Yet a reference is necessary in order to appreciate the pictures to the full, since the two are not wholly divisible. We may regret that A.O.F. did not illustrate the almost savage rush for the buckets of hash, coffee and rolls, which was virtually the staple diet and, for all the vicissitudes of the passengers, it may be recorded that they never lost their innate sense of self-preservation

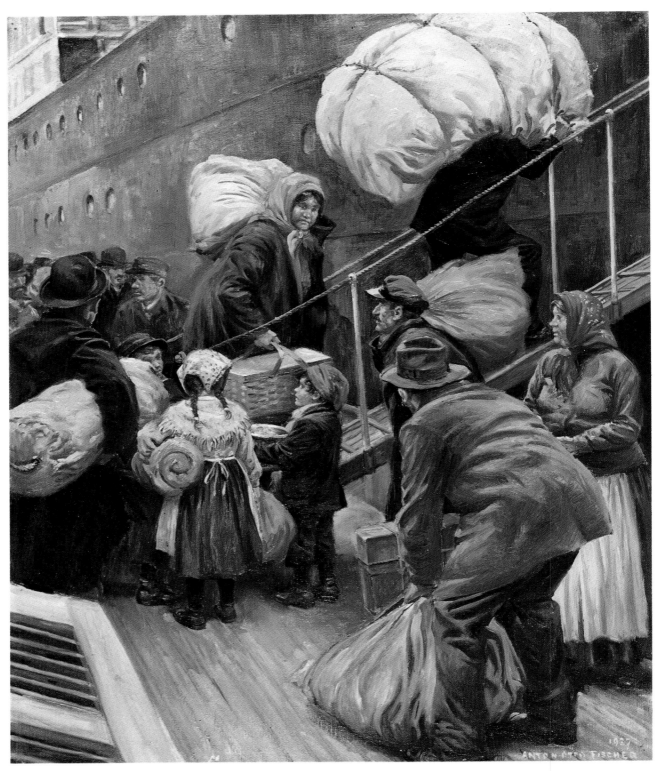

197. *Emigrants boarding the s.s. ALASKA in the Mersey (p.230).*

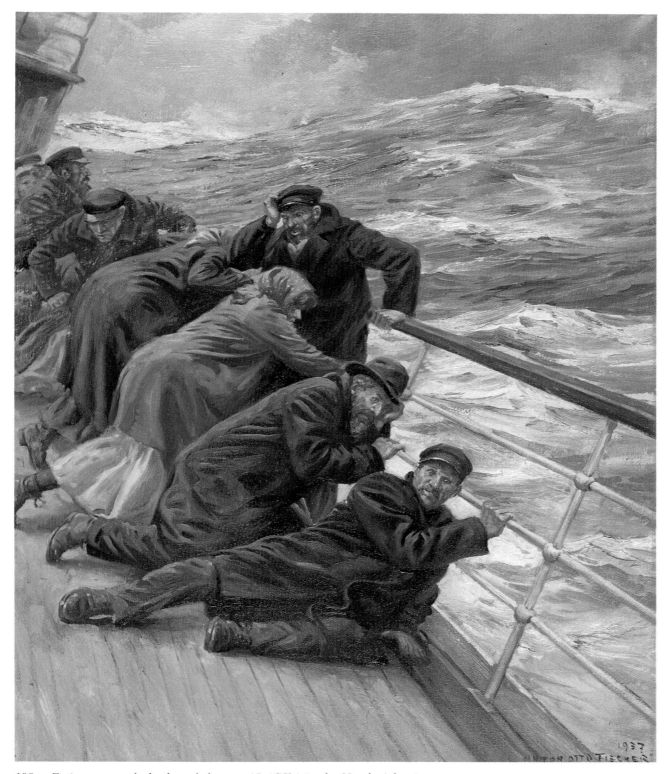

198. Emigrants on deck aboard the s.s. ALASKA in the North Atlantic.

for, on disembarking in New York, the considerable baggage with which they had boarded the ship was now even greater in bulk, as a result of being swelled by vast quantities of rolls which they had purloined *en voyage* in order to ease (?) the final stages of their respective journeys into, or across, the continent of America!

The last of the pictures from *Lower Class* to be reproduced in this book is Plate 203. Youell was in a number of the Lowestoft trawlers, and this one represents the *Bessie Pepper* about which he writes most amusingly, but which was nevertheless probably the worst in his experience. The craft was only 48 tons, which was rather smaller than most of the trawlers which were in the region of 60 tons at that time. In fact, 48 tons had been quite a respectable size for a Lowestoft trawler some years previously but now, to compete with the size of trawls used by the bigger vessels, the *Bessie Pepper* had been somewhat over-sparred and masted and, to compensate for this, over-ballasted. In consequence she had rather low freeboard* and was a very wet craft. In this picture she is shown making out to the fishing grounds, close-hauled with a single reef in her main.

Eleven years before, in 1916, A.O.F. had illustrated Joseph Conrad's magnificent short story, *The Shadow Line,* in the *Metropolitan Magazine.* The three pictures on the opposite page are from this series. In Pl. 199 the young master, in the barque beset by interminable calms in the Gulf of Siam, is telling the assembled crew that he has discovered that the ship's supply of quinine has been replaced with some other powder. The mate and half the crew are sick of tropical fever, and it seems that the personality of the late master, now dead, is haunting the vessel. Finally the master himself is taking the wheel, for such steerage way as the ship might have, and old Mr. Burns, wasted with fever, has staggered up on deck to sit on the sky-light, while the only other hale man in the ship is Ransome, the steward, who is a tower of strength to the young master. When finally, after the sky had piled up and the sails were somehow clewed up, with the yards squared, and wind had come, the master saw Ransome sitting in the galley clutching his breast, for it was appreciated throughout that he had a weak heart, and the effort of handling the yards and sails had been too much for him.

The Shadow Line ranks amongst Conrad's greatest stories, with all its human relationships: its descriptions of the becalmed, fever-ridden barque and its feeling of the evil influence of her previous master, coupled with a measure of Conrad's innate fatalism. It is not an easy story to illustrate, and one needs to know the tale to appreciate the pictures.

*The vertical distance from the deck to the load water-line.

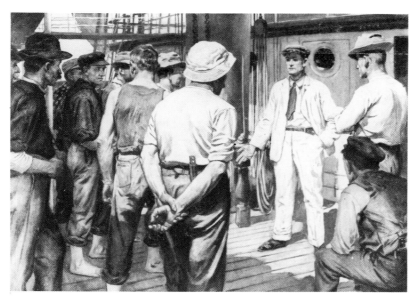

199. *The master in Conrad's* The Shadow Line *assembles the crew to tell them that there is no more quinine.*

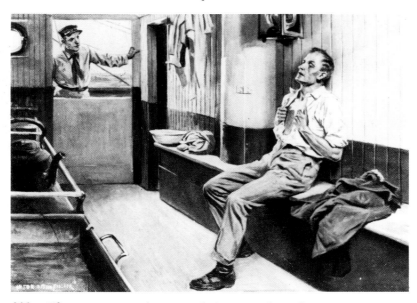

200. *The master sees the steward sitting in the galley.*

201. *Wasted by fever, Mr. Burns, the mate, sits on the poop skylight while the master steers. (Both this plate and No. 200 are from* The Shadow Line.)

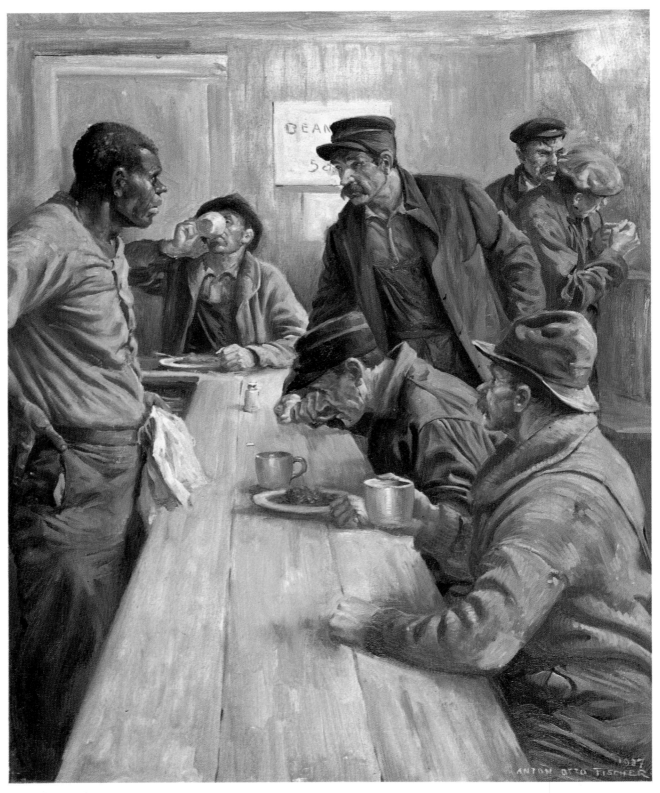

202. *Characters in a Negro's snack bar, from* Lower Class.

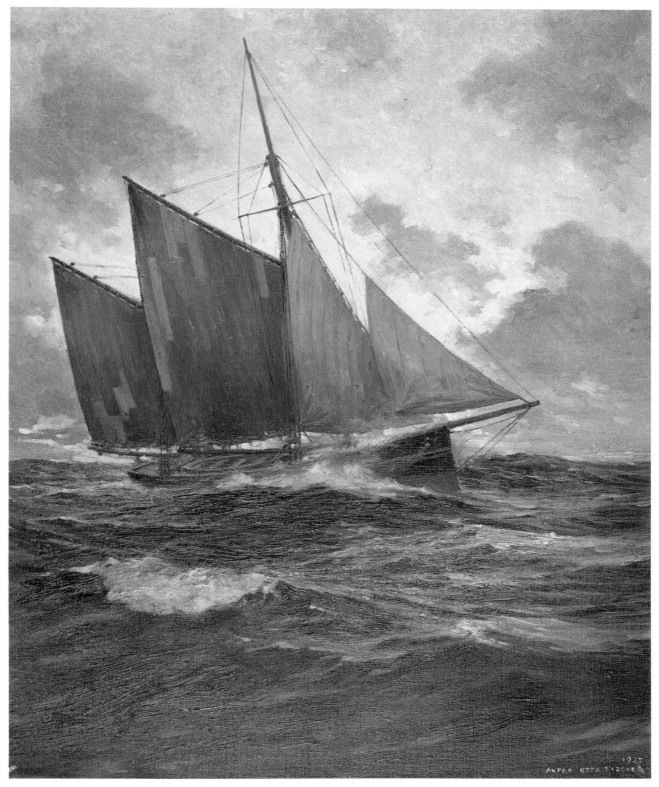

203. The *BESSIE PEPPER* beats out to the fishing grounds. Local marine researchers doubted Youell's veracity when they could find no records of this vessel! Once again, a real vessel was given an invented name—a name derived from the maiden name of a friend of his parents.

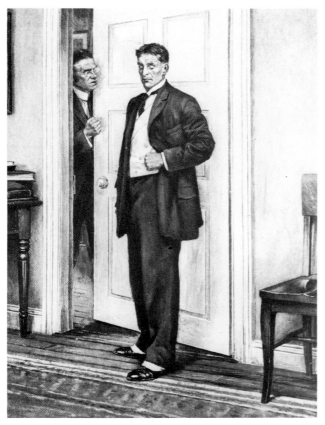

204.

205.

206.

Three illustrations A.O.F. made for Conrad's The Partner in 1911 for Harper's Magazine. Plate 204 shows Cloete, who had ingratiated himself with the Dunbar brothers, telling George Dunbar his 'heart is no bigger than a mouse's', when urging him to have his brother's ship wrecked, to claim the insurance money. Pl. 205 shows Stafford, the employed mate who interfered with the cable (which parted and set the ship ashore) asking Cloete if he is satisfied, and Pl. 206 depicts Cloete in the inn, after the crew have been rescued (and Stafford has shot Capt. Harry Dunbar, the master, in mistake for Cloete), denying the deal they had made:– 'What's this conspiracy? Who's going to prove it?', George Dunbar asks.

207. A 'Glencannon' illustration from The Toad Men of Tumbaroo. ('And all I know o' five hoonderd furreign ports are the docks and the waterfronts, each one smelling frowstier than the last'.)

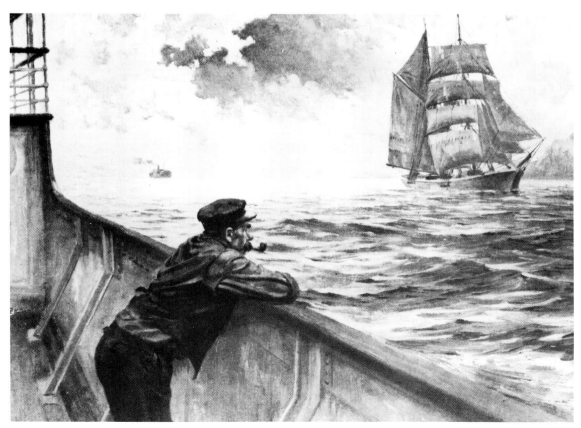

208. Mr. Glencannon—a prey to preoccupation off the Spanish coast.

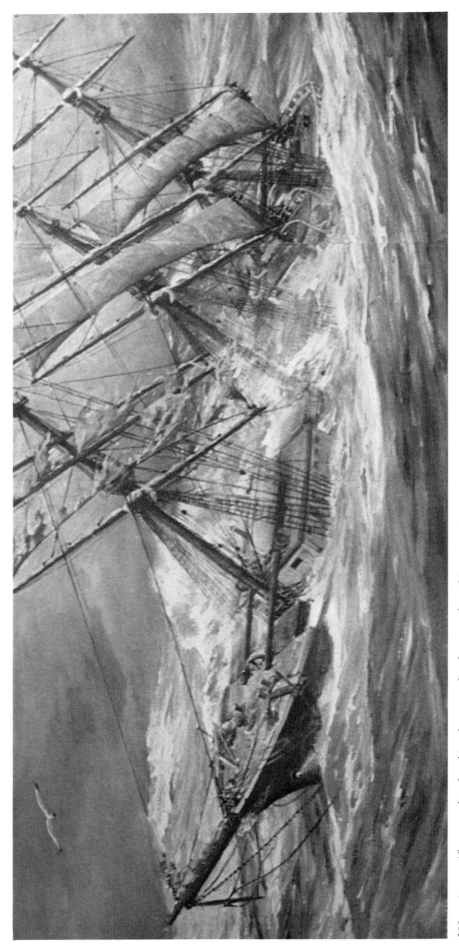

209. *A magnificent study of a ship almost on her beam ends and in extremity.*

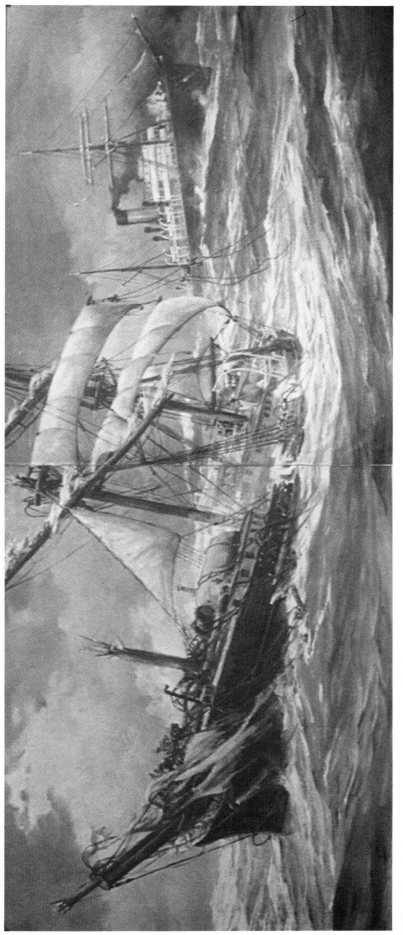

210. One of the most imaginative pictures of a dismasted sailing ship ever produced. (The ship is obviously a 'Down-Easter'—one of the later phase of American square-rigger building.)

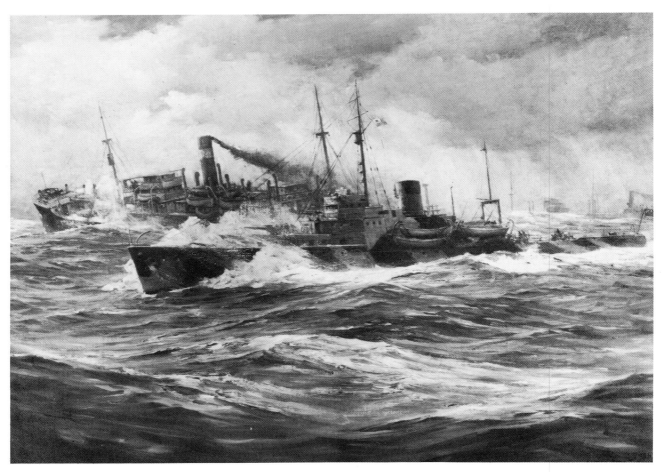

211. North Atlantic convoy and escort.

The wallowing freighter; the tanker half-concealed behind the swell, the escort vessel moving so much faster, and with spray flying over everything, this was often all that could be seen of a vast convoy scattered over many square-miles of sea. There is all that feeling of bleakness and cold and wet which typified so many of those long days bound eastwards across the Western Ocean during war. Often one might see the tops of the masts of the odd ship, or a rearing bow of another, only for each to become lost again behind the seas and the poor visibility which usually accompanied such conditions.

When one examines the tremendous range of A.O.F's paintings, there is simply no end to the choice which could be made. The latter section of this book is, therefore, consciously lacking in any continuity, and designed merely to show a small section of a few of the subjects.

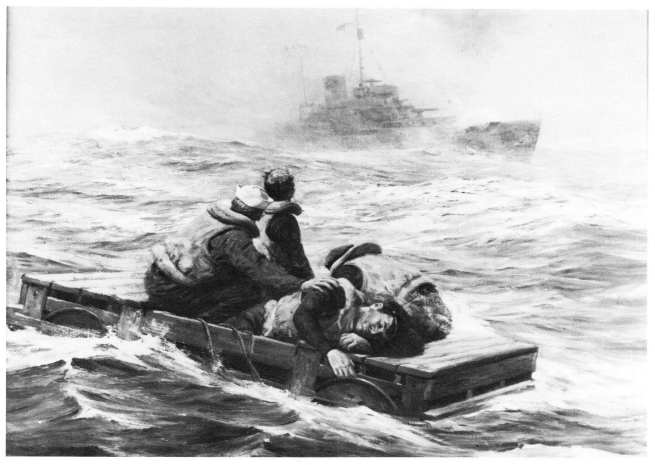

212. Saved!

The pictures could equally well have depicted a variety of junks, Elizabethan galleons, Portuguese caravels, and numerous other types of craft right through the whole sweep of maritime history. In principle, it has been the object of this book to keep its scope within certain fairly defined subjects, and these two war-time plates call for little explanation. There is no question that the theme of men in open boats or rafts was one which not only recurred frequently in A.O.F's work, but it was one for which he had a particular feeling.

He was, of course, a strictly representational artist, but so many of his pictures of a variety of craft were originally executed to illustrate one situation or another and, although they are sufficiently powerful in their own right to present a story, the fact remains that the viewer does often find himself wondering about the back-ground to the various situations.

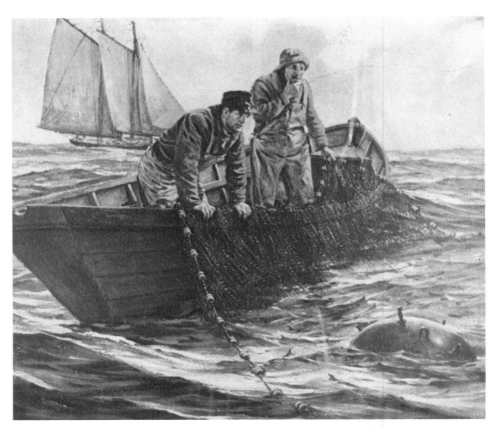

213. *Fishermen's Luck. Used as an advertisement for the firm which made the nets for the fishermen. The dory is high in the water but, when the men had completed their catch, the gunwales would often be awash when they reached their parent schooner.*

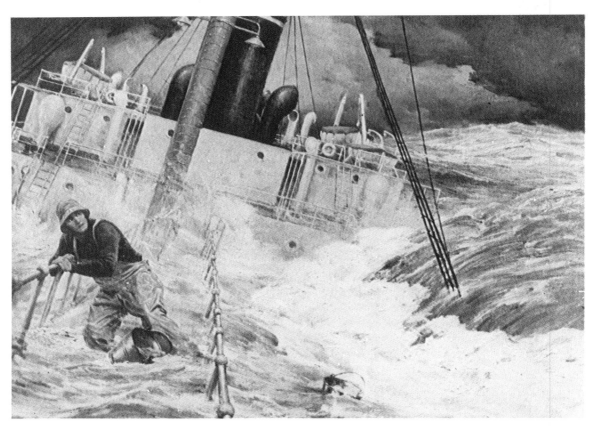

214.

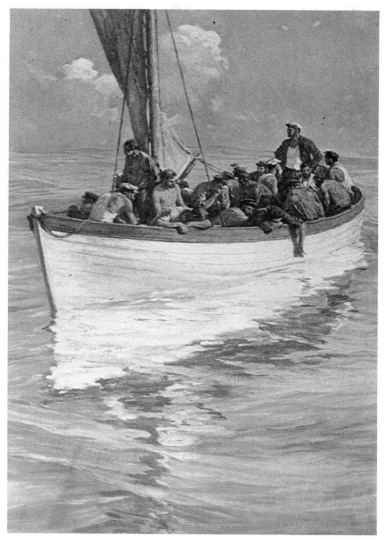

215. *The TREVESSA's boat in calm. This was a famous 'real-life' boat journey, between the wars.*

Plate 214, of an oil tanker butting her way between Marcus Hook, Pa. and Beaumont, Texas, is no less dramatic than the deck scenes aboard the *Gwydyr Castle*. It was executed for an Insurance Company as an advertisement, the Company making the point that insurance was the "catwalk through life"— "one hand for the ship and one hand for yourself".

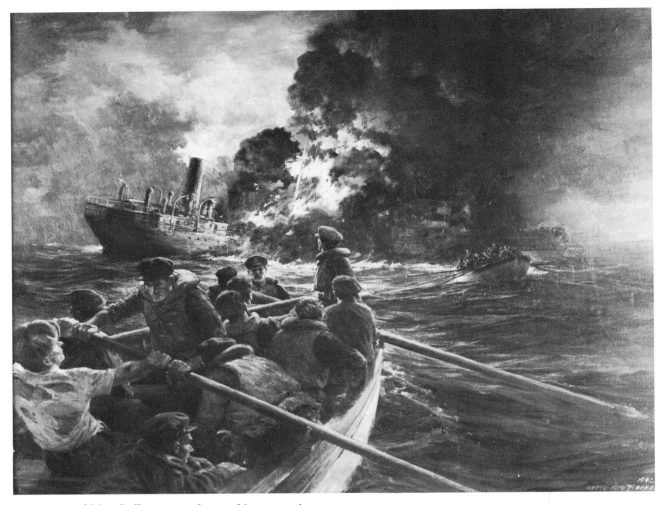

216. *Pulling away from a blazing tanker.*

Here is a torpedoed tanker at a slightly later stage than Plate 150. The fire has taken hold and the water can be seen ablaze around the hull. There is no time to lose in abandonment at a time such as this and, if there is any relief in such a picture, it lies in the fact that the boats *have* got away. It was not always so. The tanker makes a flaming torch to be seen well over the horizons as she lies, a mass of flame and smoke, with her boats gone from their falls and getting clear with their men displaying all those emotions arising from sudden catastrophe and even—and this is true of the slowest and most uncomfortable ships—a sense of failure and bereavement for their vessel. No matter what the ship and what the circumstances, the abandonment of one's ship breaks some link in a bond, often scarcely realised, between man and vessel and tears at his very heart-strings.

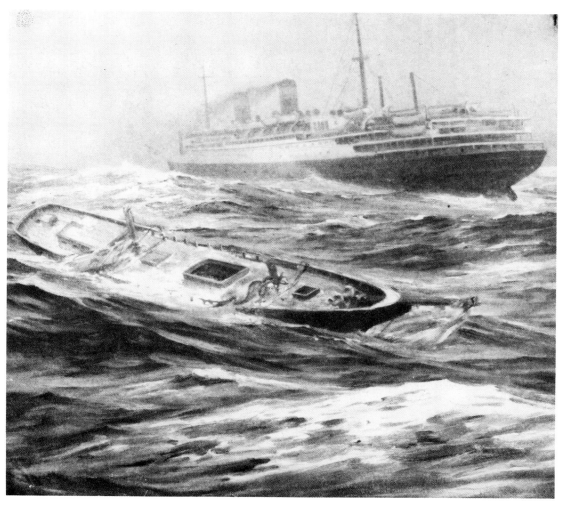

217. The fate of a Banks schooner.

The choice of pictures which might have been included in this book has been legion. A.O.F. was seldom at a loss, and painted all aspects of the sea and seaboard with equal facility as, indeed, he painted almost every subject under the sun. Most of his illustrative work was superb, and it is, naturally, for this that he is best known, since it reached the larger public. In this book the tendency has been to avoid illustrations, except in the case of well-known books or characters, since the picture was so often painted strictly in the context of the story. Some, however, tell their own story, and this dismasted and abandoned Banks schooner is a case in point. Of course it belonged to the story concerned, but it stands as a record of the sea—an incident which was relatively commonplace, yet now wholly forgotten.

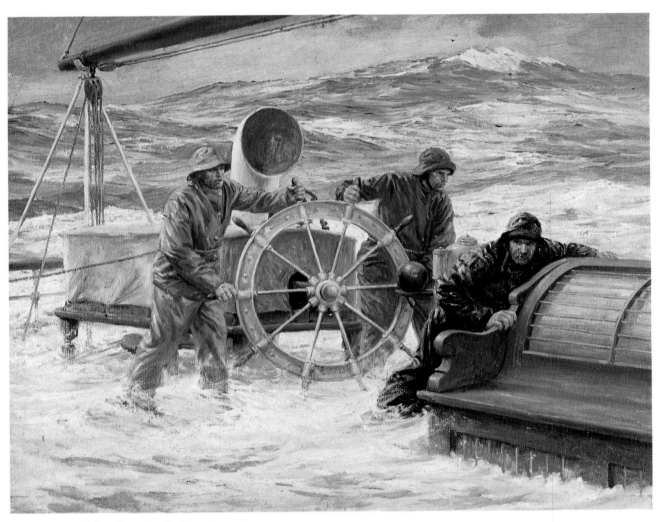

218. Running before the gale.

A.O.F. could seldom be faulted but, like everyone else, he seems to have had the odd blind spot. When one considers the enormous output from his studio, it is extraordinary how seldom his work can be criticised. Plate 218 is a fine study of a ship which has just been, barely, pooped, and gives a splendid impression of the scene. The odd thing is that it is one of the pictures which he produced almost as a vanity, for his book *Foc's'le Days,* to illustrate his time in the *Gwydyr Castle,* but he has given her a wheel common to—say— a Banks schooner, and not to a square-rigger at all. Of course, there is always the odd exception, and one might suppose that the barque *did*—very unusually— have such a wheel, but investigations have shown that this was not the case. However, the wheel does not detract from the atmosphere of the picture.

219. Woodland Brook—Shandaken.

Writing to a friend in 1952, A.O.F. said:— "I hope to take advantage of the fall color, though why, I don't really know. Perhaps to appease my soul, because, God knows, landscapes, unless painted in modernistic or abstract style, are just so much canvas and paint wasted, from the point of view of financial returns." At about the same time he told this friend that he sometimes scrapped his sea-scapes as he felt he had done it before and was just duplicating himself.

It is true, of course, that he did paint the same theme on a number of occasions. This was unavoidable with a man so prolific, but although the remark was doubtless made on one of his depressed days, the fact was that each picture, even if of a subject he *had* produced previously, always had its own freshness and dramatic quality. His comments about landscapes were by no means without foundation, and they *did* appease his soul!

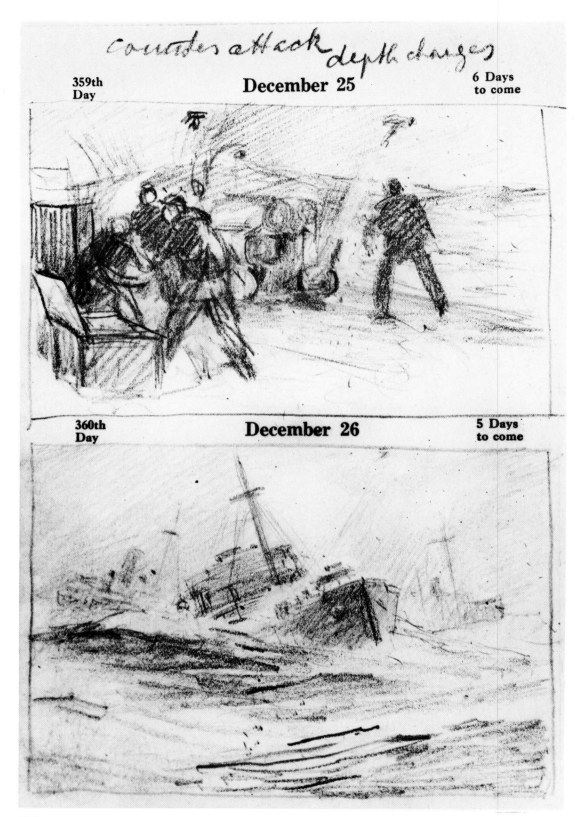

counter attack depth charges

359th
Day

December 25

6 Days
to come

360th
Day

December 26

5 Days
to come

220.

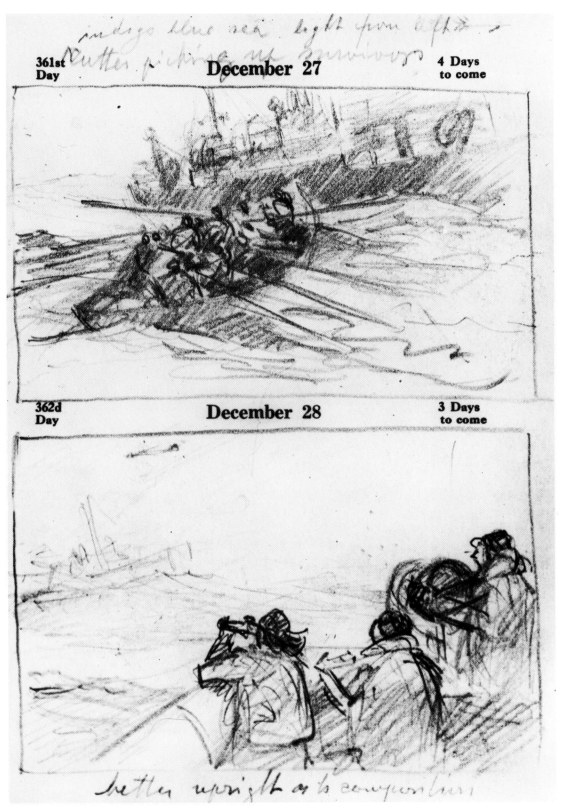

indigo blue sea. light from left

cutter picking up survivors

December 27

362d Day

December 28

3 Days to come

better upright as to composition

221. *Two leaves from A.O.F.'s diary aboard the CAMPBELL. It is interesting — and astonishing — to see the paucity of his sketches when compared with the finished pictures. This must be a measure of his innate awareness of ships and the sea.*

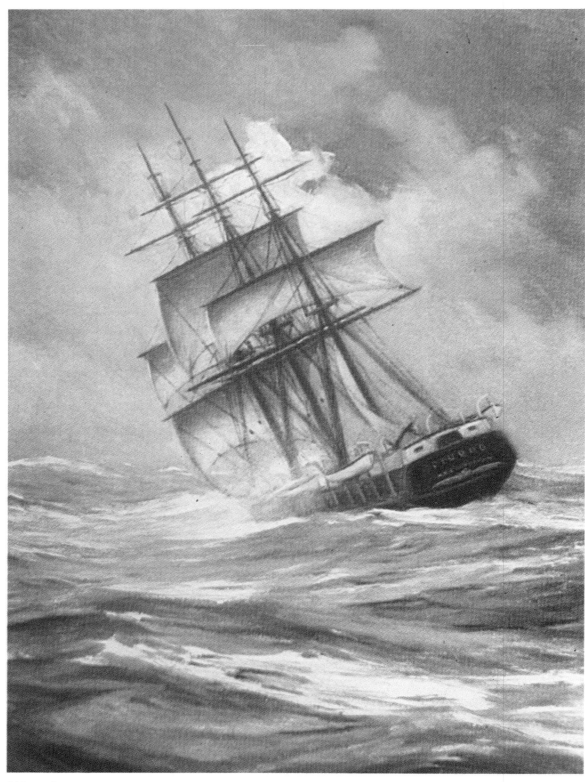

222. *The PEQUOD, questing Moby Dick.*

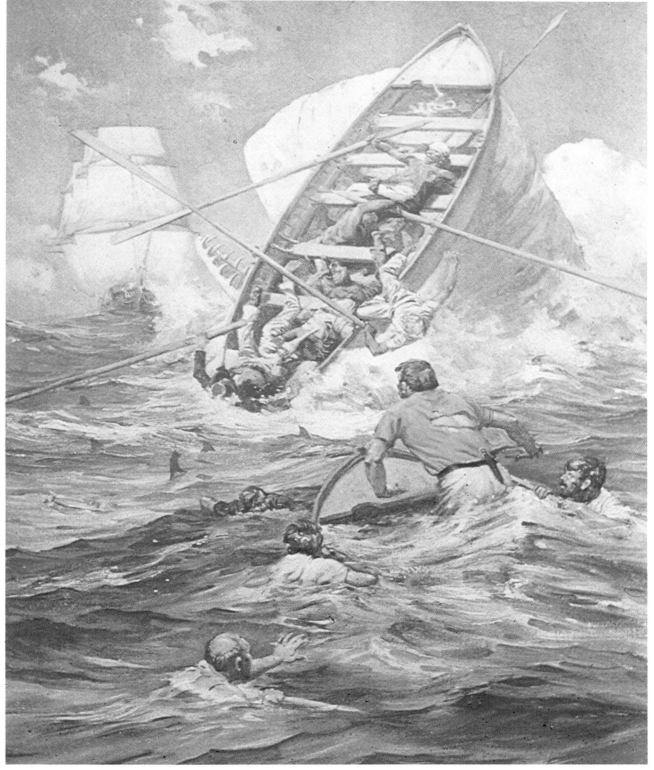

223. *Moby Dick, the white whale, dealing with the PEQUOD's boats—a conception which has something in common with his original success in illustrating Jack London's The Heathen (Pl. 17).*

MERRY CHRISTMAS and a HAPPY NEW YEAR

ANTON·OTTO ❧ MARY·SIGSBEE ❧ KATRINA·SIGSBEE
FISCHER

224. *The Fischers' Christmas card, 1930.*

225. 226.

Two of the famous Cappy Ricks illustrations.

Now Then! All Together! For 1932!

227. The Fischers' Christmas card, 1932.

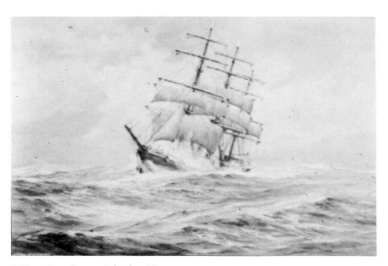

228. Battling with the Horn.

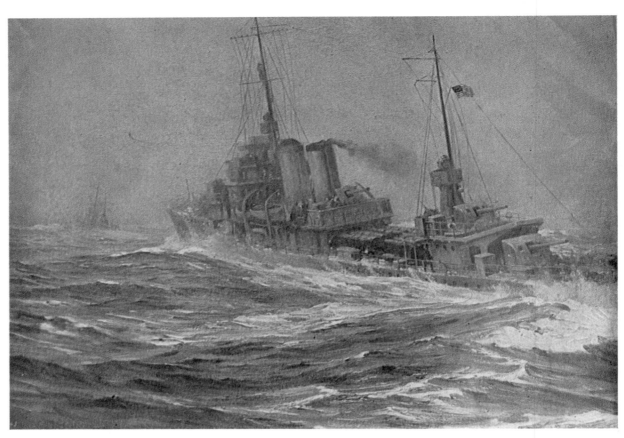

229. *Ideas translated into steel. Another commissioned picture, for a steel firm, and a useful propaganda picture, to boot, during war-time.*

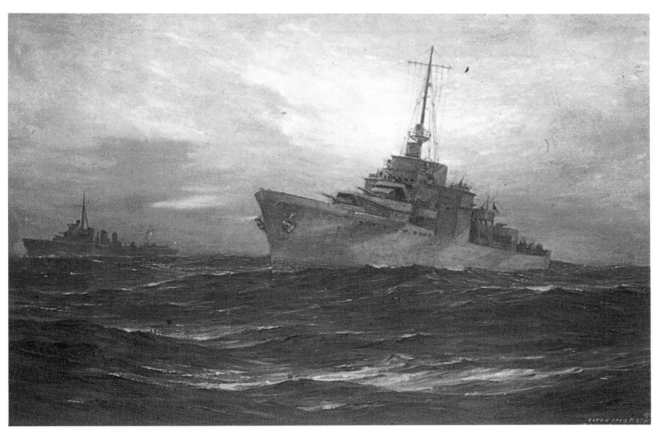

230. *The Polish destroyer BURZA screening the CAMPBELL (Pl. 95).*

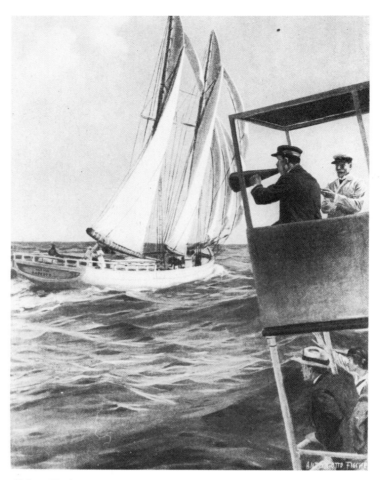

231. *Hailing a passing schooner.*

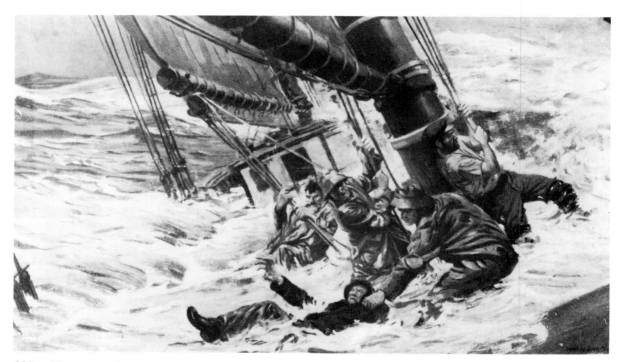

232. *Heavy weather.*

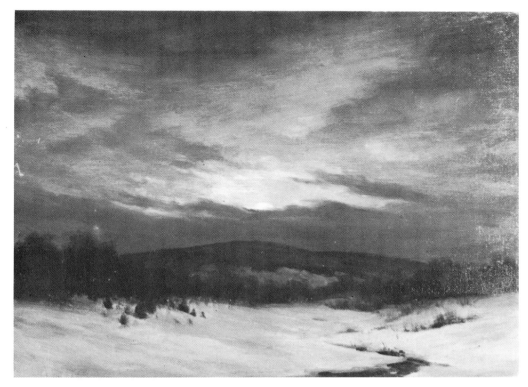

233.

A.O.F. painted this oil of the sun setting over his cherished Catskills a few years before his death. When he died, the sombre shadows of the sinking sun spread their tenebrous tentacles through the verdant valleys he loved so well until, as they vanished from view, the very hills seemed to come closer in valedictory condolence. No more would he record their riotous autumn colouring on canvas; never again would he garner the fruits of their earth, either in paint or in person, and no longer would his soul fare seawards like a soaring gull to sense the scend and pitch of a sailing ship or a steamer, as she surged through the swells of the deep oceans. His long line of canvases was complete. These are his claim to immortality and his legacy to mankind.

As the man made one with the magic of his mountains, so he was inspired by his intimate affinity with the sea and its ships, as if with a sixth sense. If the shades of his beloved square-riggers still haunt the ancient sea-lanes they sailed so long, did they vail their ghostly topsails in salute as his spirit made that last passage? Did the waters of the whole Western Ocean suddenly become calm as they momentarily conjured memories of the *Campbell* and her convoys? Who knows?

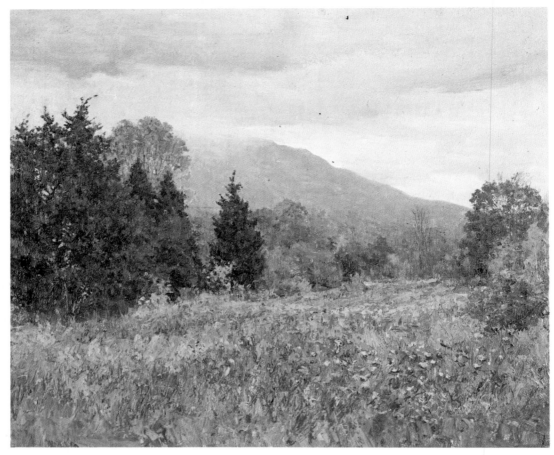

234. *No more would he record their riotous autumn colouring on canvas*

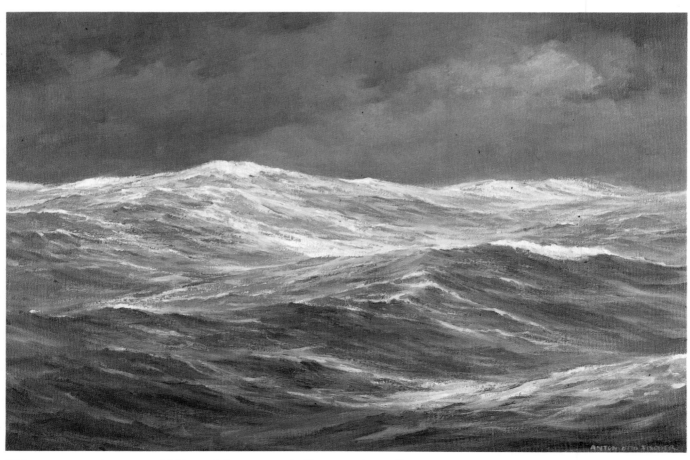

235. *. no longer would his soul fare seawards like a soaring gull*